"On the left, we are not very good
our collective knowledge. Peggy
trend in *Women Winning Office.*
getting into electoral politics but doesn't know where to start, this
book is for you."

> —**Nora Loreto**, author of *Spin Doctors: How Media and
> Politicians Misdiagnosed the COVID-19 Pandemic*

"In this highly accessible and mobilizing guide, Peggy Nash peppers detailed instructions, tips, and guidance with the stories of women from all backgrounds and lived experiences that have run and served in office. The most powerful part of reading the book was that I have witnessed Nash do the work: she reaches out to women, she lends support, she mentors and sponsors, she encourages women to run. She has shown a lifelong commitment to supporting racialized, Black, and Indigenous women in politics and activism. She is a striking example of what it means not only to ask women to run, but to stand beside them."

> —**Dr. Tanya (Toni) De Mello**, human rights lawyer, equity,
> diversity, and inclusion expert and trainer

"Nash offers us an intimate portrayal of how she parlayed her own passions and activism into a successful political career. Jam-packed with strategies and practical suggestions for how to run a winning campaign, the book is interwoven with personal stories and words of advice from many women activists, politicians, and academics. Nash's voice is the one whispering in your ear: 'Be the change you want to see.'"

> —**Tracey Raney**, professor, department of politics and public
> administration, X University (Toronto)

"Peggy Nash charts the important path from activism to elected office. This is a road map for women everywhere to get involved, get elected, and make positive change happen. Chock full of both inspiration and practical advice, it's a vital addition to the bookshelf of anyone interested in fighting injustice and changing things for the better."

—**Kathleen Monk**, communications and campaign strategist, Monk + Associates

"Essential reading for women considering running for office, and for anyone who has wondered what it takes to run for office. Nash has gathered wisdom from diverse women in elected office, as well as women with decades of experience in organizing, to gift us this practical guidebook."

—**Bhutila Karpoche**, MPP, Parkdale–High Park

"I have nothing but praise for this book. It demystifies everything about running, from initial considerations to the election to the day after. It will be a valuable reference for anyone considering running for elected office, and it is my hope that it will support more women and people from groups historically shut out of power who are thinking about putting their name on a ballot. As Nash writes: we want you to run."

—**Megan Leslie**, former MP for Halifax and deputy leader of the NDP

Women Winning Office

Women Winning Office

Women Winning Office

An Activist's Guide to Getting Elected

Peggy Nash

Between the Lines
Toronto

Women Winning Office
© 2022 Peggy Nash

First published in 2022 by
Between the Lines
401 Richmond Street West, Studio 281
Toronto, Ontario · M5V 3A8 · Canada
1-800-718-7201 · www.btlbooks.com

Library and Archives Canada Cataloguing in Publication
Title: Women winning office : an activist's guide to getting elected / Peggy Nash.
Names: Nash, Peggy, 1951- author.
Description: Includes index.
Identifiers: Canadiana (print) 20210366311 | Canadiana (ebook) 20210366486 | ISBN 9781771135993 (softcover) | ISBN 9781771136006 (EPUB)
Subjects: LCSH: Politics, Practical–Canada–Handbooks, manuals, etc. | LCSH: Political campaigns–Canada–Handbooks, manuals, etc. | LCSH: Women–Political activity–Canada. | LCSH: Women political candidates–Canada. | LCSH: Political candidates–Canada. | LCSH: Women legislators–Canada. | LCSH: Legislators–Canada. | LCSH: Nash, Peggy, 1951-
Classification: LCC JL186.5 .N37 2022 | DDC 324.0971–dc23

Cover and text design by DEEVE
Author photograph by Eoin Harris

Printed in Canada

We acknowledge for their financial support of our publishing activities: the Government of Canada; the Canada Council for the Arts; and the Government of Ontario through the Ontario Arts Council, the Ontario Book Publishers Tax Credit program, and Ontario Creates.

Contents

Introduction: This Book Is for You **1**

Part 1. Who Gets to Lead? **5**

1. Why Me? Why You? 7
2. Women at the Table—Space Invaders 13
3. Power Protects Itself 20

Part 2. You Are Formidable: Your Superpower **27**

4. When Change Is Your Only Option 29
5. Activism in Movements or Electoral Politics, or Both 37

Part 3. Beginning Your Campaign **47**

6. When Is Your Time? 49
7. Party or No Party? 60
8. Choosing Where to Run 66
9. Winning the Nomination 72
10. Building Your Team 82
11. Volunteers 92
12. Local Strategy, SWOT, and Target Voters 101
13. Preparing the Ground and Building Your Profile 108
14. Fundraising 114

Part 4. Getting Your Story Out **121**

15. Public Narrative—Your Story Is Your Power 123

16. Public Speaking and Speech Writing 128
17. Social Media 137
18. Traditional and Other Media 147
19. Eyes Wide Open 156
20. Holding the Community Close to Fight Racism 163
21. Dealing with Negative Voices 169

Part 5. Campaigning **177**

22. Tight Organization and Dedicated Volunteers 179
23. Being the Best You 184
24. Identifying Supporters—The Point of the Campaign 191
25. Canvassing 195
26. Building Momentum 207
27. Debating 211
28. Taking Care of Yourself 218

Part 6. The Election **225**

29. Ensuring Voters Vote 227
30. Election Night 231
31. The Day After 238

Part 7. Afterwords: One Piece of Advice **243**

32. Lead Like a Woman and Be the Change You Want 245
33. One Piece of Advice 247

Appendix: Twenty Questions to Ask Yourself If You Are Thinking of Running for Elected Office **257**

Acknowledgements **259**

Index **261**

Introduction:
This Book Is for You

It's your own struggle that makes you formidable. Don't listen when people try to change who you are, how you look or how you sound. Who you are is what gives you power.

We're not here to uphold the status quo. We're asking people to become agents of change. So if we hide that part of ourselves, we're never going to inspire others to collectively imagine and fight for a different possible future.

—Alejandra Bravo, Toronto City Council
and federal candidate

This is an easy-to-read, accessible guide for you to consider running for office. This is not about parliamentary procedure, legislative structures, or public policy. This is a how-to guide for progressive activists to demystify the process of winning elections.

Many people ask me how to run for office. Such a good question—Why do we not know this! I didn't know how when I started out. It's like a closed-door secret society and most people are excluded. I want to open those doors.

I ran five times as a candidate, was elected twice and served as Official Opposition Finance Critic and Industry Critic, served as the Federal NDP president in the run up to the NDP's most successful federal showing ever, and later in 2011, with the untimely death of Jack Layton, I ran as a candidate for the NDP leadership.

Joining me are some of the diverse voices of women from across Canada, most of whom have run in electoral politics. I

spent hours interviewing progressive activist women for this book, asking them why they did what they did, how they did it, who helped and didn't, and what advice can they give those that follow. Some won, some lost in their bids for election, but they all said they would do it again. Their experienced voices join mine throughout.

Once you decide to care about an injustice, to take even one small step to push back, you are moving beyond being a spectator, to seeing yourself as an actor in the world.

Some people come to activism at a young age; some people develop their engagement over a lifetime. There are many possible outlets for your activism. Running for elected office is one important, often overlooked, option. Please consider it. Some elected representatives who are most passionate and effective are regular people who see the need to fight injustice and make the world a better place.

I admire women like US gubernatorial candidate Stacey Abrams who wrote a book about her life while running in the campaign, in addition to writing novels, being a practising lawyer, and leading a movement for voter registration. That achievement takes a kind of herculean effort that I could never muster. Abrams is exceptional. But you don't have to be exceptional to run for office. Yes, it can be exhausting, and, yes, it takes a lot of effort. But it is possible. And it is worthwhile.

If you see injustices to challenge, not just opportunities for yourself, if you want to make a difference for others, not just a name for yourself, then this book is for you.

How to Use This Guide

If you've already decided to run and you're looking for the how-to, you can go straight to Part 3. Parts 3 through 6 are the practical parts of this guide: Beginning Your Campaign, Getting Your Story Out, Campaigning, and finally, The Election.

Begin with Parts 1 and 2 if you haven't yet decided to run. These two sections will help you make up your mind by introducing you to others who have run and what inspired them to do so,

how they came to that decision, and the multiple and varied paths that brought them to electoral politics. I also want you to know how important it is to have you at the table, what it feels like to be different and the impact you can have.

If you skipped Parts 1 and 2 and jumped straight into the fray, come back to Parts 1 and 2 to get reinspired and rejuvenated.

Part 7, the Afterwords: One Piece of Advice, is for everyone. I begin it with a reminder to lead like a woman and be the change you want. My words are followed by a final bit of advice offered by those who ran and those who worked closely with them. They want you to know what they know. They want you to run.

Part 1.
Who Gets to Lead?

1. Why Me? Why You?

You feel passionate about making change but are unsure that you can be a public figure. Why you? What's special about you? Aren't there other people who look like those already elected? Aren't there people younger, older, more educated, more experienced, more credible, more eloquent, more whatever? Do you really look and sound like a leader? Are you the right gender, the right colour, ethnicity, or size? Do you speak the right way? Fortunately, leaders come in all packages, but not everyone is open to it—yet.

Who Does She Think She Is? Ambition. Competition. Confrontation.

Ambition is not a bad word. As women we are often taught to care more about others and to put our own ambitions to the side. Empathy and nurturing are positive qualities, but they don't negate our desire to advance, to take on more responsibility, to get more credit for it, and to be leaders. If you want to lead, go for it. If you want a better position, ask for it. Be clear about your goals, to yourself and to those who have the power to help you get there.

Competition is not a bad word. I've seen many women, equally or even more skilled and competent, ultimately defer to male competitors and step back from competition. Men who talk over women, who rush to speak and take all the oxygen in a room, who interrupt and correct women, are competing with you. Women are often socialized to be nice and we learn that competition along with ambition makes us greedy!

Confrontation is not a bad word. Women in public life, especially racialized and Indigenous women, face a disproportionate backlash in the form of online and sometimes face-to-face

harassment and even violence. This is not what I mean by confrontation. (See more about harassment and violence in chapters 19 and 20.)

Have you ever been angry about someone's behaviour and, rather than confronting that person, you've taken it out on yourself? For example, at work, if your boss or a colleague claims credit for your work, have you swallowed your fury till it poisoned your insides? As terrifying as these confrontations can be, they get that poison out of your system and aim it where it belongs.

Name the objectionable behaviour. It's the first step. Exert your power. Don't let subtle racism or ablism slide by. If you can find a safe place to practice this, all the better. Collective bargaining in my union was great training to develop the skill of confrontation. Communicating clear goals and a clear message directly may not get you what you want, but you have the satisfaction of voicing your views and ensuring that others understand your goals.

MY VOICE, MY INDIGENOUS VOICE

In 2017 I received a call from Carol James, who was the former leader of the NDP and Member of the Legislature in Victoria. She had worked in our area, and she asked me to consider running. I felt that that outreach from Carol was important.

We talked about the importance of having more Indigenous voices in the House, and as an Indigenous women, Carol James had been elected as an MLA for a few years, and she shared some of her experience as an elected MLA. I really appreciated that conversation and I considered what she said. I talked to my family and then decided to put my name forward.

I wanted my children to see that this is an opportunity for them. That this was something that they could do. What I reflected on a lot when I talked to my grandmother,

who is in her 90s now, was that this wasn't an option for her. She attended residential school; she had to have a pass to go on to her home reserve to visit her parents and siblings because she married a member from another reserve. She lived with so many restrictions due to the Indian Act. Being elected as an MLA was not something readily available to her. I think for my mom there were also many limitations and restrictions. I saw this as an opportunity to show young women from the north, Indigenous women . . . that this is something that is an option for us.

Ann Marie Sam, Indigenous leader
and NDP candidate, BC

Who Do I Think I Am?

When I first considered running for public office, I kept asking myself, "Who do you think you are?" Growing up, I was taught to mind my place, be hardworking but to not stand out. Claiming the limelight was not a natural step. As a young woman I was ambitious but timid. I was the person who wanted to take the pictures, but not be in front of the camera. What changed my mind?

The big shift in my thinking was when I realized that it wasn't about me. I gained confidence serving as a peer educator in my union. As an activist I campaigned for changes. Most of my adult life I campaigned for progressive issues, from immigration reform to the need for more public housing, to refugee rights, tenant rights, and labour law reform.

All of us in our movements are conduits, paths to making progress. When my voice was in the service of an issue that I believed in, it was passionate, it was strong, it was confident. I jumped at many opportunities offered by my union, the Canadian Auto Workers or CAW, to develop leadership qualities. Put me in front of a crowd with a microphone and a subject I'm passionate about, and I take off.

Gradually, after many rallies, demonstrations, press

conferences, speeches, I became comfortable with my name and face being visible—they were attached to the issues I cared about, and I was one face of several.

That comfort level bled into electoral politics. I thought, why not me? Or why not any of us? Yes, it would be my name, my voice, my face, but it wasn't about me. Running for office was about making changes important to me. It was about childcare, good jobs, human rights, investment in cities, all these issues were running to win a seat in the House of Commons.

Learning how to be confident in my beliefs was easy, but learning to ask for support for my campaign was more difficult. Learning to be confident in myself is a life lesson that I want to share. I do this because I know there is so much talent, creativity, and possibility that is self-censored. And since we on the left are censored enough, we don't need to censor ourselves as women or trans or racialized or Indigenous people. Our voices are needed more than ever.

Activism and Political Agency
From activism to office: Becoming active in a movement brings many of us on the left to politics—from being aware of an issue, to learning more, signing a petition or showing up for a protest, and then becoming more involved. This is the route many of us take, some at a young age, such as with Greta Thunberg joining with other students to lead environmental protests. Others among us look at centuries of hurt and decide there is no option but to protest, such as with the Idle No More or Black Lives Matter movements. All movements are made up of individuals who decide to act.

This first step connects you with others of like mind, aware, seeking change. Being engaged in a movement, you learn more about the issue and you develop skills, expertise, and confidence. Social media skills, canvassing, phone banking, chairing meetings, public speaking, fundraising, negotiating are just some of the practical skills you can develop in movements. Eventually you

develop to the point where you recruit and train others as you develop your leadership capacity.

I really began to develop as a young activist in my union, soaking up every bit of education I could. Today, I see others develop their leadership skills in the student movement, the environmental movement, or fighting racism, sexism, or transphobia. You can build your activism in a local movement to help fight tenant evictions or police violence. Any activist movement can help you develop skills and confidence. Seize every opportunity to try something new, even if you feel nervous at first. Don't get pigeonholed into the same old responsibilities. Take advantage of the chance to learn something new.

Every activist is already on a path to leadership. Your passion is your best asset. This is what distinguishes you from candidates in old mainstream parties. You don't want to lead to preserve the status quo or defend the already too powerful. Your belief that a better world is possible drives your desire to make a difference.

The Experience Trap

Don't get trapped thinking you need more, ever more, experience. Or you feel you are unqualified unless you take every course and develop every skill. This mindset can delay your progress. No amount of training is ever going to prepare you for everything. Sometimes you just have to trust that you can figure things out. Those who are used to having power assume they can do the job, often with little or no experience or training. Don't let them take up all the space. Yes, develop confidence, but this is a lifelong journey. Too much delay gives your power over to others.

Experience as gendered: Experience can be an excuse to exclude us as women. The most glaring example of experience as a gendered concept is the 2016 US presidential election. Hillary Clinton, regardless of your opinion on her politics, was without doubt one of the most qualified candidates to run for president. Her opponent's qualification was that he was a TV star who portrayed a

successful businessman. His lack of policy knowledge or knowledge of government did not prevent him from winning.

A woman can take a lifetime gaining experience and still have people doubt her capacity. There is never enough experience to convince some people that women can handle the job. Men, on the other hand, even at a young age, are often measured by their potential to achieve rather than their past accomplishments. We have a hard time competing with a gendered perception of potential. But we can compete and we can win. Women have to keep winning and getting the job done.

WILLING AND ABLE TO FIGHT

Me running was a very local grassroots idea. It wasn't born out of the political party or any kind of political machine . . . It was an idea born in my neighbourhood. I was considered brave and a good public speaker and a hard worker, and that was what they thought made a good candidate. This was 2003. At the time, an allied progressive candidate was 26 while I was 32. Our youth was a problem for me, but not for him . . . That was just one of the many roadblocks and barriers along the way.

I think because of the oppositional nature of a campaign—it's a political contest—you should be willing and able to fight the fight.

Alejandra Bravo, Toronto City Council
and federal candidate

2. Women at the Table— Space Invaders

We've got to change the criteria of what a good leader looks like.

—*Rachel Notley, Alberta NDP premier (2015–2019)*

The arrival of women and racialized minorities in spaces from which they have been historically or conceptually excluded is an illuminating and intriguing paradox. It is illuminating because it sheds light on how spaces have been formed through what has been constructed out. And it is intriguing because it is a moment of change. It disturbs the status quo, while at the same time bearing the weight of the sedimented past.

—*Nirmal Puwar,* Space Invaders: Race, Gender and Bodies Out of Place

What Does Leadership Look Like?

If you come from the dominant group, which means being some combination of monied, white, anglo or francophone, and, until recently, male and cisgendered, and if you are a professional or someone with advanced education, or involved in business, then you tend to see politics as an option for a successful career.

If your family or community has been torn apart by residential schools, the sixties scoop, or by violence against Indigenous women, you have learned to be wary of the state. If your experience of power systems is that they are a blunt instrument that

disproportionately imprisons or randomly exercises other violence against your community then you want to keep your distance from that kind of power, the power that gets used against you and your people. If you are a working-class person who finds workplace protections increasingly weak and pay consistently low, and you can never seem to get ahead, you know the powerful are not on your side.

So what does leadership look like when it doesn't come from the dominant group?

THEY DON'T BELIEVE I'M AN MPP

In community I've been at events where I am invited as the dignitary, and I show up and they don't believe it's me. They are waiting for some other Laura Mae Lindo to appear. I've had a horrible experience at one school. I was invited to do a tour where they had an Anne Frank travelling exhibit.

Students had organized it, and it was one of those civics classes. It was very, very cool, so they asked me to come to open up this exhibit, because it was going to be open to the public. And I showed up, I was directed to sit in this room. One of the custodians had let me in . . . And, at one point, a teacher put their head into the room and looked at me and said, "What are you doing here?" and I said, "Well, I'm the MPP for Kitchener Centre, and I'm just trying to open this exhibit, just doing my job." They say, "People are coming, I don't have time for this." And then they left, and then the person that was with me was completely mortified. I said don't worry, sometimes I just have to roll with it . . . It was actually a student that came in and told me the exhibit had started, while I was sitting in this room. So we went down to the beginning of the exhibit. We took a picture and I was about to leave and another teacher came over and said to me, "Oh my gosh, Laura

Mae you're here. I didn't realize that." I explained but I didn't explain how rude the person was or how racist I felt it was. All I said was. "Oh, I was waiting in a different area."

"You want to talk to the kids?" Turns out all of the students were sitting in a room waiting; they were so excited when I showed up and I'm so excited. And the other teacher that had confronted me in that way, then realized that when I say I'm the MPP, that the words have meaning. She said, "Oh my gosh, I'm so sorry, there was just some miscommunication." I just want to do my job . . . it is a very different experience when I show up.

<div style="text-align: right">Laura Mae Lindo, MPP, Ontario</div>

Leading through the Pandemic

I've heard this mantra, prevalent for at least a generation, that says governments don't matter. Governments are slow, bureaucratic, unimaginative, and they don't deliver for hardworking, taxpaying citizens. Growing up in this soup of negativity about government, millennials wonder why they pay taxes when every government budget seems to cut back their services. Each visit to the hospital takes longer than the last. Each year at university costs more when there are fewer job prospects. Most unemployed young Canadians don't qualify for employment insurance even though they pay EI premiums. Most assume they will never get a pension and that the CPP won't be there for them. No wonder governments and politicians get a bad rap.

Governments can help: Then the pandemic of 2020 hit, and we turned to government for help. Tracey Raney, a political science professor at X (soon to be renamed) University, says younger Canadians are puzzled that a government they were told could not afford such social supports is suddenly handing them out freely. Professor Raney sums it up this way: "For years our students and the younger generation have been told we can't afford to offer social assistance. Governments can't do that. That's not the role

of government." And then, "It turns out governments can do it. Governments can step up." We all watched as the prime minister, premiers, and mayors held daily news conferences. Chief medical officers of health became the most trusted sources of information. They said stay home and many of us (although not all) stayed home. They said keep a distance, and now everyone knows how far two metres is.

Many of us lost our jobs, and then discovered that the federal government, which for years had anchored itself in the goal of balanced budgets, while rarely attaining them, suddenly found a seemingly limitless supply of cash to keep individuals, businesses, and even subnational governments afloat.

Now, it seems, government matters a lot. In fact, where many private businesses threw up their hands, shuttered their doors, and, in some cases, abandoned seniors in their beds when staff refused or were too sick to come into work, the government swooped in, even to the point of sending in troops to care for abandoned seniors. Professor Raney believes that the use of the power of governments during the pandemic can shift the terrain.

"The pandemic has exposed the way the 'normal' economy and government have benefited a small number of people," she said. "Young people now see governments can step up and help people. Even our social inequalities will be contested and debated. Young people will be engaged. I just hope they vote because it matters who's at the table."

Who is at the table appears to have mattered greatly during the pandemic. The media showered approval on several of the very few women elected to lead their countries, in Germany, Taiwan, Denmark, and Finland.

Stereotypes, again: Armine Yalnizyan, an economist and fellow at the Atkinson Foundation, says these countries have done well in dealing with the global pandemic, but she says that, while women are not naturally better leaders, their experience leads them to rely less on private-sector fixes and to have more faith in government. This would dovetail with a major component of successful

pandemic outcomes. Understanding the value of government has been central to limiting the pandemic and providing support for people. "Women use more services like health care and transit," she says. "They see government as less of an intrusion because they know that markets often fail at providing basic services."

Those who want to see more equitable leadership representation laud the performance of women leaders, hailing their examples as role models, in the hope that more women will be elected in the future. However, there are some cautionary voices. Many articles praising women leaders' performance tend to reinforce troubling gender stereotypes. We are in a pandemic, we face illness, loneliness, insecurity, and these women are listening and showing motherly empathy.

"The virus has enabled unusual opportunities for women leaders to display forms of protective femininity," according to Australian academics Carol Johnson and Blair Williams in their recent article "Gender and Political Leadership in a Time of COVID," for the Cambridge Coronavirus Collection. They point to negative media coverage of the inadequate response of some "strongmen," while women have received little criticism, by being more relatable and caring, and by dealing with the virus more quickly.

REPRESENTATION DOES MATTER

It's so important for women and other folks from marginalized groups to see themselves and see the possibilities. I definitely didn't think about politics as an option or a possibility before I witnessed my sister dive into a nomination race. With that I was seeing not only women, but women with similar life experiences as me go into politics.

So I initially ran for city council as part of a slate. Our slate was myself, a woman named Sarah Potts, and Sharmarke Dubow. Being part of that slate, where none of us really felt like normal politicians that fit the regular

mould—we were all renters, which is a rarity among elected officials. All of us have experienced income inequality. And then each of us had different life experiences that brought us there. Sharmarke was a refugee who got his citizenship and voted in the first election that he was elected in, which was just so inspiring and amazing. And I think he was the first Muslim councillor Victoria has ever had, the second Black councillor Victoria's ever had. Sarah is a single mom, queer, she's just an incredible advocate for folks who face income inequality and who are unhoused. And I can see so clearly in them, and in the work that we were able to do together, that representation does matter. Having people who have lived through the barriers that people face gives you such a deep commitment to dismantling those barriers and an understanding that we need to listen to the voices of the people who are facing the barriers, first and foremost. For so long, having people who don't understand the inequality, or who haven't lived through it themselves, be the only ones making those decisions has been at the detriment of everyone and society as a whole.

Laurel Collins, MP, BC

Better Government

However competent these women leaders may be, they may also be leading countries where people already have more trust in government. *Atlantic* staff writer Helen Lewis, in her May 6 article of 2021, cautions that focusing on women leaders' empathy and soothing care may actually limit women's progress in politics. She points out that it's easier to elect women in a political culture where people generally support and trust the government. She accepts that these women leaders are exceptional, they have to be to make it to the top job, but in addition to caring, they have been decisive, prepared, clear, and strong. "So let's not flip the old sexist script," she says. "After centuries of dogma that men are naturally better suited to leadership, the opposite is not suddenly

true. Women leaders aren't the cause of better government. They are a symptom of it."

The pandemic has created an opportunity to observe leaders who bring both competence and compassion to their work for the betterment of their countries. So young voters may now be more open to voting for a diverse range of leaders.

Perhaps future leaders will be more likely to have a collaborative, empathetic approach. Women may not always be better leaders, but more representative decision-making in leadership roles may help the world's governments make better decisions and further build popular trust.

Professor Raney is optimistic: "My hope is that young people, more than ever, are going to be engaged."

3. Power Protects Itself

> The number one way power protects itself is by not giving us language to talk about it, so we get presented with this concept of power. We think of a white guy in a suit with a big title, and . . . not only is it not us, but generally speaking, we don't really want to be a white guy in a suit. I think understanding power and building our literacy around it would make us develop beautiful power structures.
>
> —*Andrea Reimer, City Councillor (2008–2018),*
> *Vancouver, BC*

"Natural Born Leaders"

Successful business owners, those in legal, financial, or professional circles, many from these backgrounds see themselves as natural leaders and deserving of elected positions. Some have planned their education, their careers, and their networks with one eye always on the goal of assuming their rightful place in a seat of power.

Among these, there are some who see themselves as holding progressive views on human rights, but they are happy with the overall system of economic power and privilege, because it has worked well for them. They generally reinforce the status quo or, if pressed, concede incremental changes, either progressive or regressive. Retaining power is primary. Their seat on the top *feels* natural.

And there are those who seek election motivated to make change, but they are looking to the past, a more libertarian past. UK prime minister Margaret Thatcher was called the "Iron Lady"

for her determination to roll back state intervention in British society. Her iron-willed zeal to introduce deregulation and privatization and to free up trading rules made huge change. The result, of course, was greater inequality. Thatcher saw the winners and losers as meriting their outcome.

Similarly, former Ontario Progressive Conservative premier Mike Harris's "Common Sense Revolution" of the 1990s cut regulation (or "red tape" as conservatives prefer to call it), reduced taxes, and rolled back social services. The inevitable result was to drive up poverty and homelessness. More recently, US former president Donald Trump used his time in office to enact massive tax cuts, eliminate regulation, and continue the cuts to government services.

There is no question these conservatives wanted to get elected to make change, but the changes they sought are regressive. They used the power of the state domestically via the police or immigration officers and internationally with the military to impose their conservative goals.

We as progressives seek to redistribute wealth and power to those who have not been on the winning end of the economic, social, or environmental spectrum. The powerful wield the traditional political weapons of the best advertising money can buy, appealing leaders, a stable of polished candidates, and skillful campaigning, with earnest promises about making life better for the average person. However if they need to, they will win elections with racists attacks on immigrants or with sabre rattling against a foreign power. They are determined that we, the redistributive types, remain far from the levers of power.

How Power Protects Itself

Power protects itself with the use of many other tools such as:

- ***Systemic biases*** that privilege the dominant most powerful group
- ***Westminster first-past-the-post electoral system***, which favours fewer dominant parties and less power sharing and tends to exclude smaller parties

- *Lack of childcare*, which affects women more than men because of societal expectations and because more women are single parents
- *Sexism, racism, harassment, hate, violence* that can be marshalled in opposition to anyone from the non-dominant group who put themselves forward for a more powerful position whether in politics, the media, academia, labour, or business
- *Gender socialization* whereby research suggests young girls are not as encouraged to think about a political career or running for public office as are young boys
- *The microscope of public life* that can put everything from personal relationships to social media posts under a microscope
- *Confrontation*, often on display in politics, can turn off some women who prefer a more collaborative approach
- *Political parties* can be the barrier to greater diversity and power sharing by means of who they encourage to become candidates, who they support, and whose voices they listen to
- *Partisanship* and fierce allegiance to a party and the demonization of other parties can seem counterproductive to good decision-making
- *Informal norms and culture* of political institutions where the rules were set up by those who have long dominated politics and are extremely difficult to change, especially at the national level

RECRUITING DIVERSE VOICES

For a single parent, renter, someone who hadn't ever seen herself in politics, there are too many barriers. Unless you have organizations, parties, people willing to organize and support candidates who face those barriers, it's just not going to happen. And so I think it really takes intention and political will and people who value representation to

> recruit, to create the structures and the financial support
> for people who might not otherwise run.
>
> Laurel Collins, MP, BC

Calcified Institutional Cultures

Some elected women are interchangeable with the men who
came before them. Professor Tracey Raney addresses what is
called the descriptive representations of women, or the number
of women. She agrees that the numbers matter and should mirror
or reflect the societies that they represent. So if women are 52 per
cent of the population, they should hold 52 per cent of the seats in
that legislature.

However, she also highlights the notion of women's substan-
tial representation or the policy outcomes. There is no automatic
relationship between descriptive and substantial representation;
in other words, just because there is better numeric representa-
tion, doesn't automatically mean that issues important to women
will be addressed. The same would hold true for any historically
underrepresented group. Not all women support feminism, or
Indigenous rights, or social justice. Many who get elected have
other issues that are a priority.

Professor Raney studied the Canadian senate where about
half the senators are women, and the senate recently adopted
a new violence and harassment policy. Along with the policy's
strengths, it has some surprising weaknesses. Why, she wonders,
didn't they adopt a better policy when they had the numbers, by
gender, to get it done.

One factor she highlights is the entrenched cultures of these
institutions. Some would call them calcified. The culture of the
senate was established by a more homogenous group of legisla-
tors many years ago, and it is very difficult to change. She explains:

> What my research points to is because these institu-
> tions have historically been so dominated by white men
> that the culture is embedded within them . . . there's a

gendered logic of appropriateness embedded within [political institutions] that shapes how institutions "have always done" things. This includes things like a lack of parental leave for a long period of time, lack of sufficient daycare for parliamentarians, and such things as evening and weekend sittings and the lack of proxy voting in the House of Commons, all of which make it more difficult for primary caregivers—who are disproportionately women—to attend.

Critical Actor Model

Dr. Raney thinks that the model that holds the most sway is a "critical actor" model. This she says would suggest "it's not about the percentage":

It's about getting actors there, who may also be men, and this is not to say that having women there themselves is not important, it is . . . and that they are in positions of power and influence in the informal norms and culture of those places that really matters. So we want to see not just that it looks like society, but also that the policies that it's adopting and the decisions that we're making are attempting to create a more inclusive equitable equal society.

WHO GETS TO LEAD?

No matter who we see in elected office, who we see running, it gives us a message about who belongs, first of all, and who can and can't aspire to be a leader. . . .

Giving representation and voice to people who are our workers and thinking about their community of working-class people as something that has value is really important . . . in politics there is always an overrepresentation of patricians! I think this is a bit of an unspoken reality, even in the NDP. Not enough people who drive policy and political agendas know what it's like not to have been to summer camp or know what it's like to struggle to pay the rent.

I felt really comfortable going door to door and they'd invite me to join—they're making wine, I'd go in the back with them and drink wine, eat hot peppers . . . I think that we have to be really careful about not having enough working-class people in leadership positions.

There are things that are so basic about being respected for what you do and seeing yourself as a contributing member of society. I feel those concepts are being revived a bit, but for a while it was really that if you weren't going to be a lawyer, an engineer, or something professional, you just had no value in society. I think people are pushing back on that now. The racial justice uprising has been something profound for raising working-class consciousness too. It's also about other forms of inequality, and the reality is that the working-class is a lot different than it used to be, and it looks a lot different now than the romanticized idea of the past.

Alejandra Bravo, Toronto City Council
and federal candidate

Part 2.
You Are Formidable:
Your Superpower

4. When Change Is Your Only Option

In my opinion, being a Black, queer, fat woman in an often Black-queer-fat-hating world is not only my identity, but it is also a political state of being.

—*Dr. Jill Andrew, PhD, MPP, Ontario*

I think being born an Indigenous woman in this colonial country is a political act. My very own survival; my very rights, depend on me fighting or not. Even today, Indigenous women do not have the same rights as non-Indigenous women in Canada under the Indian Act. It's not a choice for me.

—*Leah Gazan, MP, Manitoba*

My Union Roots

Growing up: Even if I didn't know how to name it or talk about it, as a girl growing up in the latter half of the twentieth century, I couldn't help but be aware of power, who had it, and that I didn't. From hockey rinks and football fields that were just for boys, to jobs that had a gender attached to them, to rules like needing to change my name if I got married or getting a man's permission to take a bank loan, it was clear that the game was rigged.

As much as I saw *this* power imbalance, the Eurocentric bias of our history lessons and the systemic racism against Indigenous people, Black Canadians, and immigrants weren't part of my awareness at the time. While the energy of the civil rights movement and the peace movement bubbled up from

the US, I naively viewed these as American issues. There were a few Japanese Canadian families on our street. I found out later as an adult that they had all met at an internment camp during the war.

Focusing on getting good grades was a way to distinguish myself from my athletic brother. My parents were hardworking, kind people who had grown up in very hard times during the Depression and had lived through the war, my dad serving on a minesweeper in the North Atlantic. They were the first generation in our family to finish high school and to scrape the money together to buy a home. They hoped I would get a skill to improve my job prospects and encouraged me to train for clerical work. Instead, I insisted on university, working at Air Canada to help pay for my studies. Unlike today, I was then able to graduate without debt and I continued at Air Canada.

Union work at Air Canada: While I had engaged in solidarity work with refugees, my activism really blossomed in the labour movement, through my involvement in the union at Air Canada, a small independent union, that eventually merged with the CAW, today called UNIFOR. My union sent me for training to become an adult educator and occupational health and safety rep. This was the motivation I needed, and I threw myself into training workers in my own union and around the province. I loved the work, but as a single parent with a toddler, life was challenging. There was no funding for childcare let alone overnight care. My parents sometimes helped out but they were busy with their own jobs. It was hard on my son. I was torn.

There were also huge storm clouds on the horizon. Airline deregulation in the US had wreaked havoc on the industry. Under the guise of lower fares for consumers, companies began ferociously competing, and workers were a liability. Dozens of companies went bankrupt, and thousands of workers lost their jobs. Deregulation was coming to Canada. We knew that our next round of collective bargaining with Air Canada would be very challenging.

Nevertheless, our union president agreed to allow us to hold our first women's conference. While most of our members were women, all the service reps (who negotiate and enforce the collective agreement for the membership) were men. There were very few women in leadership positions. None of the men had heard any harassment complaints. At the conference we held a workshop on the topic. Hands shot up from women who had experienced or witnessed harassment. Overall, the conference was a huge burst of energy at a time when the union needed engaged members.

The only other woman on staff at Air Canada's union was Jane Armstrong, who was hired as a part-time librarian. Jane was involved in international solidarity with South African unions against apartheid so she knew a thing or two about organizing. She became the union's researcher and, more importantly, was my partner-in-crime in trying to mobilize the membership against contract takeaways. We got important information about the key issues into the hands of the members before contract talks. Even though Jane and I weren't at the bargaining table (that was all guys), we did our best to keep the members informed. While some in the union believed that the membership was too complacent to fight back, we disagreed. A strike vote proved us right. The membership didn't disappoint.

As predicted Air Canada came gunning for cutbacks, and the membership voted to strike. We had no strike pay, but the membership struck anyway. Many of the women who attended the women's conference became informal leaders on the picket line, inspiring members to keep strong. Many were later elected in official leadership positions, including the airline union's first woman president, Cheryl Kryzaniwsky. Cheryl worked for Air Canada at Toronto's Pearson Airport and had a strong following among the members there. She helped lead the union into a later merger with the CAW.

We didn't get through bargaining unscathed. There were some concessions but compared to what the company wanted and what we would have achieved without a strike, there was

no comparison. That experience taught me to trust that an informed membership with good leadership can make the right decision to stand up for their rights. I was so proud of the Air Canada members.

Working for the Canadian Auto Workers: By this time I was happy in a "recombined" family with my partner, Carl Kaufman. Our youngest son, Thomas, was born soon after our union merged with CAW, and I was offered a job by Bob White, president of the CAW. With Thomas just a few months old, and older children, Colin and Nick, we had our hands full. But Carl encouraged me to take the job. He took an unpaid leave from both his job on the railway and his union leadership position to be home for the kids, especially the baby. He was and is a man way ahead of his time.

The lesson of trusting workers to make the best decisions has been proven time and time again with workers in public and private sector workplaces. A similar experience with the former Canadian Airlines membership several years later again showed me the courage of people to make difficult choices if strong leaders are encouraging them to stand up for their rights.

While my activist grounding blossomed in these and other struggles, I was privileged to have the support of the leadership and to work with a team of talented colleagues, developing human rights and harassment policies and programs for the newly merged union, the CAW. We organized conferences for women and racialized, Indigenous, and gender diverse members. We organized against free trade and neoliberal policies, and advocated for childcare programs, lower drug prices, and workers rights more generally. It was a very turbulent time in labour relations and society more generally. I was thrilled to be exactly where I needed to be, in the middle of these struggles.

Beyond the Union
A union offers working people an incredible opportunity to

learn skills, to develop an in-depth analysis of workers' rights locally and globally, and to build the confidence to take on employers. Our union was still very male dominated with a strong masculine culture. This helped make it effective in collective bargaining and standing up for workers' rights, but very challenging sometimes in other ways. After many years on staff at the most senior level, I was told point blank that "people weren't ready for a woman leader." I felt that it didn't matter how hard women worked or how loyal or dedicated they were or how much they participated in the union. Gender created a glass ceiling. This was a sad familiar pattern. While the culture is changing, it's an ongoing struggle. For me it was such an honour to work for the union, an organization people gave their lives to establish. The union helped define my life and I am grateful for all the experiences and opportunities I have had. I had achieved more than I ever thought I could but I needed to get out of the way and let others have the opportunities I had enjoyed.

I was a founding member of Equal Voice, an organization started by journalist Rosemary Speirs, dedicated to electing more women; I'd heard former New Zealand prime minister Helen Clark speak about electing more women; I'd led many leadership courses for women to encourage them to run for office in their local union: Maybe, I too should step up.

When I decided to run for elected office, I was determined to fight for the same issues we were fighting for as a union and against the regressive laws that were taking away hard-fought gains at the bargaining table. I had voted NDP but was not a party activist. I was, however, on the left, and that would not change.

The Fire in *My* Belly

It's the people who are getting the short end of the stick who need champions, who need to get involved, who need to fight. That's where the energy is. That is the fire in my belly to make a difference and to never give up. It is only on the left that there

is forward-looking change. From environmental protections to social programs, to innovative technologies and discoveries, it is the goal of making life better for the majority that drives progressive change, progressive movements, and, ultimately, progressive governments.

Movements and activism are the engines that fuel progressive change, and they are essential to it. From fighting to save a local swimming pool to Black Lives Matter, movements politicize people and mobilize them to make change.

Your Superpower

If you have fire in your belly for climate justice, Indigenous rights, anti-racism, gender equity, workers' rights, whatever your issues, that is your superpower, and it is what propels you to fight for a better world. You are formidable.

BEING ANGRY

In 2015 or 2016, I gave a talk on International Women's Day at, if I correctly recall, Heritage Toronto, called, "We must allow women and girls to be angry." Because as a feminist, as a person who had a background in women and gender studies, I was always curious as to why society has wanted women and girls to take up as little space as we can, to have as small and polite and feminine a voice as we can, and the way the world has sought to police how we're supposed to look, how we're supposed to put ourselves together, dress, present ourselves as women and girls in a professional setting and so forth. So, I wrote this piece, "We must allow women and girls to be angry," as a way of talking back to and against all of the economies of oppression that attempt to box in and restrict us as women—from the beauty-industrial complex, to confronting gender-based violence, to fighting back

against misogyny, to addressing racism such as anti-Black racism and anti-Indigenous racism and others, misogyny, homophobia and size discrimination for instance. I wanted to remind each and every woman and girl in the room that our rage is one of our best tools. It is an oppressive society's kryptonite . . . After giving that speech I had a few people come up to me, some elected, asking, have you thought of getting into politics, you know you sound like a strong advocate for women and girls. We need your voice.

Dr. Jill Andrew, PhD, MPP, Ontario

CARING MOTHER: ANGRY POLITICIAN

And I remember when my son was born, I was really struggling with not getting enough sleep. I did question myself . . . should I continue to run because it was such interesting timing for me. But I was so lucky in a way, I had a lot of women sisters who are feminists and strong women, who, every time I share with them I'm struggling with this thought . . . then those sisters will tell me that's why you need to run. And so, now, when . . . the same question came up again about are you able to travel to Victoria? how's your child? . . . I had people actually who said they may not support me because they're worried about me . . . one actually was a politician, unfortunately, who said, you know you've just started as a school board trustee and also your son is so young, I think this [other] guy may be better. And then I was like, but he has a young child too, he actually has a child who is about the same age as my son, so why are you not questioning him? . . . He actually angered me, I cannot tell you how much over the years. Then I think it turned into a motivation . . . and continues

to be my struggle and impacted my family. I'm glad that I'm working on an inclusive universal childcare plan for BC now, but I became a single mom last year, and being an immigrant without family here, and having to do parenting and all that, childcare continues to be a struggle for me, so when I'm saying that in anger . . . he got me running, but it's still a barrier for me.

Katrina Chen, MLA, BC

5. Activism in Movements or Electoral Politics, or Both

There is a thirst, especially among women, to know if elected office is worth it . . . my conclusion, after the World Women's March in the year 2000, was that if I passed my life looking to government to change things, then I need to be in government.

—Manon Massé, députée à l'Assemblée nationale du Québec

I've told many other women who wish to pursue leadership positions that people will tell you it cannot be done. It can be done, or I would not be here. I was told "you are running against an established male for nomination, it's unlikely you will be chosen as the candidate." Well, the movement got me elected, the movement continues to support me, and I feel beholden to the movement in all my choices and positions I take.

—Leah Gazan, MP, Manitoba

We need activists engaged in successful movements to make progressive change, and we need receptive ears in elected office to enact the changes our movements and activists are demanding. Progressives in elected office function best when they are connected to vibrant movements. And what becomes clear when speaking to progressives in politics is that many of us get our start and our experience as activists in movements. Both movements

and electoral politics can be powerful at making change. And we are most effective when we are working together.

Movements and Political Change

Relationship building: Grassroots mobilization and collective action are the cornerstones of resistance for the feminist movement. Like many of us, I have been active in various movements and protests for much of my life. From immigration reform, childcare, labour rights, gender violence, reproductive rights, LGBTQ2S+ rights, anti-racism, environmental justice, international human rights and more, I have taken up many causes and cared enough to show up and get involved. For some movements I was very actively engaged; for others I was an ally.

Activism and forms of protest can be successful. They depend on effective organizing. From Pride marches to Black Lives Matter protests to illegal strikes by workers to Indigenous rail blockades, there is no question that movements can pressure those in power to the point where they can no longer avoid action. Our global peace protests in 2003 didn't stop the US and its ally the UK from invading Iraq, but we did keep other countries from joining, including Canada. Spontaneous outrage stemming from the police murder of George Floyd in Minneapolis in 2020 sparked global protests and forced some steps toward police accountability.

Through activism in movements, some of our despair can give way to seeing that another world is possible. When we get engaged in movements that speak to our reality, we become politicized. Engagement in a movement is a process of relationship building that can take a long time with much discussion and education, or it can happen rapidly when events shock us into action.

Idle No More Movement: The Idle No More movement began with three Indigenous women in Saskatchewan, Jessica Gordon, Sylvia McAdam, Sheelah McLean, as well as non-Indigenous ally Nina Wilson, who were fed up with proposed changes to Canadian laws by the Stephen Harper government that would further erode their rights to their land. They decided to take action with a grassroots

movement, amplified by social media, which caught attention worldwide. They relied on education, local community initiatives, and tactics to raise awareness about their issues.

Black Lives Matter and George Floyd: On the other hand, the murder of George Floyd in the custody of the Minneapolis police in 2020 sparked immediate protests globally and highlighted police oppression of Black people and the need for many reforms, especially in police departments. The footage of Mr. Floyd suffocating at the hands of the police deeply affected millions of us and the Black Lives Matter movement seized the moment to mobilize for change.

Power matters: Movements and their activism are essential to holding powerful interests to account and to advancing change. Activism in movements not only politicizes us but can help us develop leadership skills in organizing, educating, public speaking, and all kinds of advocacy.

For most of my adult life, I operated with the belief that if we organized enough, if we made enough noise and reached enough people, that we would persuade or at least pressure those in power to make the needed changes. Early on, I naively thought that being right was enough, that if justice was on our side, surely, we would win. Many struggles showed me that this was not necessarily the case. Being right often doesn't matter. Power matters, and powerful interests often don't care about what is right. Their priority is what matters to them; what increases their wealth or power or reaffirms the status quo to their benefit is what matters to them.

Injustices can rally us to act through a movement. The murder of George Floyd by a police officer happened to be captured on video by a brave young bystander. Her video that showed Floyd gasping for air, saying he couldn't breathe, and calling for his mother, shocked others into action. It sparked protests around the world and prompted serious discussions about defunding the police.

Beyond Movement Politics

Limits to activism: But as a labour activist, I have seen some frustrating limits to movement politics and activism. Despite massive organizing and mobilization, Canada has repeatedly signed on to free trade agreements, allowing companies to chase cheaper labour around the globe. I saw firsthand the impact of free trade agreements with the loss of hundreds of thousands of manufacturing jobs, as well as the deregulation of our transport and communications sectors and the privatization of government services, exerting downward pressure on wages and working conditions here in Canada. Despite ongoing organizing and protests this neoliberal austerity agenda of weakening public services and undermining the role of government, has enriched the wealthy and either impoverished or undermined progress for the many.

As we get closer to a climate catastrophe, we see governments professing to tackle the climate emergency but time and time again avoiding meaningful action. Some of us know our jobs are in industries that are harming the planet, and we fear for the future of our kids, too. Yet, in the immediate term, there is no clear plan for a just transition to a green economy, and we need to earn a living. Government paralysis for short term political gains is contributing to the destruction of the planet.

Childcare broken promises: As a feminist by instinct and deliberately since the time of the birth of my first son, I got involved advocating for childcare and was part of the childcare movement. We organized, demonstrated, wrote policies and letters to governments. Here we are, more than forty years later, and parents continue to pay huge sums and struggle to access too few spaces for childcare.

Many governments promised childcare, most notably in the Liberals' 1993 election *Red Book*. When in power two years later, the Liberals made some of the biggest cuts to Canada's social safety net, still reverberating to this day. Childcare was off the table because it was "unaffordable," meaning that parents would have to find a way to afford it. My fury was stronger than any

doubts about my ability to run for elected office even though it would be almost another decade before I stepped up. Those politicians who promise one thing and deliver another in office need to be challenged. The Liberals again promised pre-2021-election to deliver childcare and are now entering into agreements with most provinces and territories. So I hope this time they can deliver. We are closer than ever now but how sad that another generation lost out on this crucial social benefit.

Who gets elected matters: What these events have taught me is that it matters who gets elected. It matters if working people are represented, and it matters if women are at the table. It matters if those who are most marginalized and most impacted by government policies have a say in those policies. It matters if those elected have demonstrated by their actions that they are committed to change rather than just mouthing platitudes at election time.

These thoughts simmered with me for a few years before I finally decided to act. I became convinced that activism in movement politics is essential to making societal change, and also essential to progressive electoral politics.

THE INSIDE OUTSIDE RELATIONSHIP

The people that I see who are really effective as politicians come from social movements. Similarly, people in movement work who are politically active are effective because they have a really good understanding of power. Ultimately, I think the objective in a movement is to win material change, policy change, specific concrete change, and you have to have an understanding of the way the inside works. I think that the inside outside relationship is kind of the sweet spot.

Alejandra Bravo, Toronto City Council
and federal candidate

The Struggle for the Right to Vote

When I was running for office in Toronto, I met many people who didn't vote. Some had no history of voting in their family, and it never became part of their practice. Others had voted in the past, wanted changes to happen, and were disappointed when election promises evaporated with the winning party. They didn't vote because they saw that nothing changed. They felt their vote didn't matter. Some people came from countries like war zones or with dictatorships where voting was not possible. I also met people who told me that they voted but they just voted the way their family had always voted or the way a family member, usually a man, recommended they vote. In other words, voting for many people is not something they value or think a lot about.

But I have been to countries where wars are fought and people have died to gain rights, including the right to vote. We shouldn't be surprised to learn that even here, in Canada, the right to vote has been a power struggle. For generations people have organized and fought to extend the right to vote from a small landholding elite to the broader populations. Indigenous women did not fully have the right to vote in Canadian elections until the 1960s, and voting among Indigenous people remains a contentious issue.

Electoral Politics—Useful or Not?

Politics are the choices made every day by people who have the power. And if they don't want to protect the planet then leaders of ecologist movements have to get the power to lead the country in the ecological transition. When I look here in Quebec, who are these leaders of the ecologist movements, who are the leaders of Black Lives Matter, it's women. The future movements, it's women of fourteen, fifteen years, who have the leadership of these organizations.

—*Manon Massé, députée à l'Assemblée nationale du Québec*

Getting the right to vote has been a long hard struggle. At the same time, there continues to be a vigorous debate about the usefulness of electoral politics. Some among us argue that capitalism cannot be reformed, and it's better to dismantle it. Naomi Klein (among others) argues that the challenge of climate change is a product of capitalism and cannot be solved within it. In her book *This Changes Everything*, she argues that environmental justice can only be realized with a new inclusive form of governance that includes economic, social, and environmental justice, and first world colonial reparations: "The real reason we are failing to rise to the climate moment is because the actions required directly challenge our reigning economic paradigm . . . Commodification of capitalism is at odds with social good."

Neoliberal capitalism affects us in different ways. Some of the most affected have had the least chance of getting their voices heard. The most marginalized know best what changes are needed but have had no access to power. Those in power decided they knew what was best and they acted on it.

Among the most marginalized there is a lack of trust in political parties. Formal political processes look exclusive and bureaucratic. Professor Deva Woodley, in "#BlackLivesMatter and the Democratic Necessity of Social Movements," a talk given to X (soon to be renamed) University, said "Picturing yourself as an actor in the political process can seem foreign to most people and requires a big shift in thinking."

But we have seen it is possible. Many examples in history exist, where people have made that big shift in thinking, some, most recently, in Georgia in the US, where organizers built a movement for voter registration of Black people excluded from political power. Years of organizing and leadership development, led in part by politician and voter-rights activist Stacey Abrams, helped Georgians exert their agency and denied Donald Trump a second term as president.

Electoral Power Matters

If electoral power weren't important, wealthy, powerful people wouldn't fight so hard to get it. It matters if those in office tackle climate injustice, inequality, labour rights, justice for Indigenous Peoples, increased tax on the wealthy. It matters if governments decide to spend money on the military and vote for a war rather than invest in social solidarity. Who is in government matters.

Some argue that a social democratic party in Canada should be the voice of conscience and not aspire to power. I disagree. I believe that a party of the left can have a conscience, stand for what it believes in, and gain power to enact what it believes in. There is a reason why federal governments bounce back and forth between the Conservatives and the Liberals. As a senior bank official once told me, they trust both those parties. They don't trust the NDP. I take that as a badge of honour. The banks know that they won't control all the rules of the game if Canadians elect a non-traditional progressive party.

I believe that a political party working with progressive movements, connected at the base with people fighting to bring in social, economic, environmental, and political justice is exactly what we need. Fighting for and winning elections, is the way to get it.

SUPPORT FOR ELECTED PROGRESSIVES

But one of the hardest things when I was elected, was that as soon as I was elected a lot of the people in the movement assumed that now I had put on this politician's robe of some kind, and I was no longer part of the movement. It was fascinating because I didn't anticipate it. I assumed that we had all said let's get behind her because we needed the movement to continue in a different space. And I had events cancelled, and people literally cancelling, saying this is a nonpartisan event.

We would say we don't want an event to be political, because you knew that the politicians that you were inviting were just going to talk, talk, talk, but not act, act, act. But those attitudes were getting levelled against me. So it's not just getting us elected, but what is the support system around us so that we can do the work?

Laura Mae Lindo, MPP, Ontario

Part 3.
Beginning Your Campaign

6. When Is Your Time?

I started whispering to some people I knew, saying I would like to run one day.

Politics is all about timing. So I had built this core team of three friends who were supportive of this idea and wanted to be part of new politics in Canada. When the nomination opportunity opened up in Toronto Centre in 2013, Bob Rae had stepped down, I was actually in Russia with the Girls 20 Summit, and they were messaging me saying, "Did you see this news? Bob Rae is stepping down. We think you should jump in. We don't know how competitive it is for the NDP, but there's a moment here." And I'm in Russia on a train going, "oh my gosh, is it now? What do I do?"

I think it's really important that you do have a team, even if it's a couple people who encourage you to make that first leap because it's very scary. There are so many unknowns. It requires resources you probably don't have. The timing is never ideal.

—*Jennifer Hollett, federal candidate, Ontario*

Never the Perfect Time

There is never a perfect time. If you wait for just the right time to take on a leadership role, time may pass you by. Don't listen to the naysayers who proclaim that "people just aren't ready to elect a trans woman in this area yet" or "I'm not racist, but you know how people can be around here."

When I ran for Federal NDP leader, I was told more than once

that the time wasn't right for a woman. Women had been elected NDP leader twice before, and some people said, "it didn't work out." Because the NDP was the federal Official Opposition when I ran for leader after the death of Jack Layton, and the party just might still win power, they believed it was time for a man to step up. This narrow mindedness from people in the party I was representing just increased my determination. Their limitations were not going to define me, and they should not define you.

However, be wary of people who say, "just go for it," because it's your life, and there are real consequences to running for office. Being an ambitious woman who is a public figure in a competitive and sometimes confrontational race can be a difficult adjustment. It can be disruptive for the career path you are already on, which may or may not be a good thing. It can be challenging for relationships with family and friends. There may be financial considerations for you. As a candidate you are a public figure, which takes some getting used to. So how do you decide? When is the timing right for you?

Just the Right Age

From young students to activist seniors and all in between, movements are an opportunity for us all. I've heard many say somewhat paternalistically "keep at it and maybe one day you too can be a leader." Don't be deterred if you want to act now. There are many notable young leaders, from environmental activist Greta Thunberg to courageous Pakistani Nobel Prize winner Malala Yousafzai. Some people get elected at a young age and are re-elected because they are effective. Youth is no barrier to leadership.

My advice is wait for no one. Young activists can inspire thousands and even millions. I have seen student leaders at X (soon to be renamed) University, where I teach in Toronto, who are not waiting for permission to show leadership. They are challenging colonialism, fighting racism, struggling for better labour standards, and they are part of grassroots struggles for climate justice. What I see is a refreshing impatience for change and a belief that they can create a better world. Many young activists see that they

are receiving a legacy of inequality and environmental degradation that they will be expected to deal with.

Young women are sometimes dismissed as not serious, too attractive, or too inexperienced. But there are women breaking these stereotypes. Social democrat Sanna Marin became prime minister of Finland at age 34, becoming the country's youngest ever head of state. She is the third woman to lead Finland and now most of her cabinet members are women.

Alexandra Ocasio-Cortez at age 29 was the youngest person ever elected to the US Congress in 2019 when she defeated a ten-term incumbent in a huge upset for the Democratic Party.

What about old age? Joe Biden was elected US president at age 78, and Nelson Mandela was first elected president of South Africa at age 76. While not without discussion, their advanced age was clearly not a barrier. Sometimes women can do this too, although older women are sometimes dismissed as unattractive, weak, inconsequential. A longtime Conservative MP once told MP and former NDP leader Alexa McDonough, then in her sixties, to "stick to her knitting" during an election campaign, a comment he likely would not have made to an older male MP.

Nancy Pelosi, a rare exception, has at age 80 been re-elected Speaker of the US House of Representatives. And there are many older activists who refuse to give up. I, too, have felt, as an older woman, the assumption that I would just fade away. The sexist message is: who wants to see, let alone hear from, an older woman. Men can also face ageism but, as usual, there is a gendered aspect that is dismissive, paternalistic, and infuriating.

Gendering Age

Pelosi aside, age considerations in politics can be particularly gendered. Young men right out of school, men in their 70s who have retired from successful careers, men with infants, school-aged children, teens, all are considered fine as candidates. In fact, we don't usually even ask about men's personal life. We just assume that whatever personal considerations he has, someone is looking after things for him.

Our lives as women, in contrast, are often a source of great interest and speculation. Prime child-bearing years for women are precisely the time when people start to move up in their careers. If we are limited during this time, it's likely to be hard to catch up.

When Jacinda Ardern was running in a general election as leader of New Zealand's Labour Party, she was repeatedly asked if she intended to have children, and if so, how could she devote herself to the job of running the country.

Ardern's answer to the media was that if she chose to get pregnant that was her private business. She then became the world's youngest female head of government at age 37 and later became the world's second elected head of government to give birth while in office. Her partner took time off to care for the infant when Ardern returned to work. A subsequent article about her had the headline: "Honey, hold the baby. I've got a country to run."

She's an inspiring leadership role model to many, as an engaging leader who speaks frankly of the challenges of parenthood. Ardern has garnered plaudits around the world for her handling of COVID-19 and for her response to the terrible Christchurch Mosque massacre. She showed great empathy with the affected families and community members, and she acted quickly to pass tough gun laws.

There are now many women who have given birth in office and nursed babies in parliament. While there is still much work remaining in establishing supports for new parents, especially childcare provisions, the situation is improving.

The only question is: When is the right time for you? Leading an organization or running for and winning office is very time consuming. You need to be motivated and energized. If it will tear you apart to run when you are pregnant or have your kids at home, then don't do it. But know that it can be done and done successfully. Yes, sometimes there is guilt when you can't be in two places at once. It's a terrible feeling, but a couple of missed family events won't destroy your children or your partner. You can manage to

keep strong family ties when elected. Likely you won't be starting a time-consuming hobby. Save that for another period in your life, but you can choose how to use your time in a satisfying and productive way.

WHEN IS THE RIGHT TIME?

I've heard people say "Oh, I can't run right now, because I have to get a Masters first." Or "I can't run until I achieve X, Y and zed." This notion that there's a particular standard CV or life experience, your biography, that counts above others in politics is a number one operating impediment to running . . . I was 32 with two kids, told I was too young, too left, too. Latina. Progressive councillors gave me the advice to get a makeover, gain thirty pounds, so you have more credibility, wear high heels when you canvass. I was told politics is about image, never about values or the capacity to lead. The advice I got was never around substantive questions of policy or even strategic political advice. Unfortunately, you have to have a high tolerance for unfair scrutiny of areas of yourself that have nothing to do with your political capacity.

Alejandra Bravo, Toronto City Council
and federal candidate

Working and Running for Office
Can you take time off? Can you afford to take time off to run for office? Running an election campaign can take months of work. If you have an employer who is flexible with your hours and you would face no repercussion from running for election, then you're in a great situation. If your employer wants you to stick to your job full time, then you are going to need to be prepared to work evenings and weekends on your campaign. Some high-profile people

won't announce their candidature till late in the game so that they can keep their current positions. This can be risky, but they are counting on their high profile to win them votes.

Be prepared for any outcome: If you run for office, you need to be prepared for any outcome. If you run expecting to win and you don't, you might find yourself looking for a job. Women who are already in the public eye, for example in the media, sometimes cannot return to their previous position because they ran for office. They are told they need to be *seen* as impartial as well as *to be* impartial.

Conversely, if you run only to be a name on a ballot and suddenly your party has an upswing and you are swept into office, a win can derail other career plans.

THE ORANGE WAVE AND RUTH ELLEN BROSSEAU

In 2011 in the NDP surge of the Orange Wave, many candidates were elected who never expected to win. Students had to set aside academia; people left jobs they were happy with. One candidate, Ruth Ellen Brosseau was a single parent, a student, and part-time bartender. Long before the election she had planned a trip to Las Vegas and went on her holiday during the campaign. When the NDP swept most of Quebec in the 2011 election, she was elected to represent a francophone riding, while speaking very little French.

I remember the day of our first caucus meeting after that election. We were in a beautifully decorated huge room in Centre Block of the House of Commons. It was so different from the tiny meeting room in the basement where we had gathered the last time I was elected. A massive painting of the Fathers of Confederation loomed over us. There was a striking contrast with the "Fathers" and our caucus members, since almost half of our MPs

were now women, many quite young, some were Black, Indigenous, many francophones. It was thrilling.

I took a seat waiting for things to start and when the doors opened to let the media in to get some photos and footage of our new group of MPs, an overwhelming crush of reporters with cameras and microphones came flooding to where I was sitting. Then I realized I was next to Ruth Ellen. She handled the bombardment of questions with grace. The media and pundits tried to make her election a joke and called her "Vegas." Little did they know that the voters in Berthier—Maskinongé, Quebec, were not going to be pushed around. Their votes were not a joke for the entertainment of the media. They rallied around Ruth Ellen, and she reciprocated by quickly becoming proficient in French, and she dedicated herself to the people she was elected to represent. When many New Democrats lost in 2015, as the Trudeau Liberals pole-vaulted from third to first place, Brosseau was re-elected to her seat and just narrowly lost in 2019 when the BQ surged in Quebec. Running for election unexpectedly changed Brosseau's life, and she excelled with the opportunity.

Peggy Nash

Consequences, win or lose: Whatever your current career path, whether your work is precarious, or if you are an academic on tenure track, if you've just lost your job, or you are about to make partner in a law firm, or you're involved in a big research project, or you've just been elected head of a community organization—whatever it is, think about your career priorities and the consequences whether you win or lose if you run for office. This is a personal decision only you can make. There is not just one right time to run.

Personal Life

"Real life" can be the priority: If a parent is dying, if a child is

seriously struggling with mental health, if your partner just lost their job, these are real life factors to consider. I raise these situations, not to discourage you, because I know people who kept their sanity during these lifechanging challenges by being in public life. But if for you the timing is not great, there's no harm in waiting for another chance. Sometimes real life is the priority.

Your finances: If you can, get your life in order before you run. While local election campaigns, unlike in the US, have reasonable spending limits, you should consider the financial implications. If you have a massive student debt, or just took out a big mortgage and can't afford to take time off work, think carefully about your plans. Unfortunately, the massive burden of student debt today in Canada can take decades to pay. This debt shouldn't deny you democratic participation.

But do consider your finances. You will fundraise most of the money you need for your campaign from others, but you do have some expenses. Some parties will reimburse you for your incidental expenditures like meals, childcare, and transportation. But if you want to buy new outfits and shoes for the campaign you might end up having to cover that.

We need more elected representatives who understand what it's like to live paycheque to paycheque, to worry about the rent, having a cheque bounce, or not be able to pay off debt. These representatives might make decisions more in line with the everyday needs of the people they represent. But do think about the personal pressure that places on you.

Know that life goes on: Life goes on, even during an election. The first federal election I ran in was on my birthday. We had worked our hearts out and the polls were looking good in our favour. The election had been my focus for months but the last few weeks I was ultra focused like a border collie chasing a ball. Election night was heartbreaking; we didn't win.

A few months later I was driving on the Gardiner Expressway in Toronto in bumper-to-bumper traffic. A police car behind me

put the flashers on and pulled me over. It was impossible to be speeding. My infraction? My licence sticker had expired on my birthday, election day. I had been so engrossed in the campaign I had let it slip by. Fortunately, I got away with a warning. I had let a lot of my life slip while I was focused on the campaign.

Prepay, prebook, organize: Do your best to get your life in a semblance of order. You don't want financial insecurity nagging you if you can help it. If you can, prepay bills so they don't get forgotten. Plan for childcare or parental care ahead of time. In a campaign you will be busy, and the rest of life seems to take a back seat.

Organizing a team of personal supporters is how many candidates do best in a campaign. These are friends who will do daycare runs, prepare a meal or pick up dry cleaning for you. This village of supporters can also be a circle of support when the going gets tough in a campaign. If you are a non-traditional candidate you need your posse around you during the campaign. After all, you are running for those like you whose voices have too long been ignored. Collectively you can win.

The Political Landscape

As well as considering the time of your life, career, and personal circumstances, you also need to consider the local and broader political context. Strong indications of a good time to run are:

- a vulnerable incumbent where you plan to run
- solid issues for you to run on
- a community that will be with you
- your party's leader is performing well
- your party is up in the polls
- your opposition party's leader is losing support

These trends, though, are often hard to know in advance. Governments tend to have a shelf life of two or three terms. After that people may be looking for a change. Sometimes you can catch a wave of change to get elected. Sometimes you can win by

bucking the trend because of your profile and hard work. The key is to get a good sense of the politics in your area and provincially or nationally. If it looks like your party is winning nationally, more people will vote for you.

It may seem that all the odds are against you, but you want to run anyway. As outlined in chapter 5, Activism in Movements or Electoral Politics, or Both you can run for a variety of reasons, not just to win. Perhaps you want to run provincially to build support and name recognition, but your real goal is city council or the federal seat. Perhaps you want the chance to speak about universal childcare in meetings in your area and in the media. There are many valid reasons for running. Just remember, whether or not you intend to win, sometimes you do. Politics and elections can be unpredictable.

Don't Wait to be Asked

Make a clear-eyed decision about when the time is right for you. Don't sit back, waiting to be asked. Even leftist parties don't necessarily understand or recognize the power of non-traditional candidates. Your hard work and dedication won't automatically be rewarded. People may think you're doing such a great job they want to keep you where you are. Hardworking but modest women are often seen as dedicated, unselfish, *and* unambitious. Waiting to be asked gives away your power to someone else. Use your passion for the issues you care about to fuel your desire to speak up.

Women are often asked several times to run for a position before they decide to go for it, whereas men will step forward and run without being asked. There are many good reasons for not running, but sometimes they are excuses for not wanting to step into the limelight. Unless you go after what you want you might get overlooked. Your shyness can turn to resentment if you don't act.

You decide: Early in my political career, when I needed to make a significant decision, my first campaign manager told me to talk it over with the most important person in my life, do a final gut check, and then to let them know the answer. Solid advice that guided me over many hurdles.

Ultimately, you are the one to make the final decision based on your own circumstances. Only you know your innermost feelings, your relationships, the stability of your life and your finances, your history, your goals, and your comfort level. Do your research, think about your life, speak with your loved ones, check your gut.

THERE'S NOTHING IN OUR WAY

But the thing is, we're taking the voice we had in the old world, and we're just screaming it louder in this liminal [or transitional] space that's been created by the pandemic. It's like, you know that game—with your kids, when you press against each other, and the other person jumps out of the way, and you fall on your face? There is nothing in our way right now, . . . So if we just sort of go flying to the abyss it's a waste of our energy. So it is coming up with some strategies, now that we have all this room and voice. How are we going to use it? What are we going to say with it, that isn't shouting at the wall, or at the man. It's not to say the wall and the man aren't there, it's just that their power has greatly diminished in liminal times.

Andrea Reimer, City Councillor (2008–2018),
Vancouver, BC

7. Party or No Party?

If you are passionate about wanting to make change and know you want to engage politically, you will face the decision of whether to support and join a political party.

Branding

Most Canadians are not involved in political parties and don't know much about them. At election time some people spend less time deciding which way to vote than they do on choosing a brand of toothpaste. And just as companies spend huge sums of money on advertising agencies to brand their products for consumers, political parties usually devote large sums to differentiate themselves from other parties. They brand the party and the leader through advertising and social media to maximize public support. A person who doesn't get involved in politics, doesn't read about policies, or watch political debates, may just vote based on their impression of the party or leader's brand.

When you're serious about an issue, you know that details matter. Political parties can appear to take action, while doing very little. How many transit announcements or reconciliation pledges does it take to actually get something done? This deliberate superficiality and sleight of hand can be frustrating to the point of cynicism. I'm convinced it doesn't have to be that way.

Rather than marketing a leader to appear to be sincere and authentic, how refreshing would it be to have the real deal?

Running Independently

Municipal elections: Municipally there may be coalitions or movements but usually there are no official parties, so candidates

can run independently. However, most candidates identify informally with a political tendency. For example, you can identify the conservatives or progressives on a city council just by looking at the way they vote. Do they support or oppose funding for women's shelters, anti-racism programs, or childcare? A candidate for city council may not campaign under the banner of a political party, but they may tap into volunteers, funders, and resources from a political tendency. If you run for a municipal position you don't need to identify with a political party, but if you do so informally this can boost your campaign.

Provincial and federal elections: You can also run provincially or federally as an independent candidate, that is, without an affiliation to a political party. This gives you complete freedom to run your campaign any way you like, to take any position you like, and to be fully accountable for your campaign and yours alone.

If you are running independently, you are the big fish in your pond. You and your team make all the decisions about policy positions and the campaign. This sounds appealing but there are challenges. A political party gives people a shorthand about the candidate's policies (see branding above). Without a party brand this shorthand is absent and it's harder for people to find out what your stand is. And while you might be progressive on social issues, maybe you are conservative on the economy or vice versa. Most people don't want to take the time to investigate.

Without a party it becomes harder to get noticed. Usually the media only interview the candidates of political parties. They are the ones who get invited to media debates. You often have to fight your way into community debates. It's more difficult to recruit volunteers and fundraise.

Harder to win: In short, it's harder to run a successful campaign and win as an independent candidate. Harder but not impossible. Former Liberal Jody Wilson-Raybould, who, standing up for ethical integrity, quit the Trudeau cabinet during the SNC-Lavalin scandal, had a massive national profile. She was one of the rare

independent candidates to get elected. If you have that kind of profile, you can attract volunteers and financial support.

Some candidates want to run to profile an issue and don't care if they win. Being independent may be integral to the issue they want to promote. Run as an independent candidate, but know that it's difficult to win.

Running for a Party
Being a candidate for a party gives you advantages and limitations.

Membership conditions: To start at the beginning, as obvious as it may sound, to run for a political party, you must first be a member and you can only join one party at a time. Once you run for a party, you are subject to party discipline and you sign an agreement pledging to support the party and its policies. If you act in a way that deliberately damages the party you can be expelled.

Candidacy and nomination: Once you are a member of a party, you need to apply and be accepted as a candidate. This can take a lot of time, as parties want to mine your social media and determine if you are a good candidate, if you are electable, and if you have any negatives. If you are accepted as a candidate then you need to be nominated, which can mean winning a nomination race. This is a contest against others in the same party to be the party's candidate for a particular constituency or riding. Party officials don't officially endorse anyone but they may play a role behind the scenes based on who they think is the most electable person.

Party support: If you do decide to join a party and you win the nomination you will get many benefits. You will win the automatic support of that party's members and supporters. If the riding association has any funds, you will have access to them. Your campaign immediately has a brand and a profile that provide a shorthand for voters to determine what you are about and whether they should support you. It brings you media coverage when your leader's

image and words appear on Facebook pages and in mainstream news. If your party leader makes a major announcement about an issue that is a priority in your community, voters will applaud you as though you personally made this change.

For example, in many parts of Canada, lack of shelter is an urgent priority with people sleeping in parks and under bridges, even in the depths of winter. If your leader announces a commitment to a housing first initiative to ensure every person has their own place to live, the popularity of this announcement benefits you as a progressive candidate from that party. You might get local media interest or, perhaps, you could generate interest by holding your own news event with local housing advocates.

Your party will also offer you advice on commenting in the media and on social media posts, usually with policy background documents, so that you fully understand the issue and chief points for the media and constituents. If you are relatively new to politics, this kind of educational support is invaluable. Your party might ask you to be interviewed by national media or participate in a TV or radio panel discussion. All this gives you profile and helps your campaign on an issue that you care about.

If someone asks you about strategic investment for green manufacturing, something you may not know a lot about, likely the party already has a position that you can read up on and send out. You do not need to reinvent each wheel.

Party baggage: Your support rises but also falls with the party. I remember knocking on doors in my riding when the NDP took the position that Elizabeth May, the Green Party leader at the time, should not be included in the leaders' debate. The logic was that she was the only MP from her party and did not have official party status. To exclude the only woman party leader became a big issue that I heard about loudly and repeatedly at the doorstep.

Controlled at the centre: Running for a party can also make it somewhat harder to do politics differently. Political parties are often tightly controlled at the centre, especially in the

leader's office. Leaders have different styles, and this can make a difference.

Regardless of the leader, running for a party means living with party discipline and less individual freedom as a candidate to follow your own heart or the goals of your constituents. However parties do debate and adopt policies democratically at conventions, and once elected, you have the opportunity to advocate for your constituents. Elected members often vigorously debate within their party's caucus before the party adopts a position.

Party or no party? This depends on your values. I was aligned overwhelmingly with the values of the NDP. But that is a personal decision.

PARTY OR NO PARTY

As a first-time candidate, the learning curve is very steep. When you're working with a political apparatus a lot is already set up. You don't have to make all these tough decisions that you might have to make when running as a municipal Councillor or as an Independent. There is a party platform already set up, and there are staff people who will work for you. Because you are affiliated with the NDP you don't have to go out and recruit in the same way. Provincially, and I also think federally, the riding that you choose and also the leader can make or break your campaign in ways that are far greater than most individual candidates' influence. I can run the best campaign, run a race to the maximum, have 400 volunteers and I could still lose because people don't like the leader—or, alternatively, I could have momentum if the leader is popular.

Jessica Bell, MPP, Ontario

One of the reasons municipal politics in Toronto can be exciting is because, while there are definitely political parties quietly present, there aren't official parties there and votes aren't whipped in the same way as they are provincially and federally, creating more opportunities to win on issues.

Michal Hay, Executive Director, Progress Toronto

I always thought I wouldn't belong to a political party at all . . . I was always just more interested in the values and the issues, what we need to focus on, environmental protection or community protection. So the NDP, when it came down to it, was the closest aligned to my beliefs and what I was raised with. That was the main reason. And when you get a call from Carol James, former BCNDP Leader, former Minister of Finance and an elected Indigenous woman herself, asking you to run, that helps also.

Ann Marie Sam, Indigenous leader and NDP candidate, BC

8. Choosing Where to Run

You have decided that the passion you pour into your activism can now best be channelled into elected office. You have looked at the political party offerings and have made your choice of party or not and level of government. Now the question is where to run.

Factors I Considered

I ran for elected office at the federal level where I felt most at home with the issues. I ran for the NDP where I felt my values were best aligned. I chose to run in my home riding, because I knew people from my kids' schools, sports teams, hobbies, neighbours, and long-time friends. However, when I first ran all elected officials in our area were from another party. I faced a real uphill battle since, not only were those in elected office not keen to help me, but, understandably, they were helping the person from their own party.

While our riding had never elected a New Democrat at the federal level, we had elected members of provincial parliament, including a former cabinet minister. And a former progressive city councillor from our area, David Miller, had recently been elected mayor of Toronto. Consequently, our riding did have some dedicated NDP supporters and funders, principled and pragmatic people who had worked on previous campaigns and had succeeded in electing people at various levels of government. These were some of the factors I considered before deciding to run in my area.

You Don't Have to Run Where You Live

Surprisingly, you don't have to run where you live.

Representing where you live: For me, being a voice for the community meant being in the community, living there, connecting with people everyday. Impromptu conversations can happen with people unexpectedly when you're just going about day-to-day activities. I remember going to a bank machine in a bank lobby a few blocks from my house. While I was waiting in line, a woman asked me if I was the MP, and once I confirmed this, she began to tell me about the cost of childcare for her two kids. She asked about plans to help parents with this enormous expense. While we were talking, a couple of other people came in and soon we had a mini impromptu meeting about childcare. It was invaluable. I felt the woman who had started the conversation would not have come to my office or even to a local meeting, but clearly childcare was a major concern for her and her family. I was very appreciative that she had reached out to me on the fly as it were. These kinds of informal conversations were just one way of connecting with constituents.

Representing where you don't live: Many candidates get elected in ridings other than the one they live in. One long-time MP from another party was surprised when I told him how I appreciated living among my constituents. He lived far from the area he represented. "How do you have any privacy?" he asked. Now it was my turn to be shocked. "How do you stay connected to the community?" I responded. Once elected, I didn't expect privacy unless I was in my own home. Outside my home I felt that my time and reputation were in the hands of constituents.

The voters will decide: I once thought that residency should be mandatory. Now I believe that is a decision left up to voters since there are legitimate reasons for not living in the riding you represent.

Jack Layton and Olivia Chow as a couple lived in the same house but represented different ridings as Members of Parliament. Riding boundaries can change so that a representative who was inside the riding might be outside after a boundary change.

Someone might have grown up in an area and still feel attached, even though they now live somewhere else. Another person might have worked in the area for many years.

So there are different ways of being attached to a riding and, perhaps, in some areas voters don't care as much about residency. I'm now less of a stickler on the residency question than I once was. However, if you choose to run in an area where you don't live and have no connections, that lack of connection can be used against you as a candidate.

Do Your Political Homework

Voting history: If your party has never received more than 10 per cent of the votes, it's not impossible to win, but it is less likely. What is the voting history in the area? Is it a two-party horse race or can you win on three- or four-party splits in the vote? Where is your party strong in the area, and where are the possibilities for boosting the numbers with new voters? (For more on targeting voters, see chapter 12.)

Other levels of government: If your area is represented by your party at one level of government, then there may be an opening at another level, especially if the former candidate does not want to run again. There is a huge advantage of having someone already elected from your chosen party in the area you want to represent. They will usually have committed activists and volunteers, the ability to fundraise, and a deep knowledge of the riding, the communities within it, and the leaders of those communities. Being able to work collaboratively with a party colleague who can act as a mentor gives your campaign a real boost.

Ridings change: Knowing past results is useful but is never a determining factor. Ridings change, people move in and out, conditions change, the economy is strong or it's more and more unequal, unemployment goes up, house prices are too high, there are local issues that become dominant. If there are many disaffected or non-voters in an area that you believe you can inspire

to vote for you, you can build a winning campaign by engaging many new activists and voters. Sometimes the right candidate in an election can inspire people with her story and her goals, and if she works very hard and the conditions are right, she can win.

Local Riding Associations

Political parties are represented locally in each electoral district, federally and provincially. These are called electoral district associations or riding associations. Some of these local bodies function better than others, especially in areas where their party has had electoral success. Sometimes at the local level the federal and provincial bodies combine to better pool their resources, with some of the same people having overlapping duties.

Most of these local associations will have membership meetings at least once a year, and the better ones connect with members more frequently with events and training. Usually, the elected executive of the local association meets monthly.

Get on the mailing list for the local association and for the national and provincial party to keep abreast of what they're up to. Become a volunteer, attend some events, ask to observe an executive meeting, or meet with some members of the executive to get a sense of the personalities and their capacity for running a campaign.

Other Candidates

If your area already has an elected representative at the level of government that most interests you, or if they have a candidate from that party who narrowly lost last time and wants to run again, you can still challenge them to win the nomination or you can look for a different place to run.

Some mainstream parties will appoint candidates, often "star candidates," sometimes over the wishes of the local district association. Some will also routinely reappoint incumbent elected representatives. There is no appointment of NDP candidates. Even seeking to run for re-election, a candidate must stand the test of a nomination meeting where someone might run against them.

However, if the candidate has worked hard, has shown success in campaigning whether elected or not, and retains strong support in the community, chances are they will succeed in being re-elected as the candidate.

Other Ridings

Suppose there is no reasonable opening in your area with your party because incumbents or committed candidates who came close last time are running again, and you don't want to challenge them or don't think you can defeat them. Or perhaps you feel more attached to a riding where you grew up or where you work, even though you live somewhere else. Or perhaps your motive for running is to win and you believe that your local area is nearly impossible for your party to win. Then look somewhere else.

Look at nearby ridings. During a campaign you will spend most of your time in the riding you want to win, so you don't want a long trip home at the end of an eventful day. Again, check out the local party in the area, get to know past candidates and if they are running again.

Find out about the communities in the riding. If there is a large tenant body in the area and you are a tenant rights activist, you might find a natural constituency. Look at the census demographics. If you're an antipoverty activist, a very high-income area may not be a good fit. If Black Lives Matter activism and defunding the police are priorities, communities with a significant number of Black and racialized residents might warm to you as a champion for these causes. If you are an Indigenous activist having a large Indigenous community in the area you want to represent can be a huge boost.

When Ontario NDP MPP Bhutila Kharpoche ran for the first time, the riding she chose in Toronto was a natural choice. As a leader in the Tibetan Canadian community she ran where there are the greatest number of people of Tibetan origin in Canada. They were just one of several networks she drew on, but they helped her with donations, door knocking and links to the community. She ran in a seat that had been held by Cheri DiNovo from

the NDP for whom she had worked. So she had deep roots in the riding and many connections. She won.

×

To find your place to launch a successful election bid, look at all the factors that come into play during an election campaign. Find that community where you connect with people and they with you. People want to believe you are one of them and that they can trust you. Now, you're ready to commit.

9. Winning the Nomination

To Run You Must Win

You made the decision to run, perhaps after months or years of consideration. Or maybe someone asked you to run, and you jumped right in. Now what?

All the previous chapters are about the context of and the preparation for running for elected office. The first real step is to campaign to win the nomination race to be the candidate for your party in the electoral district you have chosen. This race may officially only take a few weeks but unofficially might be in the works for months.

Many ridings have a competition for the party's candidacy. If the riding you want to run in is one that looks winnable for your party, the nomination is often hotly contested. If you don't win the nomination, you can't become the party's candidate, although, you could still run as an independent candidate without party support. Some people just assume that their high-profile or past accomplishments will make them a shoo-in for the nomination, to their great disappointment when they lose.

CONTESTED NOMINATIONS

When I ran for the MLA nomination, it was a contested nomination. I had had a baby, and I was in that era of I just left my work with childcare, I was working with the province, and I have to say, it was with a lot of self-doubt and a lot of "what am I doing? This is crazy." It was because

of the support that I had from the people closest to me that were in positions to support me. They were in government, they believed in me, and they said, you should do it and I'm here to help you. And I think, really, I attribute a lot to that. Then I just had to close my eyes and jump. . . .

I actually was convinced every single day that I was going to lose horribly and that was just going to be the way it is. I was preparing myself for that. Do your best do your best and it's all you can do.

The person I ran against had been the party president and was there for a long time and then ran there . . . I put my head down and I called as many party members as I could. I prepared as much as I could for the debate. I attribute winning to hard work. And because the election for the nomination was called so quickly, we had to deal with the membership list the way it was. . . .

I was on the phone constantly. I think it was almost terror to some extent. You've just got to do it all; you can't leave anything on the table. You've got to go for it, and that's what I did. I did have support. People came out to support me when I asked for it. I think that's the first thing. I was grateful to have it. You don't know until you ask, but I wasn't sure if support was going to be there. It was a matter of getting to every member . . . I think back at the sense of terror that I had at that moment, when I made it public, and I think to myself, thank God, that I didn't let that rule the day . . . it was powerful that fear.

Niki Sharma, MLA, BC

When I was interested in the nomination, the people that were also looking at our riding were really good potential candidates, and I wasn't sure I could win against them in a nomination battle. I thought it would also really divide our riding association. I definitely knew my best option was to try to get them to back down. And it worked. But I do believe, generally, that contested nominations can be

really important opportunities to grow party membership, and if you need to establish yourself as a potential candidate, it really helps.

Marit Stiles, MPP, Ontario

Know the Rules

What my nomination experience taught me was to know the rules before jumping into a campaign. When running provincially or federally, most people run with a political party. Municipal candidates sometimes run with a slate of like-minded candidates. (See chapter 7 about political parties.) Each party has its own rules for the nomination process, which can also differ provincially or federally. These rules should be posted on the party's site, but if not, you have a right to ask for them. The party's rules will explain the nomination process including by when the nomination meeting must occur, how much notice is required, who is eligible to run, what information must be given to party members about the candidates, what are the candidate fundraising limits, and other important information. While these are party rules and not election laws, violating them can disqualify a candidate, and ignorance of them can lose you the nomination. Find out the rules; know what the process is.

This process can seem obscure and mystifying. Find out as much as you can as quickly as you can. There are formal rules and informal practices. Speak to people in the riding association executive and other long-time members who have been involved in campaigns to learn as much as you can before jumping in. If you are afraid to show your cards before finally deciding whether to run, task a reliable friend to ask on your behalf.

An NDP rule that helped me states that before a nomination meeting could be held, there had to be at least one candidate from an equity-seeking group running for nomination. Rather than appointing specific equity candidates, the NDP requires them to run and win the nomination like everyone else. This provision recognizes that those outside the pool of usual leadership candidates,

those who don't see themselves in leadership positions, may hesitate to commit to run, whereas those who are traditionally in power tend to jump into the fray. Without this provision, by the time I decided to run, the nomination might have already been decided.

Vetting
All parties have an application process for vetting candidates. Parties have the right to refuse a candidate for a variety of reasons, and they are not usually required to tell you in detail why you have been refused. For starters you need to be a member of the party (this can be a recent thing; you don't need to have a long party history), and you can be refused if you continue to hold membership in another political party. However, people do change political parties over time, so it's fine if you had been a member of one party and left to run for another one.

The nomination process cannot go ahead in a riding without the approval of the party, which may have reasons for delaying it. For the NDP, this may be that the riding doesn't yet have an equity candidate running. Sometimes the party has a star candidate who wants to run in the riding but, for a variety of reasons, doesn't yet want to declare their candidacy. If other candidates are approved, they would have an unfair head start to lock down endorsements and funding, since party members wouldn't have a full picture of who would be running. Sometimes the vetting by the party is taking a long time because an applicant has many publications or has been very active on social media.

Parties do their best to avoid candidates whose past public statements or social media would be an embarrassment or very contradictory to the policies of the party. Something you thought was cute and a little bit naughty that you posted during your university days could be used by another party against you and end up being an embarrassment to the party. By carefully vetting candidates, parties scrutinize as much as possible to prevent problems during an election campaign. Perhaps this will change in the future. With generations growing up with this technology

and so much of their lives lived online, perhaps embarrassing social media posts will lose some of their sting over time and may not be such a problem.

WITH STRATEGIES, EVERYBODY IS ELECTABLE

One concept that I've tried to crush in political discourse is the concept of electability.

Electability is bullshit because it is a concept that tends to be subjectively assessed. Sometimes people will count out tremendously capable and important people from running by arguing they are not electable. Electability gets weaponized against women, Black women, Indigenous women.

If I am making a case for somebody to run, I am sure to be able to create a more balanced conversation about the person's capabilities, when it comes to building an electoral movement behind them that's going to elect them and building out a communication strategy that can mitigate sexist or racist attacks.

If you organize and strategize, everybody is electable.

So electability is a concept that the left really needs to reckon with and realize that electability is weaponized. Certainly, within society there's systemic racism, so let's have a strategy about how to out organize our opponents, and let's not weaponize and further systemic racism, or concede to it by deploying electability as a reason to shut out candidates who do not conform to the typical white man lawyer who runs for office.

There's no question that people are smashing the electability argument, but I also think that these barriers are incredibly present. And remain so.

Jen Hassum, Executive Director, Broadbent Institute

Electability

The local riding association and the national or provincial party will often look at the electability of a candidate, especially in a priority riding, that is, one the party wants and expects to win and where they will often put scarce resources to help the candidate. Non-traditional candidates may face a real battle with a party about electability.

Running for the leadership of a political party is like a national nomination race where you run against others from you party. When I was running to be the next NDP leader after the untimely death of Jack Layton, I remember during the months long national race being told on a few occasions that "we tried women leaders and they didn't work out" or "we had women leaders and they weren't electable." Given that at that point the federal Liberals had just burned through four leaders in short order, I replied that by that logic, the Liberals would never elect another male leader. Clearly the fifth one worked like a charm for them.

A non-traditional candidate can bring new constituencies, new talents, new opportunities that may be invisible to the mainstream party representatives. As recent elections are showing, who is electable is in the eye of the beholder, and we should not be underestimating the capacity of voters to recognize new and perhaps better talent.

Timing

Once you get approved by the party to run for the nomination you can announce your campaign. The timing of this announcement is an important political consideration. As we already discussed in chapter 6, When Is Your Time, sometimes candidates want to delay their announcement for work considerations because they will need to take a leave of absence, or for other personal or political reasons.

Or you may decide to get out early—very early—even before you have been approved to run. Why? If you are seen to be a strong candidate, others may not run and instead support you. Or

if those who might want to run are friends or acquaintances who wouldn't run against you (only women seem to think this way) then by announcing early, you stake out ground and friends may defer. Sometimes you want to test the waters by having a Facebook site to draft you as a candidate. This way you can gauge the interest while you mull over your decision.

Team
Something you learn early on is that you need a team. The team that helps you get nominated may not be the team that runs your election campaign, but they need to be the best people to help you win the support of the party members in that riding. You will need a manager, a main organizer, and a communications/social media person. In addition, you will likely tap someone for fundraising and as a treasurer to manage those funds. For the nomination, these are likely volunteer positions. (See chapter 10, Building Your Team.)

Letter of Intention
It is essential that you know why you are running. If you are motivated not by just getting into a position of power, but by the desire for a better world, you should write down why you are running, what it means to you, what are your core values, what you want to do in office, what you are fighting to achieve. This is a private letter just for yourself. In the toughest times during your political journey, you can pull out this letter to remind yourself why it is all worthwhile.

Public Narrative
See chapter 15 on public narrative. This is not a mask that you wear in public, but it is the most persuasive way to tell people who you are and why you are running. You likely will want to get one person or some of your team to help you with this statement. It will be repeated during the nomination, while canvassing, fundraising, in debates and literature. Don't be shy about asking for help to develop this narrative. This is about presenting you in the absolute best light possible.

Endorsers

You may want to seek endorsements for your candidacy from significant people who are held in esteem by the party members in your area. These endorsers are often distinct from those who may endorse you for the actual public campaign. These nomination endorsers are more likely to be party activists, current or former elected representatives, or well-known people in the party. Party voters will look to the people they trust in the party to see who they are supporting. Your endorsers are not required to be in the riding, nor will they necessarily vote. They are like social influencers for the political party.

Supporters

Draw up a list of contacts to recruit to support your candidacy. These are people who support you and want to see you elected. Only those who live in the riding and are members of your party can vote in the nomination, so they are the priority. But you can bring others in to help you with the campaign. You can sign up new party members who join to vote for you. You will also want to contact all existing party members to ask them to support you. The more energy and excitement you can generate about your campaign, the more likely you are to gain supporters.

Communications

Even for the nomination you might want to develop a look for your campaign. Catchy graphics, a great photo, bold use of colour, all these elements can draw attention to your campaign, but they are not essential. If the nomination timeframe is very short, just keep focused on phoning and contacting members for support. Don't forget the use of social media to generate buzz and recruit support.

Strategy

A nomination vote is different from a public election. For the nomination you are appealing to party members. You need to find out what their priorities are and respond to those needs. Maybe

the biggest concern for the membership is this notion of electability. Then show why you are the most electable. Maybe the focus of the membership is where you stand on a particular issue. If that's your position, then run your campaign on that issue.

Your opponent in a nomination contest is also a party member who has other party members who are supporters. You do not want to alienate your opponent. You want your opponent and their supporters to come to your campaign when you win. It can be tricky to campaign to win and to inspire not alienate your opposition, but I highly recommend it. When Linda McCuaig won the nomination over Jennifer Hollett, Jenn worked on Linda's campaign and became a big supporter. Either person would have made a terrific candidate. Seeing them come together as they did is the gold standard for nomination solidarity.

Figure out your winning strategy. Is it to sign up new members to overwhelm the existing membership? Is it to win over the existing membership? Is it to generate star power and media buzz to show how you can win the riding as a whole in an election? Is it to recruit young racialized activists, a new generation of progressive activists? Decide what it is and then go for it.

Win or Lose

If you win, win with grace. Congratulate you opponents publicly and then later meet up with them and recruit them to your team. If you lose, maybe it wasn't your time. Be graceful. If you can support the winner and build the party, that's always the best course of action. Perhaps, try to run there another time, try a different level of government or a different riding. A defeat is just a setback. It's only a permanent defeat if you let it be so. I lost my first election in my local union. I lost my first federal election. But I went on to win two federal elections and the party presidency. Perseverance, dignity in defeat, integrity, and progressive values will see you through.

My Contested Nomination

After announcing to my coworkers and friends that I was going to run federally and had arranged to take some time off work, I realized I didn't really understand the nomination process or rules. I belatedly found out that there was already another candidate for the nomination who had announced his intensions some time back and had already been building support. Even worse, I announced my candidacy right before the year-end holiday season and the deadline to sign up new party members was early in the new year. I was terrified that I was looking at a humiliating defeat.

Sitting around her kitchen table, I said to my long-time friend Jane Armstrong: "I feel like I've just jumped off a cliff and that I'm going to hit the rocks down there."

"Don't worry," she said, "people will come around to support you. We just need to get to work and organize."

My terror about losing fuelled an energetic campaign. We built a team, began signing up new members, and worked to win over existing members. We worked hard, pulled out all the stops, and with some luck, we won. It was terrifying but a great training ground for the actual election campaign a few months later.

The process of running for nomination was invaluable to me. It challenged me to get comfortable campaigning for myself, putting myself out there and asking people for support. I'd had lots of experience as a public speaker and advocate for issues or for others but needed to get comfortable advocating for support for me. I found this very hard, but the nomination process made me comfortable with it.

Winning the nomination at a huge meeting gave me the confidence and the necessary funds to make a running start to go out publicly as the candidate and campaign. We got right to work knocking on doors. I felt as if all the people at the nomination meeting were with me.

10. Building Your Team

> It's not just about knowing the key people who have the talent to do that job, it's how they all fit together . . . but you also don't want them to have such different personalities that they just butt heads constantly.
>
> —*Lindsay Mathyssen, MP*

If you're coming out of an enthusiastic nomination victory, as I was, you may already have some sense of who will be your campaign team. Whatever your circumstances, building your team requires much thought.

Politics Is a Team Sport

You do not win just by having good policy or scoring points in a debate. You need to start with a team that can help you build and win support. This can be hard for those of us who have struggled all our lives to get control rather than being controlled by others. Our natural tendency is to want to "be in charge" of our campaign. But remember, politics is a team sport.

Campaign teams can vary according to the nature of the competition, the timeframe, the geography, and the constituents. There are no hard and fast rules. The best advice—I can't stress it enough—is to gather a team of trusted people to serve as your primary advisers. These are the people who have your best interests at heart. They will support you and give you personal advice. Within that team, it's helpful to also have some members who are experienced.

When I Decided to Run

When I was finally seriously considering running, I remember vividly the night David Miller was elected mayor of Toronto, November 10, 2003. We were celebrating at the Bamboo Club, basking in the delight of a successful campaign. I remember approaching Toronto Labour Council representative Julius Deutsch, who I knew had played a major role in helping Miller get elected. For many years, Julius had been key to successful progressive candidates in the west end of Toronto, including when Miller was elected city councillor in our area and during the Rae provincial government when Elaine Ziemba was elected MPP from our riding.

"So Julius, do you think the NDP could elect an MP for our riding (Parkdale-High Park)?" It had never happened with the current riding configuration and boundaries. He looked at me and said it would be very difficult.

"Who were you thinking of?"

I just looked at him, and then he realized: I meant me. He stared pensively at a distant point across the bar, turning the idea over in his mind.

"Hmmm, labour leader, soccer mom, feminist, progressive activist—It would be very hard. But if you decide to do it, call me right away."

A few weeks later, around the end of the month, I did just that. I didn't realize that Julius and his partner Bob were driving south, heading on vacation. Nor did I know that with that call, Julius and Bob turned their car around and headed back north. Julius agreed to manage my campaign along with party veteran Jill Marzetti and organizer and activist Winnie Ng.

YOUR KITCHEN TABLE TEAM

For former Much Music VJ Jennifer Hollett, an interview she conducted with then NDP leader Jack Layton ignited

her long-time interest in current affairs and progressive issues and got her wondering about electoral politics and the NDP. This led to a conversation with one of her best friends from high school about how politics could be so much better, with more interesting candidates. "We wondered who was going to magically do all this? Then we realized that it comes back to us as voters, as citizens, as people who see a different future for what politics could be in Canada."

Years after the Layton interview, Jenn reached out to Jack telling him of her interest to run one day and in getting more involved. "And he as leader made the time for me and met me in a coffee shop on the Danforth and so that was very exciting . . . he saw me as a viable candidate even perhaps someone who could work in the party. He was very keen and that was something that Jack had that was contagious, which was a passion and excitement."

Jennifer Hollett continued:

"I remember when we were talking, he said to me if you're interested in running, gather some friends around your kitchen table. And that scared me because it was saying out loud that I wanted to get involved in politics, saying out loud that I was seriously thinking of running and asking other people to give me their time, their ideas, their money.

"But you have to do it, and if you can't get a few friends around a kitchen table, you're going to have a really hard time getting into politics and building a campaign.

"So that's what I would suggest to anyone who is running—what Jack Layton suggested to me. Get some friends who share your values, who you talk about the world with, and start talking about the next step, start talking about what might be possible.

"And it could be you running, or perhaps it's someone else at the table running, or perhaps it's the three of you

saying we're going to get involved in our first campaign this year to learn more, and to see what it's all about. But ultimately politics does come back to the kitchen table, and I think of me growing up being raised by a single mom, it was the kitchen table where my mom would say, 'How was your day?' We would talk about what we were seeing in school, what we were hearing on the news. I think one can really develop a strong voice at the kitchen table and then move to organizing, and that's how it happens. It's building relationships one at a time. Your friends are a pretty good place to start."

The Campaign Team

During a campaign, you the candidate, will be out meeting voters, debating, attending events, and winning over voters. You won't know every detail of what happens in your campaign office. You don't have to know what everyone does or the many tasks and decisions of their work.

Your inner circle: You'll have an inner circle and then increasingly larger circles. Think about who you want to be close, in that inner circle:

- Who has the best ideas and is highly motivated to help you win?
- Who really understands organizing?
- Who really understands the community where you are running?
- Who helps you feel good about yourself?
- Who do you need for support during the ups but especially the downs of a campaign?

Diversify: While trust is an important part of selecting your inner team, there are also other considerations. You need a variety of skills. Find great social media people. Diversify the team to

include people with different backgrounds, identities, networks, personalities, and points of view. Homogeneity leaves you blind to alternatives.

Pay some people: Whether for your nomination but especially for the election campaign, if you have some money to pay a few people you will have better consistency. Phone calls will get returned, messages will get answered, media interviews will get set up. And your campaign materials will look better. However, every campaign needs committed volunteers for many positions.

RELATIONSHIPS

When I first ran, I built my team with a couple of local people who worked on campaigns before and wanted to prove a point about what we could build. After that, it was through relationships with people who I worked with on a lot of campaigns. I'm a serial volunteer, so in a way, I helped to build the teams that are in this riding. A lot of the marks on the canvassing sheets indicating voter support are my marks. And I think you learn a lot, and this is what I always advise people, if you're thinking about running, get yourself onto a campaign, try out different roles, understand what the campaign is for, and build relationships in your network.

Alejandra Bravo, Toronto City Council
and federal candidate

Where Do You Find the Right People?
- People who urged you to run: if they asked you to run, they believe in you and will likely work hard to help you win.
- People with experience in political or other campaigns: these are people you know from having volunteered on campaigns,

or you learn about by asking around for the people with the skills that you need.
- People with essential skills: excitement and enthusiasm will only get you so far. You also need to know how to run a campaign.
- Friends and people who get you and will support you.

BUILD YOUR CONTACTS

Working as a journalist meant that Jennifer Hollett couldn't be partisan or get involved in campaigns. So, when she thought seriously about running for office, she would sometimes just whisper to friends that she was considering a run for office one day. People responded with offers of help and commitments to support her campaign. There were offers of skills, money, and time. Jennfier Hollet continues:

"People would shout back I'd love to work with you or I'd be on your team, or I think you should run and you have my support. So I started making a list of people who would respond when I'd say yeah I am interested in politics, you know I'd like to run one day. Anyone who said I'm happy to help you. I've been involved. You'd be great. I just made a little list because those people tended to have more experience than I did in politics."

Key Team Positions

The campaign manager: Your campaign manager (one person or a small team) is your key person. They oversee the machinery of the campaign. You may defer campaign strategy to your manager or you may require that no strategic decisions are made without your input and authorization. I chose this latter approach.

Do you choose experience or closeness when deciding on

your campaign manager? With experience, you may have someone who has led winning campaigns. With closeness, you may choose someone who you trust to make the best decisions in your favour. This person may never have run an election campaign but has led community organizing and campaigns.

Whomever you choose, to be successful, this relationship has to be one of absolute trust. You need your manager to give you their best advice. On the worst day of the campaign, you and your manager still need to be able to make vital decisions. You don't want to have to switch a campaign manager midstream. So think long and hard about who this person will be.

Some campaigns are run out of the candidate's house and the manager is the partner, parent, or sibling. For larger campaigns, you will also have other members on your team. If your campaign catches fire and you have the resources, the team will grow.

Financial officer: There are strict campaign finance rules for all levels of elections. You will be raising money and issuing tax receipts. You will be hiring vendors for phones, office supplies, refreshments for volunteers. You may need to rent a space to run your campaign, which means paying rent and utilities.

Your financial officer needs to be completely trustworthy and competent. Most parties will run a workshop on the financial requirements of campaigns which your financial person can attend.

You absolutely do not want to be that person who wins an election and then has it taken away because of financial irregularities.

Candidate aide: Your candidate aide comes with you when you are out every day on the campaign trail. In the heat of a campaign this person monitors how you are feeling, knows when you need to eat or rest, fields media calls while on the run, and is also a confidant. This position could be volunteer or paid.

Musician, educator, and close friend Beverley Taft played this role with me in a couple of our campaigns, and she was priceless.

I depended on her amazing memory, her sense of humour, her political skills, her ability to speak multiple languages, and her uncanny sense of what I needed and when. When we met a grumpy or rude voter, she would crack a joke afterward. When we got a tough media story, she'd help me quickly move on. She is a smart, talented person with incredible political radar. We became great friends.

Volunteer and canvass coordinator: Knocking on doors and phoning voters is a central part of your campaign. If you have the money, hire a full-time volunteer coordinator. This person will be recruiting volunteers, educating them on the campaign, and putting them to work contacting as many voters as possible. The more people you and your team connect with, the more votes, money, and volunteers you will have.

Communications and media: Most local campaigns don't have money to hire communications people, but some are able to give small contracts, and then rely on a lot of donated talent and time. If you have the good fortune to have a volunteer photographer or filmmaker, they are worth their weight in gold. It's hard to exaggerate the value of eye-catching and professional social media and leaflets.

Tech person: Whether you hire someone or you are lucky enough to find a great volunteer, you need someone to help overcome the raft of technical and technological glitches that can tie up a campaign. Sorting out email and social media accounts, getting phones up and running, dealing with computer down time, these are just some of the jobs of the tech person.

Data entry: Campaigns rely on data. Each voter you speak with, each person who says they will support you, who are on the fence, who tell you their priority is childcare, the environment, or health care, if they live in assisted housing or a mansion—each person provides information that can help you win their support.

When I first started canvassing, I thought all this information was vey important and I would write it down on the canvass sheets. I later found out that our office was disregarding a lot of this information. Bev and I began carrying little leaflets on various topics so that we could respond directly to the concerns at the doorstep.

Now, especially since much of the information is entered electronically at the doorstep, there is more interest in keeping this information, enabling your campaign to target pertinent information to each voter and motivate their support.

Election day coordinator: This person coordinates the army of volunteers to go to each supporter to ensure that they know the dates for the advance polls and election day, where the polling station is, and ensures that the voters who are supporting you get out and vote. This is another key position. All your work is wasted if your supporters fail to get out and vote.

RAISE SOME MONEY

I started pretty early. I was nominated a year out, and you have to start from nothing. You think people are going to say okay we're going to lift you up and help you now, but it's not that simple. You have to hustle, so I recruited my campaign chair who was a Federal NDP Toronto organizer, and she was very helpful in identifying other people from the riding association. But it didn't really get going until we'd raised enough money to hire a canvasser to help with the door to door work and help with fundraising. Once you've got money you can hire people. So these were the two people that were really instrumental.

It really helped me to have someone who knew what they were doing around the campaign.

Jessica Bell, MPP, Ontario

✕

Your campaign may only be you and your partner or friend in your apartment spending almost no money. Yet you still may win. If there's an election sweep by one party, people who didn't even campaign can get elected.

It's also true that many hotly contested campaigns hire a team and then rely on an army of volunteers. There is no one right way to run a winning campaign. Much depends on the party, the leader, the ads, the debates, the events, and plain good luck. But executing an excellent campaign puts you in the best position to take advantage of the favourable winds from the election gods.

11. Volunteers

Often people volunteer, and they are not very political, but they want you to win. And I think your job is to take this energy and to politicize people, to give them the means, the analysis, the arguments so that they can deconstruct the point of view of the right. So, for me, these are very beautiful moments.

—*Manon Massé, députée à l'Assemblée nationale du Québec*

Volunteering Is an Opportunity

Most people engage politically by catching the news occasionally and by voting. They don't belong to political parties and have no idea about the machinery of politics. Maybe they see politics as some special club for political elites, or they dislike what passes for public political discussion, or they are disinterested. Some people think partisanship is a dirty word. For others, they've never been involved because no one has asked them. What a loss for our democracy. You can help change that.

Rather than thinking only about how volunteers can help you in a campaign, consider the opportunities for the volunteer. Invite them to be an important part of the political process with the opportunity to join with others to make a difference and advocate for the changes they want to see. Political parties are an integral part of our political process. They offer opportunities for engagement and insight into how our democracy works. They are not only governed by electoral laws but by their own internal rules

and processes, which are debated at conventions and democratically voted on. Invite others to be part of this process.

Volunteers are the oxygen of your campaign and breathe life into all the work you are doing. The more volunteers you have and the more energized they are, the more you can achieve.

CREATE EXCITEMENT

My candidacy showed politics could be done differently, it was young, it was fun, it was accessible: it felt different. There was a diversity and people could see how they could get involved, so our campaign wasn't like the others, and that helped not just recruit volunteers, but also donors and voters and media coverage—you can create a real excitement and buzz with your campaign itself.

It does a lot of the work for you, but that means you have to be a different type of candidate, and lots of people are different types of candidates in different ways, and that can be age, gender, race. It can be approach, it can be style of campaigning . . . we were bringing a lot of new people to the party and a lot of new people to politics, so it was really exciting.

To me it was always exciting when people said I've never voted NDP; I want to volunteer in your campaign.

Or I'm a conservative and I'm making a donation—to me this is what it's about.

. . . Canadians vote for different parties all the time and sometimes within the same election year, provincial and federal.

Jennifer Hollett, federal candidate, Ontario

Motives for Volunteering

If you are running for a political party, many existing dedicated

party members will volunteer in your campaign. They are the ones you can rely on each election. Some people see your campaign through an ideological lens. They are on the left, and you are a progressive candidate advocating for their goals, so they will support you by getting involved. Others may generally share your values, but they don't come from an ideological perspective. Here are some other reasons people volunteer:

- for a sense of community, coming together for a common cause, and a sense of worth
- to support a specific campaign pledge like improving the minimum wage or seniors' pensions
- to gain new skills, experience, and to network for people between jobs, newcomers, or students

Whatever the motivation of a volunteer, create a path for them to learn and develop new skills, to meet others who share similar values, and to work for a common goal.

WHY PEOPLE VOLUNTEER

People volunteer to be a part of something; people volunteer to make new friends; people volunteer to have a fun social experience.

The best relationships come from a place of shared values.

It's actually really hard to make new friends in a big city, especially when you're an adult, especially when you're not in high school or college or university. You can make friends at a job, but usually those friendships, they kind of fade after work hours or when you leave the position. In politics, especially working on an election campaign, it's one of those few places where you're going to walk away with thirty new friends.

Jennifer Hollett, federal candidate, Ontario

Where Do You Find Volunteers?

All existing party members will be contacted by your team to engage them to volunteer. You'll bring your own friends and networks to the campaign. Some of these will support you financially, but some will gladly help in the campaign. You need to ask them.

If you are known for advocating a particular issue, whether around ending gender-based violence or cycling infrastructure, put out a call for volunteers to help achieve that goal. People want a champion, and you are it.

Wherever you go during the campaign, many people will tell you they agree with you and they support you. Ask them to take another step by coming to one of your events, signing your petition, or coming to volunteer. You need to gauge how far they are willing to go. There is a continuum from

- the act of voting,
- to expressing support,
- to showing that support publicly with a sign or petition,
- to coming to an event,
- to coming to the campaign office and playing a role in the campaign.

I have met people at the doorstep who had no previous involvement and who developed into skilled senior organizers. Some people are willing to jump right in the deep end and volunteer right away. Usually, people like to take it one step at a time. If they go to your event and they like what they see and hear, then maybe they will stop by your office. This is when you and your team welcome them warmly.

YOU NEED TO ASK

To build a team, you need to ask. Candidates need to be comfortable asking people if they would volunteer. We can all reframe how we think about asking people to volunteer.

Sometimes I think people feel guilty thinking that they're asking people for something. When I'm asking you to help me with something, it could be seen as though I am taking something from you. But that's actually not how volunteers often experience it. They can see it as an invitation to join something. And if we are inviting people to join us in the work that we're doing, we're actually sharing. We're sharing information; we're sharing power; we're sharing community; we're sharing friendship. We need to reframe in our minds how we think about volunteering and that will help us ask people more readily.

Michal Hay, Executive Director, Progress Toronto

Who Can Be a Volunteer?

Anyone can volunteer. Some people don't have much money to contribute but they want to help, and they can give their time. Sometimes, when I canvass someone will tell me that they can't yet vote because they don't have citizenship. I invite them to join us, starting with a small step that I think might interest them. This kind of engagement can be very appealing to a newcomer who may still be searching for a sense of community.

Don't write off anyone because of their age. I have canvassed with people who are in high school and seniors in their late seventies. Older and younger people can also be involved as there are many important roles that don't require a lot of walking and running up stairs. Kids sometimes just want to complete volunteer hours if they are required to do so, while some want to learn about politics. Retirees have a wealth of experience and more free time. With a bit of accommodation, people with physical or intellectual disabilities can contribute. Everyone can participate, and there's a role for everyone. The only requirement is that they support you and want to help your campaign.

What Can Volunteers Do?

If your campaign has few financial resources, volunteers might do most or even all of the work. However, most campaigns recruit volunteers to do some of the following work:

Phoning and foot canvassing: This is the core of volunteer work. Talking with voters, winning their support, and encouraging them to vote will win you the campaign. You need an army of volunteers to engage with voters. Not everyone wants to speak directly with voters. I usually take new volunteers out with me or with an experienced canvasser to help them see what is involved. Some who are hesitant at first become terrific at engaging with the community.

Social media posting: Whatever you do and wherever you go as a politician you want to leave a social media footprint (see chapter 17). Volunteers can amplify that footprint, circulating it to their networks and reposting positive reactions. Ensure your volunteers do not engage trolls or get into social media punch-ups.

Dropping leaflets: There are times when you want volunteers to leave literature at the doorstep or mailbox for voters. When you come out with a new flyer you want everyone to see it as quickly as possible.

Data entry: Data may be entered on a device right at the door during a canvass, but often the results of a conversation with voters is recorded on a sheet of paper. This data can include their support for you (or not), if they will take a sign for you or if they have one for another candidate, if they are a non-voter either by choice or by ineligibility, and if their contact information is incorrect the canvasser can correct it. All this can be entered by a volunteer for tally and analysis.

Sign distribution: When a voter wants a sign your sign crew swings into action to deliver it to them. At the end of the campaign, they gather all the signs, which you can use for the next campaign.

Communications: Do you have a volunteer who is terrific at video production, graphics, or writing? They are invaluable!

Button-making: Buttons or stickers in a campaign identify supporters or get out critical messages. Stickers can be printed in your office and buttons can be assembled by volunteers. Kids love this job.

Office administration, food preparation, decoration: Your office must run smoothly. At its best, it is packed with people and a hive of activity. Why not decorate the office with names and pictures of volunteers and campaign activities, inspiring quotes, or fun images? Ensure your team members are nourished. Food is a part of every campaign. Enlist someone to buy on a regular basis some fresh or dried fruit, veggies, and other good snacks. Keep a kettle handy and the coffee replenished. Offer recyclable water bottles to your team.

Welcoming visitors: A busy campaign office has people coming and going. Ask a volunteer to be a greeter who can quickly determine who is coming in and why. Is this a person who wants a sign or to make a donation? Is it a local reporter? Is it another volunteer coming to canvass? Determining quickly what people need is welcoming and saves everyone's time.

Phone, email, and triaging: A busy office gets inundated with emails and has phones ringing that need to be answered quickly. A volunteer can find out what the person wants and steer them to the right place and ensures messages left are answered quickly. Nothing is worse than someone who has left a message and never gets a call back. Similar triage can handle incoming emails and social media posts.

Envelope stuffing: In a time of email and social media this may seem anachronistic, but there are some voters that you may only be able to reach by regular mail. Also, donations made by cheque need to be receipted on paper and these get sent in envelopes.

Supporting and accompanying you, the candidate: You may decide to go places on your own, but as the candidate it really helps to have people with you. Whether just for a show of support, or to help out taking notes of voter concerns, or just to make sure you move on, supporters can help. When you are out speaking with voters, you don't want to make them wait while you take a call from the campaign office. A volunteer can relay information to ensure you get to where you need to go.

Staffing events: When your campaign holds events, you need visible supporters to help generate energy. If you go to a march or parade you want to be surrounded by energetic supporters in t-shirts waving signs. If you have a table for your campaign at a street fair you want to ensure it is well staffed with enthusiastic and helpful volunteers leaving you free to speak with voters there or to wander the crowds and meet as many people as possible.

All these activities are just suggestions. Each campaign will determine what their needs are and how volunteers can help.

How to Involve More People

Be open to change. Sometimes I get asked by the leaders of a riding association how to get more people involved. They say they have put out calls, but no one is interested. My diagnosis usually is that those in charge want to control everything tightly and don't let others play a full role. Or sometimes they fail to recognize the different experiences and perspectives of others, people who want to be involved but get shut out or shut down. Those in leadership need to open the windows and let in some fresh air. If the long-time leadership can't adapt and share opportunities, they may need to step down and let a new team have a chance. You can't just wait for people to come and volunteer. You need to go to them.

You need to hear who they are, why they want to be involved, and what their ideas are. Inspire them and invite them to help be part of the change they want to see.

Get to Know Your Volunteers

Volunteers come out to support you and your campaign for a variety of reasons. Get to know them. Engage with them through canvassing or just having a chat. Who are they? What are their goals, and what can they offer? You might find a social media or artistic genius just by taking the time to ask questions. Your campaign will also do this, but when the candidate herself takes the time to engage with volunteers, it means a lot.

A crucial part of your job as the candidate is to engage, inspire, energize, and thank all those who are doing the hard day-to-day work of the campaign, some as paid staff but most as volunteers. If your feet hurt, you faced rude comments, or you are exhausted, never show it. Remember they too are tired. You need to be up and smiling for your team, and they will repay you in kind. You are together fighting to build a better world, and it's worth every minute.

12. Local Strategy, SWOT, and Target Voters

We need to change things, so it's not just about me, it's also about the people you bring with you.

—*Leah Gazan, MP, Manitoba*

Local Strategy to Win: Inspiring, Organizing, Mobilizing.
You have decided that you want to run for office in a particular place. You have begun to assemble a trusted team and to recruit volunteers. Now what? How do you win?

1. ***What is strategy?*** A desire to win is not enough. The answer isn't that everyone will work really hard. A goal is not enough. You do need to set goals and priorities, which will take resources. But it takes more. It takes a plan.

 A strategy is a plan, a way to achieve a goal. In politics it generally answers the question: How are you going to win?

2. ***Who develops the strategy?*** If you are running with a political party, the party will have its own strategy for the central campaign that influences local campaigns. Pivotal messages, platform priorities, big speeches by the leader are all designed to help win voter support.

 For example, if tenant rights are a priority in your area, a party commitment to strengthen tenant rights is helpful, but it's not everything and it's not enough. In addition, you need your own local strategy to win. The central campaign is important, and you want the leader to do well. But each candidate needs a strategy for how they will win locally.

You and your trusted team will develop your local strategy. You can consult to get as much input as possible but only your trusted team will map out the local plan and execute it to win.

3. ***What information do you need to develop the local strategy?***

- Detailed knowledge and history of the electoral district, including:
 › The current representative: their achievements, failures; their strengths and weaknesses; their party's strengths and weaknesses.
 › Your party in the last campaign: strengths and weaknesses. This includes a poll-by-poll analysis of support for your party to identify where support was strong and where it was weak.
- An analysis of the finances to determine how full a campaign you will be able to run, as well as a clear-eyed capacity for your fundraising potential.
- Issues in the community; what's on the minds of the voters. Are they generally happy with how things are going and with their current representative or is there an issue brewing that the current representative is unable or unwilling to address?
- The strength of your party in the riding including financial resources, the number of members and volunteers, the skill of the campaign workers (the more experience the better).
- The skill of the team to deliver strong messaging, events, efficiently organizing the candidate to get to events.
- Your profile, as the candidate. What is your power base and what strengths do you bring? Are you well known or a newcomer? Have you lived in the community all your life, or did you just move there? Are you already a public figure in the media and a person who is known for championing progressive issues?
- Your networks. The more networks you have the better you are able to bring in volunteers and raise money. If you are an

environmental activist with movement-building experience, others you have worked with are more likely to come out to support you. I joined with many committed activists to improve the lives of working people, who then volunteered for our campaign.

- Your skill and attributes. Are you a wonderful orator or does your skill lie in the warmth of personal connection one-on-one? Are you someone with long career experience or are you a fresh new face? Are you racialized, trans, or do you speak with an accent? Do you wonder if some of your attributes will make people less likely to vote for you? You need to dig deep to discover if maybe those attributes are, in fact, the source of your strength and commitment, and therefore an asset. You will need support to ensure that at no time are you put in a vulnerable situation.

- Do you need accommodations during a campaign? For example, are you a high energy person or do you have limitations that affect how much canvassing you can accomplish? Do you need childcare or regular insulin doses? Can you run up stairs or do you need an attendant?

Power of the underdog: Take a good look at your opponent. Remember as an activist candidate running against established power, you also have the power of the underdog. The underdog has the power of the many (if you can reach out to them) and the power of David against Goliath.

Veteran organizer and Harvard professor Marshall Ganz reminds organizers of United Farm Workers union leader Cesar Chavez's saying that "power can make you stupid." He means that power and the reliance on overwhelming resources can make you overconfident. The powerful can be surprised and beaten by a well-placed stone from David. Use the power of the powerful against them. Hold them to account for the unjust positions they need to defend to be beholden to their elite base. Find out who their actions have negatively affected and rally them to your cause.

Use their power of evasion by shining a light on their actions and exposing the truth. Champion an issue on which you know your opponent is on the other side.

Once you and your team have gathered as much information as you can, then you can determine your overall Strengths, Weaknesses, Opportunities, and Threats (SWOT)

Strengths, Weaknesses, Opportunities, and Threats (SWOT)

When I first ran, I had been a labour activist and leader for many years. This was a *strength* and a vital source of my power. I knew these networks would lead to many volunteers, donors, and resources. I also had a public profile because of my work in the labour movement and the community. This public profile made my strength a *weakness* with those who did not support unions. I decided early on that I needed to affirm this strength and just disregard those people who would never vote for a labour person. My first opponent tried to make my labour connections a *threat*, accusing me in the media of bringing "outside union thugs" into our community. For me, these attacks were an *opportunity* to reach the many working people in the riding and convey that because I was on the side of working people, I was the best candidate for them.

By the end of this exercise, you will have an analysis of all these strengths and weaknesses for you to assess. You will see the strengths that you need to emphasize and take advantage of and the weaknesses that you may need to deflect for your campaign. From this information, you need to decide your best strategy to win.

How I Activated SWOT—Part 1

In my campaign for MP, we decided that if the voters in our riding took a good look at my candidacy, that I had the strongest appeal. Our challenge was to get past the thinking that a New Democrat couldn't win the federal seat, simply because we hadn't in the past. Our strategy was to go with a high-profile campaign to win non-aligned voters. We needed to focus

heavily on those who were, or ought to have been, our core of support. Anyone who was disadvantaged, including young, racialized, and Black voters, lower income people, renters, workers and those on social assistance, were the logical base of support for a candidate advocating better redistribution of wealth and social justice. Central to our strategy was engaging those potential supporters who didn't usually vote. Among others, we worked with labour, tenant advocates, newcomer organizations, and multilingual canvassers to bring in community leaders and inspire people to vote.

I had some national profile, but I wasn't known as a public figure in our area. Since we knew that we would be successful in fundraising, we decided to go big out of the gate to make a splash and get noticed. The day the vote was announced in my first election campaign, our sign team planted many dozens of signs with my picture on them from one end of the riding to the other. The signs got attention. People wondered who I was. Our campaign sent a strong message that there was a new candidate running, and she was a serious contender.

Identify Your Target Voters

Begin your strategy by deciding who are your target voters, those who are a priority for your campaign. Remember who you are and why you want to run for elected office. This should be a major inspiration for your campaign strategy.

If you are a community champion fighting against inequality you could find a broad constituency of those who don't get treated fairly and their allies. Poor and working-class people are underrepresented at the ballot box for many reasons. Traditional campaigns are not pitched to them. Appeals to middle class voters are aimed to reach mostly suburban voters or those who feel relatively secure. Even if many working-class people also identify as middle class, their dual identity may not find these appeals compelling. People who are poor and racialized are often working multiple "gig" jobs to keep a roof over their heads, and many don't have the time or the technology to keep informed about elections

more than identifying the faces of high-profile leaders. People who lack economic resources may not have the required identification to get a ballot. Many believe quite rightly that no matter how they vote, nothing changes. They don't believe they can make a difference.

If you can engage this underrepresented and often disaffected constituency, you can boost the likelihood of them voting, which can change outcomes.

How I Activated SWOT—Part 2

My first opponent was a woman who didn't live in our riding. She lived in one of the wealthiest areas of the city. She didn't connect with the many lower income and working-class community members. They were not her target voters. Our plan was to inspire them to vote. If they voted, we knew together we could win.

We listened to the community concerns and enlisted their support and their help to make their goals a reality. Our campaign pledges, events, and community presence made these neighbourhoods a priority. My campaign had a campaign office in this community where a diverse group of multilingual volunteer organizers would be based. This made it easy for community members to drop in to get information or help for immediate needs. I did not ignore the rest of the riding and visited every neighbourhood, canvassing and attending events. I spoke out on many issues. But I always knew that those who had been forgotten by government after government were my target group, my priority.

We knew our strength would be grassroots organizing. We had an army of volunteers who hit the streets with a BIG pamphlet that had a full colour picture on the cover. We had a plan to ensure that volunteers felt inspired, that they could be engaged and participate, and that they could see momentum increase as the campaign progressed.

I vividly remember the day after the first election I won. I went with a team of volunteers to Parkdale, a working-class

neighbourhood, to thank people for their support. The neighbourhood had many racialized people who worked in manufacturing and the service sector. Historically, there has been a large Filipino community. As we were gathering on one of the main streets, a Filipina Canadian woman flew off the streetcar and ran across to me shouting, "we won, we won!" All the energy and hard work of the campaign seemed to culminate in this one moment, and we hugged and hugged. This was exactly our goal—for this to have been a community campaign and the win a community win. My heart was bursting.

13. Preparing the Ground and Building Your Profile

You've assembled a core team, you've developed a winning strategy, now you need to execute it. A crucial part of the strategy has to be building your profile in the riding. Unless you are already known as a community leader, this usually takes some time. Here are some ways to do this.

Be Seen Everywhere

Enlist your team to find out what's happening in your area. Wherever there are people is where you want to be, whether it's farmers' markets, bake sales, school concerts, festivals, community meetings, ceremonial events, or just strolling down the main street on a Saturday afternoon. People's consciousness needs to be "touched" by you on multiple occasions to have an impact. You want to be seen everywhere. Some days I would go to ten or twelve events. This work is not to give you information about whether people support you or not, although you may have some conversations. This is about raising or maintaining your profile.

BE EVERYWHERE

My philosophy was to be everywhere at once . . . I think if you're going to run, even if the odds are against you, go all in. Commit every single moment of your day. If you're going to do it, do it and be everywhere. So in all of my

campaigns, It started with building a list of community leaders and influencers, and requesting meetings with all of them, coffee chats to say hello, to get their feedback, to see if there was anyone else, because they all talk. They all talk, and they also get offended if you don't reach out because this is what all the candidates do all the time. We also identified all the places that I needed to be from farmers' markets to, you know, certain spots where people hang out.

And you will know if you're everywhere, when people say "I see you everywhere," or "Do you have a clone or a twin?" . . . you know when you're getting close when people say "oh my gosh, you again." That's what you want.

You can also use other tools like social media to do this. I'll give you an example. Because I've run in high-density communities, you can't always get people at their doors or by phone, so we would spend a lot of time at grocery stores or other places where local people go to shop, to interact. I remember, I was in front of a Metro grocery store, and a young woman going in said "oh my gosh, I just saw your campaign video." And the campaign video was notable because I talked about interviewing Beyoncé and interviewing Jack Layton. That really just embraced my background as Much Music VJ, so it popped out; it wasn't a traditional campaign video. To me, it was really encouraging that someone saw the video and then saw me at the grocery store. So, they're already getting to touch points. Ideally on a campaign, you have three touch points with as many people as possible.

That helps you be everywhere. So you want people to be seeing you in the community, but for a lot of people community is also the neighbourhood Facebook group, community is the local hashtag, and in the pandemic our community has really been online.

Jennifer Hollett, federal candidate, Ontario

Reach Out to Community Leaders

Assemble a list of organizations for tenants, residents, businesses, community organizations, religious groups, ethnic communities, the arts, issue activists such as environmental activists, housing advocates, food security activists, community gardeners, etc. Determine your priorities and set up meetings. Try to cover all your bases. Even if you believe a group is not going to support you, it's better that they at least meet you and know who you are to try and prevent them actively opposing you. You find support in unexpected places. People appreciate that you at least took the time to respect their position and hear them. Most groups, even if they are not actively supporting you, are careful to be respectful of your candidacy because you might just win, and then they can better work with you. These meetings will also generate more invitations to community events. When I reached out to the large Tibetan community in Parkdale-High Park, they were thrilled and invited me to their events. I got to know the leaders and active members well and became very supportive of the Tibetan struggle. This led to me attending many of their events and ultimately building mutual support.

CHAMPION A CAUSE

Being a school board trustee is incredible training, because you have no resources and you have to just get really creative about how you're going to connect with people in your community. If you just focus on the schools, you're missing a whole lot of the opportunity. I would just go out and put up posters that said "Have coffee with your Trustee" around the neighbourhood. Then I was sitting in a cafe for three hours sometimes alone . . . I did a lot of that, and I really think it paid off.

Also I spent a lot of time standing outside of the schools, talking to parents. I tried to go to each school a few times a year, so using those opportunities . . . it really

did help me to connect and to build a reputation as being an advocate for a lot of people who needed an advocate . . . Then I picked issues as well that were more community issues like developments around schools and stuff like that to go to more of those community meetings and again to fashion myself as a fighter for the community—it was somewhat conscious and some of it wasn't, it was my own interest in doing the job well.

It was a very frustrating experience to be a trustee with no budget. Nobody to help you—you've basically got all the expectations of any other elected official. And so you just have to learn to be really, really creative. I think it's incredible training, but the problem is, it is so undervalued that so few people could actually afford literally to take the time required to make it useful.

Marit Stiles, MPP, Ontario

Be a Community Champion

If you can position yourself as a community champion for a good local cause, people will see you already representing them even before you are elected. In my area we fought against a local public pool closing, against the city putting in a parking lot on precious Lake Ontario shoreline, and in favour of the electrification of a new airport rail line. When championing a cause, you obviously want to find a cause in keeping with your values. If your opponent is on the other side, then you benefit by standing with the community. To advance a cause you can create petitions, canvass to build support, generate media coverage, organize rallies, hold or speak at community meetings.

Make a Media Splash

Whether from effective, eye-catching social media, a well-placed opinion piece, or earned media from an event accompanied by a picture or TV coverage, this let's people know you're there, you're taking on issues, you're a presence.

Enlist Volunteers and Other Resources

If you speak at an event or even if you're just attending, when you meet people, some will tell you they support you and want to help. Be sure to get their contact information, so that you can get back in touch with them. Also think about asking for donations. Be ready. Have your team with you to get contact information and to offer them ways to help, including volunteering or donating. Your team then needs to follow up with each new contact to pull them into the campaign.

Build a Hub-and-Spoke Process

As your campaign progresses some of your dedicated volunteers and supporters can play a larger role. Canvassers can become canvass leaders. Supporters can hold coffee parties or some other event, usually at their home, to invite local friends and encourage them to support you. You could come by and speak to them, or they could lead this on their own. Fundraisers can contact ten friends and ask each to give a specific amount to support your campaign. In best-case scenarios, these are mutually beneficial arrangements, where volunteers develop skills and confidence that they take to other areas of their life.

Hold a Drop-In Event

When I first ran for the NDP nomination of our riding, our campaign manager urged me to hold an open house. It was a bit nerve wracking—would anyone attend? Would they be hostile? I was so new to this process. But we put out a notice to NDP members and supporters and our house was packed. At a given point in time, Julius, our manager, pulled up a chair and said to me, "Okay, stand on this, and let them know why you're running." I was so shocked I didn't have time to be nervous. I jumped on the chair and belted out the issues I was passionate about and the reasons I was running. We got a lot of support and donations from that event. You can also do a coffee shop drop-in, a condo lobby drop-in, a library drop-in. Letting people know that you are doing this sends the message that you are accessible and open.

×

These are just some examples of ways to boost your profile. From Facebook live events, to google hangouts, to hosting outdoor film nights or winter skating parties, there is no limit to the creativity of letting people know you are connected to the community. This was my reputation; I was known as someone who was always there for the community. It was a huge amount of work but I took the notion of being a representative seriously. To represent people, you have to be with people.

14. Fundraising

You Need Money

You need money to run your campaign. Unlike the US, where people spend millions of dollars on campaigns, in Canada we have fundraising limits and every donation is available for public scrutiny. There is also public financing for elections. Most donations qualify for a tax rebate and parties may get a per vote subsidy from public funds.

But it can still be a lot of money. Federal candidates can spend anywhere from ninety thousand dollars to one hundred and forty thousand, the higher amounts usually in more remote areas where travel costs are high. For a city councillor seat, the limits can be much less.

Donation Rules and Rebates

Only Canadian citizens and landed immigrants can donate federally. Foreign citizens non-resident in Canada are prohibited from donating federally, as are corporations and unions. There are strict limits on the amount of donations for all elections.

You likely will do fundraising at your nomination meeting. The person fundraising will detail what rebates are available for the donations, which can be an important incentive.

The ones I am familiar with, at all levels of government, are very generous. This information is readily available online for your area. Once people understand that they can get rebated a large chunk of their donation at tax time or later in the year, they are more likely to donate.

Financial Accountability

Financial accountability is central to fundraising. Your financial secretary is responsible for setting up your bank account with the proper security and record keeping. Normally two signatures are required to spend this money. Each donation needs to be scrutinized, recorded, and receipted for tax purposes. You don't want to take money from a person who is ineligible to donate. All donations are reported to Elections Canada or the corresponding provincial, territorial, or municipal body.

Fundraising rules vary from province to province concerning eligibility and donation limits. Ensure your financial officer is someone who is a stickler for the rules, who has some background in or aptitude for their role, and who you trust completely. Victories have been taken away from winning candidates who broke the rules and were disqualified.

I have observed elections in many countries where it is the wild west in terms of fundraising for candidates and political parties. Corruption can run rampant and quite understandably people have little confidence in their elections or the outcome. Strong rules with effective enforcement are essential to democracy.

FUNDRAISING WITH YOUR NETWORKS

Most of my fundraising was through my network of people that I built up over many years. And I didn't have many max donations, people giving me the maximum of $1,000. My donations were given in increments of $50 to $100 to $200 by a large number of individuals. Asking directly was the most effective way to fundraise. We had an online ask through email, as well as social media. We also had a captain model, where I would ask one of my big supporters to go and find five or six donors to contribute. It was difficult and uncomfortable as a woman candidate to be asking

for money. We did it by phone, email, social media, and by asking people to take ownership over specific amounts of money to help fundraise in the campaign . . . Out of all the tactics we utilized, the most effective was the candidate just asking straight up for support, but the next best approach is asking somebody who really passionately believes in you to go through their own network and ask, on your behalf.

Rowena Santos, Regional Councillor, Ontario

Ask Everyone You Know

Men have traditionally had a fundraising advantage based on wider networks, such as from playing team sports, community leadership, volunteer boards, workplace networks, etc. But today women are just as likely to be connected to networks at work, in the community, and on social media. Activists build strong networks that can be highly motivated to support a like-minded candidate.

I was hesitant at first to ask for money for my campaign, but I quickly got over it. Without money there is no campaign. When I first ran, a friend gave me great advice. She asked me to write a letter letting people know why I was running for elected office. She also asked me for a list of everyone who knew me from campaigns, from work, from my kids, from my personal networks and family. She and her team got my personal letter out to everyone in my networks. The response was gratifying. For many, the letter was enough. They donated. But for most we needed to call through my lists. We determined who I needed to call and who the fundraising team would call. This initial funding gave us enough money to run the nomination campaign.

The nomination meeting, whether in person or online, is a big moment to raise funds. If you can get a big turnout to the meeting, for example when there is a contested nomination, a skilled fundraiser can raise enough money to give you a great start to your campaign. Usually, this fundraising is done while everyone is in

the room or online, before the successful candidate speaks. That way people will donate in the excitement of the meeting, waiting to hear from the winner. The fundraiser usually gives remarks about the importance of fundraising and the kinds of campaign essentials the money will be used for, such as signs, online and social media ads, printed materials, and renting office space.

MONEY IS NOT DIRTY

Money is not dirty. Asking someone for money is an invitation for them to act on their values. It's an invitation for them to contribute. And so you don't have the right to deprive people of that opportunity by getting in the way and saying well, I know you don't have the money. Don't assume how much money people have, or what an amount means to them.

Understand that a big part of your job is to ask for money and that people will give to you, or they'll tell you if they can't. Don't take "later" or "maybe" as a no. The only thing that is no, is "no, never." "Maybe" is like not now; ask me again. Ask people again.

And in 2006, the clerk told me that I had the single greatest number of small, of individual donations, so many $25 donations. That made me really proud that my community, Latin American people, were giving money. They're not used to the rebate. They never believed that they were going to get a rebate, and a lot of them didn't have a lot of money, but they gave what they could and that was really important to me.

Alejandra Bravo, Toronto City Council
and federal candidate

Raising money is one of the worst things to me. I understand it, I know why we have to do it, but when it's about you it's very difficult. When I'm saying I need it, you know,

you sometimes want to crawl under the table. But I learned a lot about that aspect of it, and I've become somewhat shameless in asking for money, because we need it. The other parties have it, and we need it to be successful.

Tracey Ramsey, MP (2015–2019), Ontario

Live Fundraisers

In a live situation, whether in person or online, I have found the most successful fundraisers ask first for those who can donate the most. Some people give money because they can't give their time. It helps if you know ahead of time of two or three donors who will speak up. Naming each donor, or even asking them to say why they are donating, can encourage people to come forward. Gradually ask for diminishing amounts down to fifty or twenty dollars. Even that can be a lot for some people, and many campaigns are funded with lots of small donations. Remember, as the candidate, to thank your donors. Many candidates send a personal note to each one, showing people that you appreciate them and value their contribution.

What You Need Money For

Raising money early allows you to produce some literature to present when you or your volunteers go door to door. Even in the era of social media, you need a professional looking piece of campaign literature that has a big colour picture of you on it. With this you are introducing yourself to the riding or the ward, so make it the best it can be to highlight why you are the best candidate. Getting a polished piece of campaign literature to every person in a riding of over one hundred thousand people is expensive.

You will also need some money to hire your campaign manager and at least one canvasser. Sometimes a small campaign will have a family member as the manager. But if you are in a competitive riding, you are wise to get the best manager possible, and this usually takes some money. In many areas, election signs are

an important part of a campaign. They vary in price depending on the size and the number of colours.

In my area, campaigns compete with signs. My campaign manager, Julius, used to drive around the riding late at night after we'd closed the campaign office to count signs. This is far from precise, but they are an indication. If you have momentum, you will need a lot of signs.

Most campaigns are run with an army of dedicated volunteers. However, if you are in a competitive campaign and have the resources you can hire more staff. Dedicated canvassers, a communications person, a candidate aide, can be important additions to the campaign manager. However a big team of paid staff means you have less money for leaflets, ads, and signs, so most campaigns are very light with paid staff and packed with volunteers. (See chapter 11 on volunteers.)

Fundraising Never Ends

Fundraising continues throughout the campaign. A donation link on your website is essential. Many candidates effectively fundraise by sending out and posting messages about the work they are doing or what they want to achieve. Part of the message is a request to help the campaign by donating.

You can go back to people who have donated a small amount to ask for a little more. As long as they have not reached the maximum donation, people can donate multiple times. This needs to be done sensitively. Someone who gives twenty-five dollars may already find that to be a hardship. Don't press them for more. But another person who gives five hundred dollars, may well be able to give another two hundred or three hundred. People can also donate to multiple campaigns in a variety of wards or ridings to support a number of candidates. So if someone tells you or your fundraiser they have reached their donation limit, even if they only gave your campaign five hundred dollars, take them at their word and don't bother them.

FUNDRAISING—MAKE A LIST AND KEEP AT IT

People think, okay, now the party is going to give me money to run. Well, no, they're not. So I created an excel sheet of everyone I knew who might give me money. Right at the start I had a list of about 400 people, and very early on, I would sit down once a week with someone. I didn't want to do it on my own. We would sit in a room each night and phone, from about 6:00 to 8:30, and we did that pretty much once a week for eight months. That's where the bulk of my money came from. I recommend that any serious candidate do that. Create a list, sit down, practise and ask for money on the phone. Even people who are on the fence with the volunteer fundraiser, if I call them, they are more likely to say yes to you as a candidate. Then I always do thank-you emails or calls because sometimes when you give to an organization, you never get a thank-you email. You want your recognition, even on a personal level. Also, it increases my repeat donors.

Jessica Bell, MPP, Ontario

Your Active Role

Strong fundraising, of course, doesn't guarantee victory. The candidate who raises the most money can still lose. But late in a campaign if you need something to help you win and you don't have the money, it can be frustrating. Nothing helps with fundraising as much as the candidate. A call from the candidate is flattering and very persuasive to a voter. Ensure you set aside the necessary time to make these calls.

Get over any anxiety you have about fundraising. It is an important part of our democracy and strong rules protect us all. Could the rules be better? Yes—higher spending limits favour the wealthy. In some provinces, corporations and unions can still donate large amounts to campaigns. This needs to change. Until then, we need to run our campaigns as effectively as possible within the rules.

Part 4.
Getting Your Story Out

15. Public Narrative—
Your Story Is Your Power

Engaging the "Heart, Head, and Hands"

A number of years ago I had the opportunity to attend an organizer training program with Harvard's Marshall Ganz. He was key to the on-the-ground organizing for the first Obama campaign, and he has trained activists in many movements around the world. He is a fascinating, humble, and inspiring person. Ganz defined leadership as "enabling others to achieve a goal or goals when the outcome is uncertain." In other words, leaders don't just appoint themselves. They lead because others are willing to follow and support them to achieve goals. If the outcome were certain or predetermined, you could just follow an instruction book for a guaranteed outcome. Leadership wouldn't be needed. In politics, and especially in election campaigns, the outcome is always uncertain. Running for office means being a leader.

Writing in 2008, Ganz says that to motivate people to act in support of a common goal, a winning strategy alone is not enough. To motivate people to act, a leader needs an emotional appeal, a compelling story. He speaks about leadership needing to engage "the heart, the head and the hands: motivation, strategy, and action."

The process of storytelling and shared experiences, using the head and the heart, when faced with a choice, can inspire and motivate people to action. This practice of public narrative, this storytelling with a purpose of inspiring action, is a leadership art. I believe it also differentiates those politicians with a phony veneer of shared values from those who are genuinely from the

community and share the community's values and aspirations. The authentic rather than the plastic leaders.

Your Story to Inspire Action

Leadership on behalf of social change, according to Ganz, requires telling a story: the story of *self* tells of your values that are motivating you to act; the story of *us*, which is about values shared with those people you want to motivate into action; and the story of *now* that is about the challenge to those values that calls for urgent action now.

Ganz uses "self," "us," and "now" as a primer for illustrating this narrative technique in "What Is Public Narrative and How Can We Use It," which can be found on the website workingnarratives.org.

Ganz also points to Senator Obama's speech to the 2004 Democratic Convention where he is introducing himself to America. It is a masterful speech. There's a deconstruction of this speech on YouTube: "The Speech That Made Obama President." Not everyone has the oratory skill of an Obama, but we can all be tellers of our own story in a way that can inspire others to action.

Each of us is on a unique journey and in public life your narrative tells of that journey. Marshall Ganz would keep asking why, to get to the root of why a person was engaged as an activist. You want to fight inequality, why? You can't stand to see people suffer, why? Oh, your parents taught you to believe in fairness, why? They grew up in poverty. Not everyone who grew up in poverty chooses to fight against inequality. Some people just want to escape. Why were your parents different? Where did you find the courage to stand up and try to make a difference. How did that feel?

Remember why you are here. Revisit Part 2, You Are Formidable, and specifically, chapter 4, When Change Is Your Only Option.

Define Yourself

Ganz calls it your public account of yourself, and he says that if you don't give this account your opponents will give it for you. They

will define you. So, your public narrative is how you define yourself and it is a way to situate yourself in your community, express the challenge that motivates you to action and then inspire others to join you. Your story will include the pain of the challenges you have faced but also the hope that you have for change. This honesty and authenticity connects you with others who share similar challenges and hopes and are linked in the story of us. In Obama's 2004 Convention speech, he says, "My story is part of the American story."

Once you have shared your story of self and situated it in the shared story of us, then you can articulate a challenge or threat to these values that demands urgent action. The choice involved is a defining choice that you are all fighting for in the hope for a better future. This involves motivating others to see a better outcome and finding the courage to act. Martin Luther King's "I have a Dream" speech is a shining example of this call to action.

The Crux of Your Campaign Message

As a candidate you can develop your public narrative by yourself if you are especially gifted as a speech writer and speaker. However, candidates often rely on others to help them. This can mean getting together some trusted friends to collectively help you craft your narrative, or this could be a skilled communicator working with you, hearing your story and helping you craft your narrative.

I crafted my own story but I have come to realize that this is something that evolves over your lifetime as you are tested by different challenges and learn more about yourself. Sometimes we only understand our motivation in hindsight. I find it useful to keep probing my motives and refining my story.

Please do not skip this process. It will require you to dig deep to really understand your own motivation and values. The words you use in telling your story are important. They will inform your introduction to each voter at every door you knock on and phone call you make. These words will be the base of your speeches to

your supporters and at all candidates' debates. They will find their way into your printed and online communications. They are the crux of your campaign message.

CONNECTING ON THE DOORSTEP

It was really eye opening for me. Preparing your story is something I would suggest to people. Don't ever underestimate how important it is to take the time to prepare that because we all think we know what's interesting about our story, but you benefit so much from people listening to, other people talking it through . . . it takes sometimes many, many years, and it also shifts and changes. And it's so important to find ways that you can connect your story in a really concise way with people at the doorstep.

Marit Stiles, MPP, Ontario

Once I was in the election, I went over to this amazing woman's house, we had a glass of wine, and she just got me to tell my life story. It's hard to have this huge messy life experience with all these different pieces, which in my mind don't all fit into a cohesive narrative but have led me to where I am right now. So for a couple hours I told her every little detail that I could, and she then took some time and sent me back a draft of a script, and the idea was to create a video to tell people my story or tell people some of the motivation of why I'm doing what I'm doing.

What she pulled out of the story were pieces around my mom who was a single mom who experienced some challenges and hardship raising three kids, and the inspiration that she has been for me. And then highlighting some of the work that I did with Victoria Women in Need and some of the work I did around the environment and what motivates me, showing a simplified arc of my story.

It was really amazing to see how she was able to pull it all together.

I was pretty hesitant about it, and I know my mom's a fairly private person, and so I had to get her consent every step of the way to tell pieces of that story. When the video went out, I was really quite worried about how it would be received. But pretty quickly afterward—we had it running on Facebook ads and so on—I was greeted at a door with "Oh I just saw you." I said, "Oh yeah?" kind of nervous about it. And she said, "I've never voted for you, but your story is my story, that's me, like you were talking about me growing up. And I want to vote for you, I don't know how."

It was amazing to see this woman, she was a young Indigenous woman in subsidized housing, with small children. Clearly, she was facing additional barriers beyond what I had to face, but she really connected with what we were putting forward, and also the journey that got me here. I was able to make sure that she had someone to support her and drive her to the polls. It was really powerful to know that you can connect with someone in that way, and they want to be part of it.

Laurel Collins, MP, BC

16. Public Speaking and Speech Writing

Get Comfortable with Public Speaking

I remember vividly the first time I was called on to speak at a floor microphone in a very large meeting. I waited to be called, wanting more than anything to turn and run, but people were counting on me to raise a major challenge facing our union members. Then it was my turn. I was convinced that the entire room could hear my knees knocking and my voice quivering. I had my remarks written out for the five minutes I was allotted but I don't recall even looking at the paper. I just spoke from the heart and when I got the thirty-second time notice, I wrapped up with a call for support. It was all a blur, but I remember that I got rousing applause. After that I knew that I could speak in public and would keep working to improve. I still sometimes get a bit anxious before speaking, but that just motivates me to perform better.

For some people, speaking in public seems effortless. For others, next to death, it is what they fear most. Most of us fall somewhere in between, anxious to some degree about speaking in public. This also means that for the majority of people, public speaking does not come naturally but is a skill that we acquire and build on over the course of our lives. There are very few naturally gifted, superb public speakers. For the rest of us, successful public speaking can be a learned skill.

We are familiar with the signs of discomfort before speaking, such as rapid heartbeat, sweaty palms, and shallow breathing. These behaviours are controllable.

Replace Fear with Excitement

What helped me a lot was when someone said, "It's showtime. And like any performer, you're just psyching yourself up to do a good job." Rather than fighting against the energy I had labelled "fear," I worked with this energy, which I now call "excitement." I'm excited to be performing. Physically, I need "all hands on deck" to perform well. The extra oxygen, the faster pulse, and the singular mental focus are all marshalled to help me do the best job possible.

So rather than fear, think excitement.

×

We usually speak publicly to an audience with a purpose, such as to inform, to persuade, or to entertain. As a political candidate you might be doing a bit of this last one, but mostly you are trying to inspire and persuade. Speaking to persuade requires a level of connection and convincing to bring others to the speaker's point of view. It is this kind of speaking that we are discussing in chapter.

WHEN ENGLISH (OR FRENCH) ISN'T YOUR FIRST LANGUAGE

I think as women, we sometimes question ourselves so much. You know, English is not my first language, the first question that came into my mind is, am I going to be able to be a good articulate politician? I can do public speaking and communicate with people, I understand all the issues. So that was my biggest worry about my ability to speak English or communicate . . . I'm fortunate, in a way, because I was a constituency assistant (CA) for ten years,

and then when I ran for school trustee I was CA for seven years.

Before I decided to run, working the community I did feel, yeah, I could do this, because I know so well the policies, I had the confidence so that the years of experience really helped me.

Katrina Chen, MLA, BC

Political Speech

Usually, political speech is used to persuade, either for or against an action, or to win support for a candidate. In other words, more than informing, a political speech advocates for a course of action. A speech informing about politics or political parties may not be political, but a politician speaking about an issue and advocating action, even if it is also informative, is political. It goes beyond informing to taking a position and explaining why an action should be taken. It attempts to persuade.

What Does a Leader Sound Like?

How you say *what* you say, counts. Gendered and racialized cultural stereotypes about power and politics affect how different people and audiences will hear political speech. Research suggests that women often face a double bind in the realm of public political speech. We tend to identify masculine characteristics—such as occupying a lot of physical space and a loud voice—with power, especially in politics. If women try to imitate masculine-speaking traits they are more likely to be criticized as too aggressive or unlikeable. Yet if those who identify as women conform to the gender stereotype of feminine behaviour, they risk being seen as too soft or weak to provide good political leadership.

The Double Bind

As Caroline Turner writes, in "Obstacles for Women in Business: The Double Bind," the double bind is an emotionally distressing situation where an individual is confronted at a subconscious

level with conflicting notions of how to behave or communicate. Sometimes this conflict results from the desire to conform to societal norms, such as gender norms, which are often ingrained in the way people behave and view others.

For example, in a leadership position, a woman might speak in a way that is perceived as feminine, which may result in her being talked over and her views overlooked. However, if she chooses to adopt what is seen as a more masculine approach to communication, stereotypically more assertive, she may be viewed as abrasive and too domineering. In either case, she is unlikely to get the support she seeks within her organizational context.

Role Models

What makes a great public speaker? How can you tell when you are listening to a strong public speaker? Are good public speakers more likely to be men or women? What other characteristics can you identify?

Watch the speech in the US House of Representatives, July 23, 2020, by Congresswoman Alexandria Ocasio-Cortez, when she addresses the confrontation with Representative Ted Yoho.

What strikes you most about the speech—the content, the delivery? Can you describe her mannerisms and her tone of voice? Are there elements of the speech that you would describe as masculine or feminine?

Ocasio-Cortez later posted her notes for the speech on social media and they are worth seeing. She did not write a carefully crafted speech but rather highlighted a few key points she wanted to make to keep herself on track. Watching her speak you can see how periodically she pauses, glances at these points, and then continues to speak from the heart. Would her speech have had the same impact if she read word for word from text?

More Speeches by Women Leaders
- The amazing Stacey Abrams's TED Talk: "Three Questions to Ask Yourself about Everything You Do"
- Former NDP MP Mumilaaq Qaqqaq, giving her final speech

to the House of Commons on June 16, 2021 (available on
YouTube)
- Jacinda Ardern's full Christchurch speech: "Let us be
 the nation we believe ourselves to be," on March 28, 2019
 (available on YouTube)
- Julia Gillard's "misogyny speech" in full (2012) | ABC News,
 October 9, 2012 (available on YouTube)

Components of Your Speech

Structure and throughline: There are many sources of advice
on public speaking and what constitutes a good speech. The TED
Talks Guide to Public Speaking is a helpful resource. Here are
some tips they recommend for an effective speech:
- Decide on your main point, what TED Talks call the
 throughline. This is the message that unites everything else
 in your speech, and you should be able to summarize this
 throughline in fifteen words or less.
- Consider your structure. There are many ways to structure a
 speech but here is one example:
 › Introduction—a great opening line can spark curiosity and
 get attention
 › Context—why your point matters
 › Main concepts
 › Practical implications
 › Conclusion

Make Use of Your Story: Use your public narrative whenever you
talk. Design your opening to get attention with an eye to your
throughline. One compelling sentence or a short anecdote can
spark curiosity. Inspire your audience to want to know more.

Humour, in small bits, can work, but only if it's natural and
comfortable for you. People love stories. You've worked on your
story to be a compelling narrative. Fit it with your throughline. Be
personal and authentic with genuine self-deprecation.

Tap into your superpower, the thing that makes you

formidable. The reason you are here. Be powerful. (See chapter 4, When Change Is Your Only Option.)

Strive for clarity: With a complex topic, explanation is important, but resist the temptation to try to include too much information. Less is more when you stick to your throughline. Introduce concepts one by one, bringing people along with you. Go for clarity.

Word for word or notes? In preparation for your speech, decide if you are going to write your speech out word for word and memorize it or are you going to structure your speech with points that allow you to just speak (as did Alexandria Ocasio-Cortez). Both ways can be effective based on personal preference. Whichever route you choose, practise, practise, practise, so you deliver your speech naturally, leaving you free to connect with your audience.

Closing: The opening and closing are the two most important parts of your speech. Of course, the points in the middle are important in an effective speech, but the opening grabs people's attention, and the closing reminds them of your message and gives the listeners key takeaways. A great speech can be undermined if it ends suddenly and unsatisfyingly.

The closing should remind people of your main point(s) and urge them to action. Reciting a list of a dozen points is ineffective. The most people can grapple with is a list of three. Some people close with a story or the follow up to a story they opened with. The closing should seem natural and yet powerful.

If you are going to write out anything for your speech, write out the closing and memorize it word for word. This is the crescendo, the culmination.

There are many speeches online. Check out some by those you admire and see what works for them. Try out a few techniques to see what you are comfortable with. When you give a speech, remember to leave your audience with a strong, positive impression.

✕

Once you know what you want to say, think again about how you will say it. Consider the energy and passion that comes from authenticity, from you telling your story, and from rallying others to join together in common cause.

When you finally step out there—or onto that chair in the middle of a crowded room—seek eye contact with your audience. Depending on the topic, have a welcoming smile, show interest, and express energy. Now talk.

Finer Points to Public Speaking

Here are some finer points to think about:

Passion: Don't run from your passion for change. Embrace it. This is why you are running for office. This is the appeal of your public narrative.

Preparation: Preparation doesn't mean writing out every word, although this is the process of some public speakers. Practice will tell you how best to prepare. Alexandria Ocasio-Cortez had just a few handwritten notes scratched out and let her passion and anger carry her. It worked brilliantly.

Practice: Whatever your preparation, practise your speech many times. Video it if possible. I was shocked to see the top of my head while giving a speech because I was reading from notes. Better to go from memory, even if imperfect, and look your audience in the eye.

Pauses: Think of someone delivering a financial report in a long monotone. You don't want to put people to sleep. Contrasts create tension and drama in a speech. Part of your preparation can be identifying the words you want to stress, and looking for the places you want to pause. This can also mean raising your voice louder in some parts and almost whispering in others. Think drama.

Participation: When you include your audience, you open opportunities for more people to engage with your comments. How do you get hundreds of people to participate? You can ask a question, ask for a show of hands, or plan for applause at certain times and wait for the response. Think about how to get the audience involved in your remarks. Look at your speech from their point of view.

Presence: Think again about a report read my someone who doesn't look up, who speeds through as quickly as possible. This might be due to shyness, but it is disrespectful to the audience. Look up, look people in the eye, not just the same people but look to different parts of the room to make eye contact. Smile if its appropriate. Look like you're happy to be with this group that took time out of their day to join you.

Relax: Before you go out to speak, take a big breath or two, put a smile on your face, shake yourself to have some looseness, and then look like you're enjoying yourself, and you just might find that you do. Your mission is to rally people to your cause, to lead them to make political change together. How exciting is that!

PREPARE AND PRACTISE, PRACTISE, PRACTISE

When it comes to debates, the candidate will tell you what makes them more comfortable, and then they practise it. Be a judge and advocate for what you perceive is also where they're acting their best and if you're filming your practice, which you should, you can play it back to the candidate.

You'll cringe but then you'll see, are you better with the binder? are you better without the binder? The video doesn't lie. But if the candidate is performing better with the binder, it could be a confidence issue. Sometimes just having a binder, even if the candidate is not looking

at the binder, plays a role in their performance by giving the speaker a safety net. Generally, people perform better without notes. Time and preparation are fundamental.

In preparation for an interview, for a presentation, for a classroom, for door knocking, in preparation for debate, the candidate needs time to practise and rehearse, becoming skilled in answering tough questions. The challenge for anyone who is managing and mentoring a candidate is to prepare them for tough questions and a strong opposition but to do so in a safe environment. No one should ever feel bullied. One way of doing this is to do the work collaboratively, for example, I could say, look, let's together think of what the tough questions are going to be.

It can also give the candidate confidence when you ask them what's an obvious question you think you're going to be asked, and ask other people in the campaign, and then, you know, let's get together, think of what the strongest answers are, and then they rehearse it. And that builds confidence and prepares them. Preparing in a collaborative manner is the best advice that I can give when you're faced with public speaking in front of a tough or oppositional audience.

In terms of how to give candidates confidence in public speaking, the strongest most powerful narrative tool we have is our own stories. Especially if you're a candidate, you're largely going to be telling your own story. I often remind people, you know your own story better than anyone else. It's your story and it is a source of power. Don't let them take that away from you. No one can take your story away from you.

Jen Hassum, Executive Director, Broadbent Institute

17. Social Media

If you look at candidates that break through, underdogs that actually get elected, over the last five or ten years, social media has been a big part of how they were able to do it.

—*Jennifer Hollett, federal candidate, Ontario*

The younger politicians' fluent use of social media both increases their opportunities for leadership and changes how they lead if they win. First, social media platforms can make it easier for them to reach potential supporters and run for office. In a way, social media can substitute for traditional financial capital required to campaign. Second, young politicians use social media to voice their political ideas and to connect with voters, constituents and other young politicians. Virtual, ongoing interactions let them answer constituents' concerns with greater speed and care than non-virtual methods and enable them to act with a greater depth of understanding of their community's priorities.

—*Brittany Anlar,* Washington Post, *November 2, 2020*

What Social Media Can and Cannot Do

Social media has been revolutionizing political engagement for several years. Unlike traditional media, which presents information that usually flows one way from the voice of authority to "the consumer" at pre-set times, social media flows 24/7 from anyone anywhere without intermediaries, where the public can

communicate to authorities and to each other. Social media is a conversation that is changing the nature of politics.

Social media is also a community. Unlike anything in media before, people are finding like-minded people online and creating communities where they share their news, supplanting the mainstream media sources.

Social media is not a substitute for traditional organizing. Nothing replaces going door to door or phone calling during a campaign. A conversation in-person or a group in-person demonstration always provides a deeper connection than social media. But where in-person connection isn't possible or to augment in-person connections, social media is an important way to engage with people. With renters and condo dwellers so hard to reach, especially with so many people working irregular hours, many people cutting their home phone lines, and with cell phones not listed in the phone book, social media is an essential campaign tool. Harvard's Marshall Ganz says social media to an organizer is like a hammer to a carpenter. It is a tool but it in no way replaces the organizer (or the carpenter).

Why Social Media

As a candidate your job is to interact, especially with constituents. Social media provides you with tools to meet with voters where they are—online. Your goal is to promote your work, your campaign, and to engage with voters as an authentic person. For example, people love knowing that high-profile people from Ocasio-Cortez to Jagmeet Singh to Justin Trudeau post their own tweets. Their posts give you an insight into the unmediated real person and people respond to these posts.

As a public figure you engage in public debate and build your profile to boost support, volunteers, and donations as you champion important causes. Your profile can be local, but it can also be regional or national, especially if your social media gets picked up by journalists in other media. Through social media you can shape your narrative directly and provide a rapid response to opposing points of view. Online debates can be serious, silly, or toxic. You

don't need to engage with every comment, but taking the time as a candidate to read comments, even angry ones, lets you know how people are reacting.

Social media builds community. Unlike old technology like television, social media is interactive, and people get to self select which communities they want to be part of. You can engage the community directly in new ways by commenting on a person's social media posts, or you can reach out to someone via social media to let them know about your latest post or just to generally engage. Tag a writer about their new book you've just read or a musician about their latest video. Social media allows you—the whole you, living a full and interesting life—to be you, as a public figure.

Today, national political campaigns use social media to target their marketing messages to maximize their voter base. They also use data analysis to identify the success of their ads, the reach of their campaign. Your local campaign will likely want to target ads online to reach voters. As former media candidate Jennifer Hollett reminds us,

> If we come back to the basics of a political campaign, you need voters and those voters have to live in your riding, in your ward, in your community, within very specific boundaries, so you're looking at postal codes. But you also need volunteers, and you also need donors, and the volunteers and donors don't have to be within the riding or within the ward.

Effective Social Media

> One of the biggest misunderstandings about social media is that you just do it, when, in reality, like every aspect of a political campaign at any level, you need a strategy. Social media is not going to work for you if you just broadcast spammy messages.
>
> — *Jennifer Hollett, federal candidate, Ontario*

If you are not already active on social media, you are unlikely to gain enough followers on a personal account to make much of a difference. Let your campaign handle your social media and vow to step up your game for the future. If you already have active campaigns, then you have a head start. Many candidates are active on both their personal accounts and their office campaign accounts.

Social media platforms may be in flux as I write this, so take the advice following and transpose it onto whichever platforms are currently fulfilling these functions. There will be a variety out there for some time. Use them to their maximum value.

Facebook: Facebook continues to be very important for reaching voters, especially older voters, and is crucial for political ads and messaging. You can track the data and thereby target messages to those who can vote for you by their postal code. People expect good quality photos on Instagram and clear sound on Facebook videos. For example, iPhone camera technology has improved so tremendously that I look now at pictures I took years back with my Blackberry (sigh, yes I know), and they are such poor quality they are unusable. Candidates not only have a camera in their pocket, but they also have an entire film crew. A video of yourself talking into your phone as you travel through a rally or tour a neighbourhood can have a strong authenticity. But a short snappy video with a bit more production quality can get real attention. People are busy, so more and more, the "look" is important to grab people's attention.

Twitter: Twitter can be an echo chamber, but it is followed closely by journalists and opinion makers. It is effective for mobilizing for actions like demonstrations or rallies. Boosting your Twitter following is well worthwhile for building your public profile.

TikTok: TikTok is a platform that allows you to post very short video clips but, unlike other social media, it does not promote engagement or two-way communication. Many people don't want to take the time to watch YouTube videos, so TikTok can give

them a short clip. TikTok and other video live streaming services are important if your strategy is really focused on young voters.

Twitch, etc.: Twitch is a live streaming service which can be useful, but if you are new to it, you don't want to be seen as trying too hard. Stick to Twitter, Facebook, and Instagram.

Engaging Community

Paid social media can target your voters and provide valuable data for your campaign. As an activist, your goal is to promote your cause and get public attention. But as a candidate, while you still want public attention and profile, you need to know who you are contacting to be able to get back in touch with them, for example, to encourage them to vote. Just as you might meet people at a neighbourhood market or festival, you can join neighbourhood social media groups and lists (Facebook, Google, etc.) to keep up to date on what's happening in your community.

Social media moves beyond speaking into a megaphone to engagement, and that's what is so exciting about it. With social media you can inspire and recruit engagement beyond your riding. When you meet someone you don't know if they are eligible to vote, but everyone can volunteer and be part of your political movement.

You as the candidate can determine how comfortable you feel with social media. Some candidates won't touch it and leave it all to their team. Some candidates are all in and engage in online back and forth in ways that can be inspired. You know best your comfort level. If you have a desire to get more into social media, then do it.

Some Basic Guidelines

Create your own media: Whether it's photos from events, interviews, or statements, you need to get your message out in as many ways as possible. You can cross-promote your media or comment on issues to maintain an active presence. You are trying to build a relationship, so share yourself, your likes, dislikes, your take on the issues of the day.

Keep it simple and appropriate to the platform: Practise creating simple catchy posts that people can't help but click on. This way you can give a shoutout about something major and include a site for follow up. If you want to reach the media, Twitter is a great platform where you can promote your message with the right hashtags and by targeting interested parties.

Be authentic: This should go without saying. Let your personality shine through. Many activist politicians have two sets of political social media, one for themselves personally and one for their office. The campaign can send out official releases or campaign videos, but on personal platforms, you can engage the community and show who you are.

Be creative: There is so much online that you are competing for attention. An original, creative approach can go a long way rather than getting lost in the noise.

Choose your space and time: If you're trying to get noticed with something new you may choose to steer clear of the busiest times. But if you're commenting on something that's all over the news you can catch a lot of viewers with the right message. But be sensitive. Think more than twice about using a social media frenzy over a tragedy to extend your campaign. On the other hand, during a basketball final championship, a well-hashtagged tweet about kids' sports might catch attention.

Cross channel your message: If you are doing a google hangout or a live video, tweet and post about it on as many platforms as possible. There is such a fire hose of material on social media, the more you cross post the greater the likelihood that someone might catch one of your messages.

Engage others: Respond to a timely tweet by a journalist about an event that's happening in real time. Answer a direct message

quickly. Add to a message of support by a local resident about an issue you endorse. Be careful how you comment on other posts. Irony and humour don't always work in print. Before you hit the send button, check your emotions and imagine how your words will be heard.

For example, when former Liberal minister Jody Wilson-Raybould called for Prime Minister Justin Trudeau to stop "jockeying for an election" in June 2021, the Crown-Indigenous Relations Minister sent her a direct message, with one word, "Pension?" She was implying that Wilson-Raybould was motivated by the selfish goal of a parliamentary pension, to which MPs are entitled after six full years in office, rather than grieving about the unmarked Indigenous graves being discovered. Wilson-Raybould denounced the message as racist and misogynist and the minister publicly and privately apologized.

Use key words: Using hashtags and key words gets you in an active conversation. From #MeToo, to #Landback to #BLM to #IdleNoMore when you add the right hashtag you are joining a community of comment.

Have fun when appropriate: Think about what attracts you to social media. Yes, okay, sometimes it's cute animal videos, but sometimes it's a public figure doing something unexpected and, yes, fun. When conservatives tried to shame Democrat Alexandria Ocasio-Cortez for a decade-old university dance video, she responded by posting a video of her dancing outside her office as the newly elected congresswoman. It went viral.

Don't be reckless: Posting on social media is not like chatting with pals over drinks on a Friday night. You can be authentic, but I like to take a breath and pause before posting something. I have a rule never to post anything anywhere when I've been drinking. Careers have been upended for carelessness or "jokes" that were anything but.

Use paid Facebook ads: These ads can directly target voters in your area and allow you to engage with them.

Setting Limits

You can get sucked into everything from trolling to debate or at a more serious nature, abuse and hate speech. And sometimes you might be wasting your time because the people you're dealing with, you don't know who they are, and it might even be a tactic of another campaign to distract you or throw you off.

— *Jennifer Hollett, federal candidate, Ontario*

Just like catcalling, I don't owe a response to unsolicited requests from men with bad intentions. And also, like catcalling, for some reason they feel entitled to one.

—*US Congresswoman Ocasio-Cortez, reply to a tweet that she was refusing to take up a particular debate*

Anyone in politics who does not identify as a traditional politician is going to face online negative comments or even hate, including sexism, transphobia, homophobia, racism, Islamophobia. Hateful or threatening comments whether online, in person, by mail, phone, or whatever, need to be taken seriously and reported. Where you report depends on where the comments are received and could be to an online platform, to security, or to the police. (See also chapter 19, Eyes Wide Open.)

Plan ahead: Your campaign team needs to anticipate and plan for what you might face during the campaign, rather than react to problems as they arise. If the previous candidates were white men, there may be no experience on your team in dealing with harassment, and you may need additional experienced help.

Hate isn't limited to social media so have an overall plan. It's most likely to occur on social media because it's so easy to do but rarely is it limited to social media. It happens when knocking on doors; it happens at public events. Jennifer Hollett, who ran the

digital strategy for Olivia Chow's mayoralty bid, recalls that at public meetings she would get calls to go back to China. Racism and other forms of hate can bubble up in many places.

Your team protects you: Your team ensures that you as the candidate are protected from comments that violate your personal dignity. Establishing some ground rules about what is unacceptable can guide your team and help ensure your personal wellbeing.

With advance preparation your team is better able to deal with harassment on a case by case basis. It might mean ensuring you are accompanied by a team wherever you go. It might mean ensuring your team always knows where the exits are to get you out safely should problems arise. It might mean keeping you away from graffiti that is defacing your signs or your office.

We kept our sign crew busy following up on reports of vandalized signs with priority to replace those with vicious messages.

It can be difficult, if you want to engage with the community and personally respond to messages, to also be protected from hate or even just negativity getting under your skin. You as the candidate need to decide how to handle this. You can delegate responding (or not) to tweets or other posts entirely to your team or you can completely delegate social media if it takes too much time or is too upsetting. You know your own comfort level.

It makes no sense to go down the rabbit hole of social media with people who may not even live in the same country when you could be speaking with real voters who can put you in office.

PLAY TO YOUR STRENGTHS

You know candidates all have unique things that they're great at and things that they're not so great at. So as a candidate, build upon your strengths. If you're a writer then write. If you are someone who is comfortable in front of the camera, then perhaps you're doing videos on

Instagram. Then you take that medium, which is a strength of yours, and you cross pollinate it across other channels.

I've assisted people who come from an academic background, and they're writers and they love detail. I don't want to say, well, we need you to do snappy videos that are hot takes. That's just not their authentic selves. But they're prolific writers, so let's do a weekly analysis over Facebook, then your communications team can repackage on other spaces. Being your authentic self is how you build a following and also communicate with your audience around who you are, what you believe in, what you're doing, what your vision is. Play to your strengths. Don't try to mimic someone who you are not.

Jen Hassum, Executive Director, Broadbent Institute

18. Traditional and Other Media

As an activist you are experienced in getting your message across. Whether with social media (see chapter 17), online platforms, placards, bullhorns, or at community meetings, you are working to convince others of your point of view on behalf of a cause.

The same is true in elected politics, but with an additional burden. You need to persuade people to trust you with their causes. No longer is the message your only concern. Now it is also about you, your face, and your voice. The more you are in the public eye, the more you are seen and heard, the better your electorate will get to know you and trust you. You need to persuade people of your trustworthiness and that you are an effective representative, and that they should vote for you.

Social media can begin this process of gaining recognition, but to get beyond this circle, you need other media to pick up your story. What you face with journalists, either in traditional or digital platforms, is very different to social media. Maybe as the leader of an organization you already have experience with media interviews. Or maybe this will be new to you, and the thought of cameras and microphones crowded around you is intimidating. Your job as a public figure is to communicate with the public. Engaging with a broad range of media, other than social media, is an important aspect of this.

There is a growing diversity of media outlets providing in-depth investigative journalism, once exclusive to the traditional media, of newspapers, television, and radio. A few of these notable digital platforms are the *Narwhal*, *Canadaland*, the *Line Canada*, and *PressProgress*. Some are independent and others are tied to a traditional media outlet or a political tendency. This

growing diversity is good for public debate and offers political candidates and elected officials more ways to connect with target audiences, but also more ways to be held accountable. They can take a perspective that might be too risky for bigger outlets. When you get a call from them, don't dismiss them. These digital media outlets can generate big audiences, some of which might be in sync with your political activism.

Earned vs. Paid Media

You can self publish media through your social networks and you can get earned media, that is media coverage based on you being in a story. You can also buy media coverage, which national campaigns always do, either in a general way or through carefully targeted messages, often through social media. Local campaigns may also buy some targeted social media ads, or printed ads in local community publications, or structures like bus shelters or billboards. People are clear about a billboard being a paid ad, whereas social media ads, and even some publication ads, may seem to blur the line between earned and paid media coverage.

While paid media advertising is something many campaigns need to use, this chapter looks at earned media, that is, media where you are part of the story.

First Some Ground Rules

You want earned media: As a public figure, earned media communicates some part of your message, and it communicates your presence to the public. While social media is important, earned media can spread your message beyond your familiar circles. Some media outlets have the resources (and desire) to pay for investigative journalism or specialized reporters who cover different levels of politics.

Know the key reporters: Draw up a list of media contacts you need to do your job. Each level of elected office has its own press gallery. If you are running for a municipal seat, know the city hall reporters. There are also community media reporters and

specialized reporters on topics that can help your campaign, such as environmental, transportation, labour, and industry. Draw up this list for print, television, radio, online, independent media, and decide who are your priorities.

Introducing yourself to the media: If you are already a public figure, your announcement about running for office is newsworthy. You can decide if you want to put out a statement, hold a public event, or announce on social media. You can also select one or more journalists to meet with to pitch your story. Being open and accommodating with media contacts establishes a base for them to keep in contact for the future. Be sure to let reporters, especially the priority ones, know how to contact your campaign. Select a very few who can contact you personally. When they get in touch, get back to them right away even if you can't add much to their story.

Friendly but not friends: You want to establish good relations with media reporters. They are working people trying to do their job often on tight deadlines. If you are a helpful and reliable source for comments you make the reporter's job easier. So it is mutually beneficial. They want to get the story right and get it quickly. "No comment" is not helpful to you or the journalist. However, reporters are not your friends. They have a job to do, and they are always working. Anything you say is fair game for a quote. If going for drinks with a reporter leads to your loose lips, then it might just end up in a media story and it may not be flattering.

Being a helpful source: Keeping the lines of communication open with reporters helps foster this mutually beneficial relationship. For example, a reporter might want to contact you "on background." This means they are trying to understand the story but won't be quoting you. Clarify this with them. What isn't explicit can end up unintentionally in a story. Giving background to a reporter is important to them, so you want to be helpful, but you are not expected to divulge confidences. They are looking for

the lay of the land. Before a political party convention, reporters will typically phone around looking to find what are some of the hot debates and what kind of support the leader has. Before an election kicks off, they might call some nominated candidates to understand their party's level of preparation and what resources they have. You are in control of deciding how much detail to offer. No one expects you to divulge the state of the campaign bank account. But you could describe the enthusiasm of volunteers, the great reaction you are getting at the door from voters; you could point out some of the other amazing candidates that your party has nominated.

Off or on the record: Always assume you are "on the record," meaning fair game for quotation. This means you need to choose your words carefully. Something might seem like a funny comment over drinks with friends but seeing it in print can be disastrous. Political careers have been completely derailed by imprudent comments. "Off the record" comments are comments that will not be attributed to you but rather to "a source," or they may be treated as background. Some reporters don't accept the concept of off the record. In their view, if you say it, it's fair game for quotation. A mistake some people make is to say something is off the record, without ensuring that the reporter will treat it as such. In other words, the reporter must agree, not just be told, to not source a quote. This element of consent is important, and you cannot assume consent.

Getting Your Story Out and Getting Yourself Into a Story

When I started out, the press release was the way to go. Today, if you have a story, pushing it out via social media is the fastest way to *maybe* get it noticed. Be sure to tag the major organizations and journalists with an interest in the subject.

In my riding, for example, there was and still is an issue about rail safety for hazardous freight. There are transportation and environmental experts in some media (less today, unfortunately) who understand the issues immediately. If you have a labour

rights issue, there are shockingly few labour reporters left, but fortunately there are a few. Target them for your story through social media and directly.

Depending on what else is going on, getting your story out can be difficult and frustrating. You can try to get your voice into a story that you didn't initiate or where the reporter is not contacting you asking for your comment. If there's a media story that affects your campaign or your community, and you need to get your voice heard, find out what outlets are covering it and who the journalists are and contact them. But you do need to have something to add. A reporter won't include your voice just to help your campaign. Call or message directly and offer your take or your information. Tweet the hashtag with an interesting angle to the story. Social media is very busy. So think about how to grab attention, how to break through the noise, whatever form of media you're using.

When You or Your Campaign Get a Media Request

A rookie mistake is thinking that if a journalist calls you, you must answer immediately. Without preparation you might say something unhelpful to you and your campaign. Some thoughtful preparation is always beneficial.

If a reporter calls you, find out what the story is about and what's their angle. Unless you are sure of your answer, you can find out their deadline and tell them you'll get back to them. Media coverage can help you enormously, but you don't have to accept every media call and you don't have to answer immediately. Your first thoughts about a story may not be your best response. Shooting from the hip with the media can get you in trouble. For example, you don't want to be caught contradicting your party's national leader in the middle of a campaign. No leader likes to be surprised when they face the media by having a local candidate's contradictory or embarrassing comments thrown at them. This can derail a campaign, sometimes for days.

In 2019, Liberal leader Justin Trudeau derailed his own campaign when old video surfaced showing him dressed in "blackface" for a party. This scandal lasted several days but was escalated

when a long-time Toronto Liberal MP told a Black interviewer how proud Blacks in her community were to see their PM in blackface. It was a terrible comment that was flung back at Trudeau and served to extend the blackface scandal another couple of days. This was no rookie mistake but certainly a challenging one.

When you get a media call, find out some background about the story, see what your party is saying if it is a national issue, and take some time to consider your answer.

Reconnaissance: Media requests can come at you in many forms from a quick radio clip on the phone, to a sit down one-on-one filmed or videoed interview for an hour, to a live TV or Facebook debate on a given issue. I usually funnelled media requests through my campaign manager to assure all the right questions were getting asked, but a skilled media adviser working closely with your campaign team can serve you well. Before accepting any media request, find out everything possible about it. Some questions to ask:

- What is the format? Is it a panel discussion or a one-on-one interview? Is it a thirty-second clip or a fifteen-minute interview?
- If it's a panel, who are the other panellists?
- Where will the interview be held? Is it by phone, by video, at the studio, and if the latter, where?
- If the interview is in studio, will there be makeup and hair styling offered? (A great question to ask especially if you've been knocking on doors all day and look a bit bedraggled.) If not, you need to plan in you schedule to take a few minutes to look your best. Everyone benefits on camera from a bit of makeup.
- What is the setup in the studio? Will you be behind a table or desk, are you seated on a sofa, or are you perched on a stool? If the latter, I always preferred not to wear a short skirt.
- When is the interview? Is it live or taped for later broadcast?
- Who is the reporter or host?

- How long will you have for the interview? If you have only three minutes, you need to ensure your message is short and punchy.
- If you are commenting on a news story, will you be able to hear the comments you will be reacting to? For example, if a minister is making an announcement and then the reporter comes to you for comment, it's only fair that you get to hear the announcement.

Preparation: Once you know what the media request is about, then you can prepare how you will handle it. A quick print or radio clip about the news of the day will likely have a tight deadline. You need to quickly find out the story and determine how best to answer.

Being invited to a political panel or an in-depth interview means you need to decide what are some key points you want to make and how you will present them. What are the priority messages of your campaign? What are your strong points? How do you weave in your public narrative (see chapter 15)?

If there are likely to be difficult or embarrassing questions, you need to be prepared to answer them. You want to avoid being thrown off your message, so think carefully to anticipate these, answering sincerely and usefully. This preparation is not inauthentic. If you stumble around in an interview you appear to be hiding something. Be honest and frank and speak the best you can on your behalf. Be sure to discuss these issues with your team.

Practice: Once you have anticipated what you may face and prepared some responses, then practise them until they become second nature. This won't be the only time you'll get these questions. Just as with a speech, practise answers in front of a mirror or with a trusted friend or campaign team member. Get over feeling awkward about this process. Successful politicians practise what they want to say so that they speak to the best of their ability, and don't stumble or inadvertently say something they don't mean.

While appearing on camera: Bright lights in a TV studio can wash people out so they look tired. Cameras can also pick up oily skin and create a shine. We've all experienced this at a micro level with video calls. Everyone looks better with a bit of makeup. You can apply it yourself or ask the studio to do a touch-up. Make sure your hair is neat and out of your face. Be yourself and be authentic, but be aware that sometimes clothes and jewellery can distract from what you are saying. On camera patterns such as stripes or squares can appear to dance on the screen, and you may want to avoid these, but otherwise wear what you like. If loud patterns and big earrings define you, then go for it

Doing a street interview is different. If a reporter is following you while you're canvassing with camera shots of you running up steps and greeting voters, you just want to look as you normally would. A bit of flyaway hair or sweat on your brow shows how hard you are working.

Once you've done your preparation and you've practised, relax. You want to project your authentic self in the best possible light. Unless you are discussing something tragic, look alert, smile slightly if appropriate, and summon some energy. For a radio interview, try smiling even though you can't be seen. Smiling adds some energy to your voice. Whether in studio or on the street, ask whether you should be looking at the interviewer or directly into the camera. The reporter and the team want the best footage they can get.

If you are on a panel with other politicians, try not to interrupt. When you speak over someone else it's hard to hear anyone at all and can seem rude. A good moderator will stop interruptions, but they do want a lively discussion. So if another person has had time to make their point and they stop to take a breath, you can jump in.

The ambush: The journalist's job is to get the best story they can. Sometimes this means getting an unprepared reaction from you to a hot story that is breaking. If a reporter has your number and

you tell them where you are, they may call to get a quick comment about the campaign.

Ambushed: I won't forget my first day as an elected MP on Parliament Hill. I was first elected on January 23, 2006, after a long, cold campaign. On February 12, NDP MPs travelled to Ottawa to attend, the next morning, our first caucus meeting on Parliament Hill. I remember going into Centre Block on the way to our meeting, excited and a bit nervous. Suddenly I was surrounded my media, cameras and microphones in my face. The crush of journalists were asking me what I thought about the Ontario NDP that the day before had kicked my national union president Buzz Hargrove out of the NDP for supporting another party. In the rush to get ready for the trip to Ottawa I had not heard about the expulsion. Social media was still relatively novel. But I was annoyed that neither the union nor the ONDP had contacted me either beforehand or after. I was shocked by the deluge of media, and angry that I was put in this position my first day in Parliament. I mumbled something about preferring to discuss differences rather than expel members.

I learned a few things that morning. First, to be as informed as possible on as much as possible. I didn't want to be caught flat-footed again. Second, it's the media's job to get a story not to be nice or considerate. Third, if an MP doesn't want to be scrummed, don't walk in the members' door or out the main door of the caucus room where the media lie in wait. This spoiled what should have been a happy day, but I quickly learned that as a public figure, this is all fair game.

19. Eyes Wide Open

> Violence and harassment, I would qualify that as a separate category or barrier that not just prevents women from entering into politics but also is a potential reason as to why women might not want to stay in politics or would look at it and think, no, I don't ever want to run.
>
> —*Tracey Raney, Professor, X (soon to be renamed)*
> *University*

Public electoral space is *always* contested terrain. I used to believe that with more role models, diversity would just happen; it would become accepted. I used to believe that having better representation of women in public life would reduce the incidence of gender-based violence. I've had to change my mind on both counts.

Numbers alone are not enough. Worse, sometimes when women, especially Black or racialized women, step forward to play an active role in public life, be it in elected office, the media, or the arts, the backlash can trigger further violence. Anyone deemed different knows about the challenges they could face in public life.

Yes, role models are important, and politicians, who are still mostly not women, continue to push back. Even today when you ask many people what a leader or what a politician looks like, they still picture the traditional male stereotype and can react negatively to women candidates. Voter suppression tactics have a long history of denying the vote to people who are not deemed worthy of public participation.

This book is about encouraging progressive activists who

identify as women to run for elected office. If the levers of power continue to reside with the wealthy, the privileged, the traditional white male power elite, we can't expect governments to use their entrenched power to benefit the majority. Power never willingly gives way. I have never expected the wealthy to share without a struggle.

Women historically have faced gender-based violence. There are many important recommendations to end gender-based and other forms of violence. Avoiding public life is not one of them.

Preparing for public life, we shouldn't have to consider personal attacks on social media or in person, but we must acknowledge this reality. Violence and intimidation are designed to silence you and to prevent you from exercising your power. Be aware of the risks, take reasonable precautions, and organize to bring in solutions to end the violence. Take on the challenge of public life if the time is right for you. Run for office but run with your eyes wide open. The greater the representation in elected office of those who are committed to progressive change, the greater the likelihood of that change becoming a reality.

RUN FOR OFFICE WITH EYES WIDE OPEN

I've been threatened and my signs were defaced. People knew the route that my kids walked, and it was very violent and misogynistic stuff written on my signs. The way that they were destroyed, the way the faces were cut up with a knife, those are clear intimidation tactics. (My opponent) would open his stump speeches and would say, "I'm not coming in asking you to vote for me just because I have a pretty face." As if that's what I was saying. What about social service cuts and property taxes? There's a kind of a violent misogynistic streak to that stuff, where your appearance is just a commodity that people can trade on and judge you. And you can't win. You're either too young

or too old or too pretty, are too ugly or you're too fat or too skinny. I don't think that you can win that kind of political game when you're a woman.

The stronger you get the more they're going to threaten you. First of all, people have your back, and second there's something about getting comfortable with people not liking you and people seeing you as a threat that I think is something that might be easier for men. But for women, I think, there's a pressure to be liked. We're in a contest here, and the prize is being able to govern, so it's going in with your eyes wide open.

Alejandra Bravo, Toronto City Council
and federal candidate

Backlash

Professor Tracey Raney says it's a huge problem that we don't have solid statistics on the prevalence of violence or harassment against women in politics in Canada, because we have no tracking mechanisms. This, she says, is a global problem and certainly not a new one. The prevalence is indicated by many interviews with politicians who are now more willing to discuss their experiences with harassment and hate from members of the public or from colleagues. Women leaders have reported everything from racist or homophobic taunts, to threats, to sexual assault, and even murder. She says that many of the attacks on social media would fall under that category of psychological harassment. Women leaders discuss silencing tactics such as "manterrupting or mansplaining." And they describe the withholding of economic resources that prevent them from fully executing their work.

There have been modest increases in the numbers of women in politics in Canada, according to Professor Raney, but she notes, we are still very far from gender parity. Similarly for racialized people, there is progress, but it is very slow and far from where it needs to be. She adds that their presence, with modest increases, has created a backlash. "And one of the ways in which that

backlash manifests itself is true aggression and hostility towards what we refer to as these 'space invaders' that come into political institutions that have been historically dominated by white men. But it's partly because of a backlash to the very small amounts of progress that have been made."

She points to Nirmal Puwar's book *Space Invaders: Race, Gender, and Bodies Out of Place*, which says that these spaces are so white male dominated that when women enter into them, especially racialized women, they're like a foreign entity, so that their very presence is threatening.

Polarization

Increased partisan polarization is another source of harassment. Raney says that politics is becoming more combative and that often verbal or other attacks are launched by partisans who believe that to win you need to annihilate the opposition. Raney says:

> What this does, then, is it creates this sort of more combative, more aggressive climate between the politicians but also amongst their bases, so that dialogues between people on the left and the right, who might have disagreements over various issues, that partisanship—that hyper-partisanship, that polarization—is preventing people from seeing the other side as legitimate, or as just people's points of view. I don't want to say that everybody's doing this, but we have seen a more general increase in party polarization, and that creates a broader climate where aggression comes out towards people who are perceived as on the other side.

The other factor politicians face is the increased use of social media, making elected representatives easily accessible to their constituents. This is a boost for political accountability, and many politicians respond quickly and directly to legitimate constituent concerns. However, social media is also a source of attacks, often

anonymous, making it possible to say hurtful and hateful things to anyone. The use of bots to target political opponents makes this problem even worse.

Don't Be Silenced: Be Prepared

Fear of fierce opposition, threats, harassment, any kind of hate, is designed to silence you and take away your power. While most candidates run campaigns without significant issues of harassment or hate, it is important to plan ahead and be prepared:

Rely on your campaign team: When harassment and hate start, it often means you are perceived as threatening, whether to a political opponent or to people who see the world differently from you and who don't fight fairly. You are getting under their skin. This feels very personal, but it is bigger than you. Ensure your team helps take the burden of these attacks. Come up with team strategies that collectively deal with this hate.

Have a plan: Add harassment and hate to your campaign planning. Have your social media team know where to complain if you receive hate messages through social media. I delegated answering social media posts to my team because I didn't want to deal with the negative energy it generated. (See also chapter 17, Social Media.)

Report threats: Treat threats seriously. For anything that may be a threat, have your team report it to the police. They can help you determine if you need additional security measures. As a public figure, people often know where you live. This can make you and your family vulnerable, so treat threats seriously.

Keep your kitchen table team close: When you are the target of harassment because of who you are, rather than what you say, it can feel devastating. If you face a wall of negativity, you may need to take some time to be close to the people who love you. Your team of personal supporters can help you by checking in with you

and finding out what you need to get through the pain of such attacks. Campaigns are important, but your mental and physical health and wellbeing and that of your family must come first. (See also chapter 10, Building Your Team.)

Work with canvass teams: Don't canvass alone, especially in apartments or condo buildings. Always have someone, if not right beside you, at least within sight. I have been in a few frightening situations, but I have been lucky to never run into serious problems.

Stay outside homes: We instructed our canvass teams not to go into people's homes. Sometimes people are very kind and invite you in, especially when canvassing during very cold weather. Occasionally, I broke down and went in, but I relied on a lot of experience about who I could trust. And I think I was also lucky that I never ran into problems. Occasionally someone would invite me in to be a witness to the terrible conditions in their apartment, with mould, leaky pipes, or holes in the ceiling. Again, if you must go, go with a canvass buddy.

Rely on your community: Trust that most people are decent and that your community, the ones you are running for, are on your side. Enlist your supporters and the public to take on hate and harassment. Even those who don't support you may well come to your defence. Most people want to see a fair political competition of ideas and plans, and will oppose any kind of personal threats, attacks, or harassment.

THE WORK OF ALLIES

When I created my Facebook public page, I started getting inundated, on my Facebook inbox, with messages from random men around the world, including inappropriate pictures. I was terrified to even check my inbox sometimes

on my public Facebook page, to a point where I asked Paul Vicente, the person I was running with, to be responsible for checking it for me.

So Paul started checking my inbox for me, and I remember him walking into the campaign office, one day, saying to me, "Rowena, I had no idea how hard it was for women. I literally check your inbox every day, and I see the level of harassment and the pictures. I'm disgusted by what you have to go through."

Something a bit more subtle is when I'm campaigning, when knocking on doors with Paul. We were at the door, together, and a man answered the door, he would only make eye contact with Paul and talk to Paul and completely exclude me from the conversation. Paul would notice it and it would make him very uncomfortable. He would intentionally look at me so that the person talking would look at me too. That's another example of how Paul as an ally started to realize how much different it was for a woman running versus a man. He still does this to this day. He'll look at me and just stare at me for a while, until the person that we're talking to starts making eye contact with me.

Rowena Santos, Regional Councillor, Ontario

20. Holding the Community Close to Fight Racism

On the campaign, I remember being asked, "Can you represent us all?" That was a question that came up a few times. My response to them was "Do you ask the current MLA that same question? He's a non-Indigenous man. Is he only going to represent people that look like him?"
—*Ann Marie Sam, Indigenous leader and NDP candidate, BC*

Homogenous representation in political leadership can lead to bad decision-making for the people who most need effective public decisions. Elected representatives need to be just that: representative. Then elected bodies have a better chance of making effective decisions to improve the lives of the many. For far too long white, older, cisgendered, prosperous lawyers, business owners, and career politicians, mostly men, but increasingly women, have hogged all the power and shut other voices out. And if some of those other voices do get elected, making change with inert institutions can be overwhelming. Nevertheless, we must persist. If racism, Islamophobia, sexism, ableism, transphobia, and other forms of hate are successful in shutting up, shutting down, and shutting out diverse candidates we will all be worse off.

THEY FORGET I'M AN MPP!

If there was a protest and I went into Queen's Park, it was inevitable that a guard would ask me what I was doing and who I was trying to see. They forgot that I was an MPP.

I'm the only person that has locs at Queen's Park, and I'm a Black Member . . . but they don't remember, and they're mortified when I respond "I'm the Member for Kitchener Centre." They're mortified; they feel horrible. And then I realize that's how deeply embedded these stereotypes are. Somebody like me showing up at a protest is clearly visiting somebody. When there is no protest, they always remember me.

Laura Mae Lindo, MPP, Ontario

✕

I can only speak for my own experience as a white woman from a working-class background. However, I can listen to and elevate the voices of those with direct experience of other forms of oppression. Raising these issues and reflecting on these stories is not to discourage potential candidates, but on the contrary, to encourage them to learn from the experience of others. Here is some of what I have heard.

Recruit: So many times, political party representatives throw up their hands in mock despair that they can't seem to find diverse candidates. This is a sad joke. Effective recruiting means making the effort to reach out to networks of those from diverse communities to seek candidates, and to take the time to know them and encourage them. This may take a few election cycles. Candidates are wise to look before they leap. Parties with equity policies requiring diversity before a nomination election, that ensure that equity candidates stand a good chance of winning a nomination meeting in a riding that is a priority for the party, are more likely to

win. And representation doesn't mean tokenism. It means representation at least equal to the proportion of the population, if not more. It means that when an incumbent seat becomes open that an equity candidate must be a priority, provided with effective training and support. No more excuses. If some parties like the NDP can do this, so can all parties.

Prepare: You might think the best of your fellow community members but prepare for them to do the worst and hope that you are pleasantly surprised. Speak with your family and close friends. Have a strategy for the occurrence of racism or antisemitism or Islamophobia or other hate. Decide ahead of time what your plan will be, who will be alerted, how you—the candidate—will be protected, how to fight back. This must be a leadership team initiative and not left to the candidate. The hate may be online. Find out how to notify different social media platforms about online hate and how to make a complaint. Be aware of the municipal, provincial, and federal anti-hate laws and complaint processes. Know how to report threats to the authorities including to law enforcement. Be prepared with supporters to shield and protect the candidate online and in person. (See also chapter 19, Eyes Wide Open)

Protect: You, the candidate, do need to be protected even if you have a group strategy to fight back. You may need a few days off, to be surrounded by family or close friends. Or you may want to come out swinging with a kick-ass canvass team. You need to think ahead of time what might be needed, and then the team needs to be flexible if the worst hits. Take the necessary time to make a response that you find comfortable.

Community support: Trust the community and bring them into the response. I remember when my provincial counterpart Cheri DiNovo first ran. I felt responsible since I had encouraged her to run. Cheri is a former business owner who went to divinity school and became a United Church minister. During a time of serious trauma in her life, as a very young person, she was unhoused, lived

on the street, and had used and sold drugs. Clearly, she had turned her life around, and, far from hiding her past, she used her story to speak with youth who were going through their own trauma and challenges. In her first run for office, she was attacked with vicious leaflets as being unfit to represent the community. Social media was not yet a factor. It was heartening to see the community join with Cheri in outing this as a hate message. I spoke with voters at the door who said they usually voted for another party, they didn't know Cheri, but were voting NDP as a protest. This kind of community support, and often community organizing to fight hate, can be heartening. Cheri won handily.

Amplify: The point of hate is to silence. Speaking out louder to drown out the minority of hateful voices is a key strategy. Racists may assume that most people think as they do. While we are plagued by systemic racism, unconscious biases, and many other systemic barriers, I have seen many people become allies and support people against overt hate. I have to believe that most people want to see a fair democracy free of hate.

Win: An effective tactic against racism and other forms of hate is to win, as have the many Black, racialized, and Indigenous women I quote in this book, thereby adding more activist, diverse voices to our political structures.

Power is not ceded willingly or easily. Wrenching political power from the already too powerful to take back our democratic structures is a tough struggle but I believe history is on our side. The more diverse candidates who are elected the greater the opportunity to achieve social, economic, and environmental justice.

KEEP COMMUNITY CLOSE

Maybe it was naive, but we definitely did not expect that level of hate. It did start online, and it was on some pretty

obscure websites—mischaracterization, lies, innuendo. Initially the thought was "Don't give this oxygen. Let's keep canvassing; let's keep doing what we're doing." Ultimately, I think that those driving the hate campaign didn't like that and worked even harder to spread their message and to bring it into the communities I was running in. It was a few rounds of hate literature, flyers posted on telephone poles, and later printed in full colour and dropped on neighbourhood doorsteps, and, ultimately, people showing up to all candidates' meetings and being disruptive and abusive. Folks even picketed the campaign office. It was different forms and expressions of the same thing: hate and Islamophobia. It's awful and it's terrible. It's no wonder that we still see the composition of politics in this country as it is. For too many of us, if it's not one thing, it can be another, that discourages us from seeking elected representation, and it really does build, and it's very frightening.

We were able to pull through because of the way that our community, our supporters, and even people I didn't know, rallied and worked with us to make sure that the truth came through—just to be able to see the lies and the intimidation for what they were. Tactics like that are meant to silence and erase women in politics, Black, Indigenous, and people of colour in politics. People who are challenging the systems and structures do exist. They are fighting hard, they are winning and that is why they are being opposed. I don't think that being elected is the be all and end all of our work. I don't think that that is our political panacea. But as someone who has aspired to be an organizer, a movement builder, and an activist for issues of justice for a long time, I believe that it is an important piece of the puzzle around the change that we want to see.

So much of what we fight for and work for together eventually lands in those institutional political spaces,

in those chambers, in those halls. We want to make sure that the people who are making decisions on our behalf, casting those votes, are people who share our interests and are able to help bring home our collective work and those efforts.

If someone was asking me about how to prepare for a challenging campaign, I would say it is about being able to hold your community close, and those relationships that matter close. That was the countermeasure on social media. It wasn't that you were going to stop people from the hateful messages, but that you're going to have enough people saying something that is accurate, that is about their experience, about the reasons that they have decided to support you. And that is something that you want people to be able to see, to make up their minds and decisions. Folks I didn't even know were taking down those posters, were challenging people who they heard spreading these lies in the community circles, the mom groups that they were a part of defending a fair race. I think this kind of commitment to truth and justice is one of the incredible characteristics of the community that I eventually came to represent.

Ausma Malik, Toronto District School Board Trustee
(2014–2018) and Toronto City Council candidate

21. Dealing with Negative Voices

Criticism

In politics, if you're outspoken and take strong positions on issues, you will face opposition. Debate is the crux of a healthy democracy. Defending and contrasting ideas help to air potential courses of action prior to deciding on a path.

Criticism is different from opposition. Criticism is more about disapproval rather than debate. Often it can be, or at least feels, very personal.

Once I went to shake a man's hand, and he practically spit at me, saying: "I would never shake your hand. Politicians are despicable."

As a new candidate I answered that I wasn't "a politician" but rather a neighbour who cared about the community. He wasn't having any of it. It stung.

Being a public figure attracts attention, both good and bad. Some people are thrilled to have you attend events and join protests. Some people are shy to speak with you because they feel in awe. I remember once after I was elected, a constituent came to my community office and was shocked that he could walk right in and meet with me. He told me that where he came from you would never have access to a politician. The closest you might get would be to see them ride by in a black chauffeured limo. They were always at a distance and protected.

I worked hard to be accessible and open to the community. My predecessor MP had an office up in a high-rise. I made sure my office was at street level and had a welcoming exterior.

Many people believe that as a public figure, politicians are fair game and, because of this, the public can be and has a right to be openly critical. I've faced a barrage of it, and it was often very personal. I've been told that I look much older in person, that my hair was too light, too dark, my voice was too high or too low, that I didn't look good in a particular colour. When I ran for the leadership of the NDP I was told more than once that the party had tried a woman leader and it hadn't worked out. Many times, I was told to switch to the Liberal Party, and I might have a chance at getting elected. Why was I wasting my time with the NDP?

Women especially face a lot of comment and criticism about their appearance. When criticism slithers into racism, transphobia, sexism, ageism, ableism, or other discriminatory behaviours, you need to take action, which I've discussed elsewhere (see chapters 19 and 20, Eyes Wide Open and Holding the Community Close to Fight Racism). Here, I am talking about other criticism that may be rooted in discriminatory attitudes but is communicated as criticism.

How Do You Handle Criticism?

As a young person I was painfully sensitive. I didn't wait for someone to criticize me, I pre-emptively criticized myself. Maybe I thought, mistakenly, this was a way of exerting control. A tone of voice or a certain glance could send me home in tears. Now I chalk this up to childhood and teenage sensitivity, but I do remember the sting of it. I thought that being "nice" would help me get what I wanted. I soon found that depending on others was less successful than just being powerful and acting decisively.

Fortunately, experience taught me to handle criticism more constructively. Here are some tips that I have found useful.

1. Learn to like yourself. You're not perfect. No one is.
2. Surround yourself with people who support you and nourish you.
3. Accept compliments. False modesty, qualifiers, rebuttals just weaken you.

4. Learn to let in the good feedback. When you've done well, accept it. Really feel that positivity.

5. Risk change. Embrace the fear. So much of your growing comes from trying something new that perhaps you fear most. If you are terrified of public speaking, force yourself into situations when you must perform. It gets easier and the grip of fear lessens.

6. Recognize what triggers you. Sometimes patterns from childhood are buried deep in us but can surface unexpectedly. Identifying these patterns and taking the power out of them can help you move on.

7. Surround yourself with people who will tell you the truth. False compliments and forced enthusiasm prevent you from course correcting if you're on the wrong track.

8. Learn to let in the negative feedback that can help you. Someone tells you that your speech to a large crowd outside didn't have much impact. Yes, the comment could have been kinder. But consider they might have a point. What could you change to have more impact? Maybe you need to slow down when speaking outside to a big crowd. Slow down and pause for impact. Learn to modulate your voice. That's helpful.

9. Learn to accept you're not perfect. You're going to give the odd stinker of a speech. I used to be devasted when I knew I didn't do a great job. It was never for lack of trying. Sometimes I tried too hard. Learn from mistakes and do better next time.

10. Flip the negative to a positive. When I started to get stronger negative comments from my opponent's supporters, I knew I was getting to them. I was winning. Rather than taking any of it personally, it gave me a boost.

11. Know your strengths and weaknesses. If social media baffles you but you love meeting people face to face, then focus on that wonderful strength. If you like to be early for events rather than show up fashionably late, then do it even if sometimes you are asked to help set up the chairs.

12. Find strength in others. When I'm feeling beleaguered

and things aren't going my way, I meet up with my gang of women friends. They ground me and we laugh a lot. Then the negative comments lose their sting. I feel more powerful and happy.

Moving beyond the Voices in Our Heads

None of us has had an ideal life or has grown up in a perfect family. Some of us have faced trauma, hardship, or other experiences that have left a mark on us. We're all dealing with this in different ways.

During an election campaign, the pressures of the campaign can unearth emotions and patterns that threaten to trip you up. Try to be aware of these patterns, and have a strategy to weaken their power. Don't wait until an emotional eruption occurs in the middle of a campaign when you don't have the time or the mental space to deal with it. I'm no psychologist, but I have experienced my share of negative voices in my head, and I have developed some strategies that have worked for me.

Here are some of the personal behaviours that many of us have experienced, some ideas to neutralize them, and some goals to inspire you in laying down new healthy patterns.

Fear: Taking on new challenges can be a big step that can make you afraid. We all feel a bit nervous trying out new roles or new skills, but fear is something that can keep you up at night. You can feel a general anxiety and sense of dread that what you are trying is going to end badly. This fear can be paralyzing and prevent you from getting the campaign job done.

You can learn to neutralize debilitating fear and general anxiety—anticipating a media interview, speaking to a large crowd, or whatever it is that keeps you awake at night. First, think of how you would react to a small child if they told you they were terrified of nightmares. Give yourself a metaphoric big hug for comfort, whatever form that takes.

Dig down to help yourself define exactly what it is you are afraid of. Your team may be able to help with this by asking probing questions. Imagine the worst that could happen. Write it

down. Be as specific as possible. Is it tripping over a word, or forgetting someone's name, or is fumbling when verbally confronting an opponent?

There is an old children's story where the child who is afraid of nightmares wakes up in the night to see them. When looking more closely, the child sees the nightmares looking a bit ridiculous and notices that they themselves are afraid. They need comforting, which the child provides. In the morning, the nightmares go back in the nightmare bag, happy that they are no longer afraid. Have a close look at your fears.

Now determine exactly how you will either prevent or deal with the worst situation you can imagine. Maybe you need to do more preparation before a debate, or maybe you need a cheat sheet to remind you of all the names you need, or maybe you need to stand in front of a mirror and repeat your speech or you media points until they are second nature. Plan for ways to get you laughing more during the campaign, even at your opponent if they say something aggressive and preposterous. Maybe a close friend will be at the ready in case you get an extreme case of the jitters, and you need to tell someone so you can talk yourself down. Maybe they can get you laughing instead.

Imposter syndrome: It is surprising how many accomplished, talented, seemingly confident women suffer from imposter syndrome. We know it's irrational, but feel that somehow, we don't deserve our success, that we are imposters and will be found out. No number of degrees, credentials, or public success insulates from this.

Perfectionism: Perfectionism is linked to imposter syndrome. You feel you are not good enough, not perfect enough, that you are a fraud, you feel that you are not what people believe you are and that you need more experience or training, you need to keep improving to reach an impossible standard. This hamster wheel can prevent you from doing what you really want, and you might let opportunities pass you by.

The little voice in your head that criticizes incessantly is like some cranky person who sits on the sidelines and throws pot shots. That voice constantly questions your judgment and predicts failure.

Fear of failure: Fear of failure can be so great that when we—women—get offered an opportunity for which we are perfectly qualified, we often say we need to take another course or train more. (See also Part 1, Who Gets to Lead.)

Failure is a wonderful teacher. Every election I've lost taught me so much. Yes, it is painful, but better to try and fail than not to try. Treat imposter syndrome and perfectionism like childhood nightmares. Take a good look at them to see how ridiculous they are. Then take a good look at yourself and all you have accomplished, all that you are, and all that you can offer. Prepare, do the work, give your absolute best, then go for it. As famed folksinger Woody Guthrie said, "Take it easy but take it!"

Other destructive behaviours: In the heat of a campaign some negative behaviours can arise that undermine your confidence and the cohesion of your team. Your campaign is humming, you seem to be doing well, and you are getting lots of support. Creeping up the side of your head or, bang, right in front of you, you find yourself engaging in self-destructive behaviour. You criticize yourself, self-doubt is gnawing at your stomach, or you are taking risks that you personally set up in the middle of a campaign trip. Or, maybe, you pick a fight with a colleague, you criticize your team with unrealistic expectations, or you obstruct the work of the team, tripping up the entire campaign.

If this is a pattern that you have experienced in the past, expect a reoccurrence. These are voices telling you that you are not successful and that you don't deserve success. Don't waste time and energy on them in a campaign. Prepare yourself for success. Your team is happy with you, the volunteers are inspired, the voters are responding. Embrace it and consciously banish those shoelace-tying voices from your head to keep them far from

your behaviour. Think of a rocket taking off that leaves the booster behind. Say goodbye to those unnecessary voices. You no longer need them.

Successful You

Once you commit to the campaign, you need to focus on bringing your best self. Stabilize as many of the day-to-day details of your life as you can, and plan for the help you need. Bringing your best self also means bringing the most positive, collegial, and confident person you can be.

Be curious with voters and your campaign supporters. Enjoy the interpersonal connections you make by meeting so many people in a very short time. Find out what makes people tick as you knock on doors or chat at events and meetings. Some people fear or dislike small talk, but you can never go wrong asking people about themselves or their priorities. You can learn so much that is valuable in a campaign.

Take this incredible opportunity to help develop volunteers. They are investing their time and energy in your campaign. Invest some of your time finding out about their priorities and goals and help them develop a bigger analysis of politics.

There will be screw ups—your own and those from others. Take a deep breath and be calm and compassionate. Mistakes happen. Maybe they will make a great joke some day. When calamity strikes, your role is to de-escalate and be the calm at the centre of the storm.

Speaking of jokes, do your best to include humour and fun in the campaign. Make an effort to have a smile on your face and consider ways to boost spirits and reduce the tension of the long hours or negative interactions. Organizing an evening of food and music for supporters can give a real boost. Invite a comedian to entertain. It does take away from contacting voters, but it can motivate and de-stress activists and supporters. It builds community.

Throughout the campaign, remember to laugh. It's not life or death. It's just politics.

Part 5.
Campaigning

22. Tight Organization and Dedicated Volunteers

Once you are elected as the candidate for your party in your chosen electoral district, your number one job is to connect with voters and find your supporters. This isn't just a feel-good process. While speaking to a crowd is useful because it allows people to see you perform in public, perhaps with media coverage, what is most important is identifying your voters so that on election day you can encourage them to go and vote for you. This is the whole point of election campaigns: winning over voters and then getting them to vote.

×

Running an election campaign gives you the privilege of a direct engagement with the democratic process. Running as a progressive candidate makes you part of a movement for political change. A campaign involves so much, from canvassing, to fundraising, to data analysis of the canvass results, to answering emails, questionnaires and petitions, to pounding signs into the ground, to ensuring that every election rule is scrupulously followed. The candidate is the leader of the movement and the reason why people get involved and volunteer their time and money. Your inspiration, your motivation is what gets people involved. Your vision can create the winning strategy in which you (and your party, if there is one) are the linchpin.

Your job as the candidate needs to focus on being the face and voice of the campaign and trust that your team is running a tight

ship. You have chosen the best people you know to help you win this election. You have worked together to develop a strategy. Now you need to execute it. This section is not about how to run a campaign. That's the job of the campaign manager, not the candidate.

My Micromanaging Dream

The candidate does, however, need to respect the role of those on her team and not micromanage. This was a mistake I made early on in my first campaign. I was so used to running my life, being in control, organizing my schedule, writing my own speeches and answering emails, connecting with everyone directly. When I first ran, I realized I was in a tug of war, wanting to be included in every mundane decision, when I really needed to be out speaking with voters. I was getting exhausted trying to do my job as a candidate and everyone else's job.

Then one night I had a crazy dream. I was driving a car, and my close campaign team were the passengers. In the dream, I was clenching the steering wheel driving the car, but then I gradually and magically began to move through the car seat backward into the rear passenger seat. My manager was suddenly in the driver's seat, taking control of the wheel. I didn't feel conflicted, but instead I felt overwhelming relief. This tension had clearly been on my mind. When I woke up, this dream was so vivid, I realized I needed to make some changes, to trust my team and let them do their jobs. Of course, I wanted to be part of significant decisions, and some decisions were mine alone. But I didn't need to know how much the phones cost, or how the database worked. I didn't need to know what polls the canvassers were canvassing. I did need to have signoff on all public communications and key campaign decisions.

×

Get the very best team you can, put them in place, and trust them. That doesn't mean ignoring them. Check-in, get updates, but let

them do their jobs. Recognize them and build in some fun and some social time. Everyone needs to blow off some steam during a period of intense stress that is an election campaign. Eat meals together when the campaign office closes, or when you can find a few minutes. Create some unexpected fun. But don't micromanage. (See chapter 10, Building Your Team.)

Remember, you are challenging entrenched power and political privilege. You believe strongly in a better world. You are leading a movement for change in your community, and it starts with your campaign. Just as you need to respect your core team, you also need to recognize, respect, and inspire your volunteers.

You've got a good start on your volunteer recruiting (see chapter 11). Building in volunteer training is a great way to motivate. Canvass with new volunteers to get to know them and for them to get to know you and your approach (see chapter 25). When I've done this, they found it to be a confidence builder. They could hear me answer questions and sometimes say, "I don't know the answer to that, but I'll find out and get back to you" or "that's a municipal issue (I was running federally), but if you give me your email, I'll contact your councillor right now and put them in touch with you to see about that stop sign you want."

We had a volunteer recognition wall and included ways to help volunteers assume more responsibility and leadership. Learning everyone's name and stopping to chat is great. Volunteers want to know how they fit into the big picture. Tally their number of supporters, signs, donations, and let them see how they are contributing to the whole campaign.

On a big campaign, sometimes our volunteer team was so large I didn't get to meet everyone personally. I regret that. Volunteers are such a huge part of the democratic process.

Once your campaign is in full swing, it's a great sign that people are walking in off the street and volunteering. Welcome them, help them feel part of the team, take your more experienced canvassers and make them team leaders and trainers, build leadership and motivation. This is momentum, and you can feel it in a

winning campaign. There were times when the momentum was so great, the numbers so large, and we were all part of a wave of a winning campaign.

People volunteer for all kinds of reasons. If you lead a campaign that gives a diverse group of people fun, inspiration, new skills, the chance to build community, and to be part of something bigger, of building a better world, then win or lose you have achieved something important. Jennifer Hollett said it best:

> Taking the time to create a campaign that you can really be proud of, because that's all you have as a candidate, that's all you have, win or lose, is the campaign. That to me is my offering, which is what I created . . . I stand by the campaign, I stand by that work, I stand by all the people that we spoke to, I stand by all the people who came into this campaign for the first time and are now committed to politics in all its different forms, from working for the party, to working on other campaigns, to just being very active in issue driven campaigns. There's a training that happens, and something larger, I think, that really comes down to the candidate, as well as the campaign manager, for setting the tone and culture of a campaign.

LOVE YOUR CAMPAIGN

In my municipal campaign, I had a lot more agency and more of an organizing role than I did in my federal campaign. I really loved that kind of learning process and those pieces of the municipal campaign, organizing with people and figuring out strategy and so on. But in the federal campaign, there was something just so wonderful about handing over the campaign management to someone else

and just being the candidate. Every moment of my day from the moment I woke up until the moment my head hit the pillow was scheduled by my team. It was scheduled with things that I knew (because I trusted my team and my campaign manager) would make the most difference. It was something so unlike any experience I've had in life before because I'm usually the person who is directing and figuring things out. This time I didn't have to think about any of that. Instead I was just "doing" constantly and the things I was doing were the things that I was sup-posed do—that would make the biggest impact.

I definitely had moments where I was exhausted. A funny moment, at least in retrospect, was when my part-ner came into the campaign office. My campaign manager got one day off during the election, and it was his part-ner's fortieth birthday. Everyone else on the campaign got their days off or whatever, but I never got a day off. At this point, I was so exhausted. I had just been door knocking constantly and was not eating enough. And so my partner found me hidden underneath my desk in the office crying about wanting a day off . . .

I would say generally, it was stressful. I love door knocking, I love people, I love policy, and so, even though, the stress of the debates and that stuff, it was such a huge learning experience and such a huge honour. It's kind of daunting even to think about how many people are pour-ing their energy and time into getting you elected. And you have to step out and know: this isn't actually about me, this is about the movement. But it's still, it's just huge. It fills you with immense gratitude and humbleness real-izing how many people are dedicating their time to this project together.

Laurel Collins, MP, BC

23. Being the Best You

Women are constantly policed in terms of our bodies, and you know that doesn't stop in politics. I knew as a queer Black candidate who wasn't a size 6, my appearance would be judged more so than a white male candidate for instance. It was important for me to ensure that my appearance looked like one of a leader, but I also knew that I was not going to subscribe to respectability politics in a way that would compromise who I was. I presented myself as a leader would, in my eyes and my eyes only.

—*Jill Andrew, PhD, MPP, Ontario*

What does a candidate look like? Do you need a suit? pearls? heels? How about jeans and cowboy boots? What about tattoos? Makeup or none?

I used to be the kind of person who hated to be photographed. I ran from the camera, or I made sure I was the one taking the pictures. All this changes when you enter electoral politics. In a riding of one hundred thousand residents, many voters will never get the chance to speak with you no matter how hard you try to reach them. Social and various other media and journalism can help as a substitute for face-to-face communication. By the end of a campaign every voter should at least have seen your picture on a lawn or window sign, a leaflet, or an ad. Ideally each voter has connected with you in some fashion at least three times. At that point, they are likely to remember you.

Even if people don't get a chance to speak with you directly, they will form impressions of you. Party affiliation offers some impression. They think of you differently if you're running as a

New Democrat or a Conservative. Party affiliation gives voters a shorthand about your politics and the issues you care about. That party affiliation can be a positive or negative for voters depending on their own political views. Party affiliation, though, is not always a vote determinant. Some people might disagree with you on a particular issue but like and respect you as an individual. I've had social conservatives, fiscal conservatives, anarchists, and liberals vote for me based on personal connection of some kind.

Most people, though, will look at you and try to take a measure of you. I always felt they were asking themselves if they could trust me or not. You shouldn't try to change who you are. If you try to be someone you're not, you will just seem inauthentic. Think about the girls and young women who are looking at you as a role model. Your strong, confident self is a beacon for them to seek to follow a leadership path. Carry them with you.

My advice to candidates, whatever your gender or gender identity, is to be true to yourself but be the best you possible. What does that mean?

Clothes: Your clothes will be on public display. Let people see truth in advertising. If you love brightly coloured out-there fashions, then own it. Your distinct style helps define you. Some people will love your style, others won't. That's life. If you are the kind of person who would never wear a suit, don't wear one. If your uniform is sneakers, jeans, and t-shirts then wear that locally, and let the voters decide. In legislatures, business dress is pretty much required, but there's a spectrum. If you hate dresses and suits, don't wear them.

The general advice is to be comfortable while looking your best, whatever that means to you. There are long days in politics so wearing a skirt that pinches at the waist or jeans that really are too tight will wear you out. I was given the advice to look as though I was already elected so that people could easily picture me in parliament. So, when attending meetings or doing media interviews I often wore a suit jacket. That was sometimes paired with jeans or over a dress, or sometimes as a suit. I learned that my preference

was not to wear short dresses or skirts after being perched on a high stool for a media interview or clamouring up steps in an apartment building. Again, comfort is critical. Attending outdoor community events on a weekend I was usually in jeans, a t-shirt, and, if necessary, a light jacket. This is what I was comfortable in.

I did try to vary my clothes as much as possible. If you're attending ten events in a day and posting on social media for each one, you can have many photos of the same clothes. I looked for some variety of style and colour. This gives more freedom to candidates to play with different looks if they want. Even just changing a scarf can add some variety to the look of social media postings.

On a busy Saturday if I needed a car to travel to several events, I resorted to doing quick changes in the back seat. From a ribbon cutting to a rally, from heels to runners, from a Ukrainian parade to a Tibetan festival, I needed to be dressed appropriately. I might stop by a funeral home to pay respects then rush off to a school playground community fundraiser. Little changes help you dress appropriately and show respect for the occasion.

PEARLS, ANYONE?

Figure out how to just be yourself but in a way that respects people. It was so funny I had this picture for my sign, and I had pearls on and a shirt and a jacket, but it was cool. I liked the way I dressed for that campaign photo.

And (someone) said, why would you take a picture of yourself with pearls? You don't know who your constituents are, and I said, actually, I know who they are. They love it when I show up looking nice. Working-class people care; they want you to look the best that you can to show respect to a community where people work really hard to make a living. But there's a fine line between trying and being asked to change who you are.

Alejandra Bravo, Toronto City Council
and federal candidate

Shoes: Here comfort really is primary. Politics can be tough enough without having sore feet. If you love heels and you have a great pair that don't hurt your feet, then go for it. For canvassing or casual events, I would wear comfy shoes that I could run in if necessary. When canvassing, you need to keep on the move. Being able to sprint up stairs is an asset. You don't need to wear heels ever if that's not comfortable footwear for you.

Makeup: I used to think that first thing in the morning when I looked in the mirror, I looked fine with no need for makeup. Then midmorning, someone inevitably would ask if I was feeling unwell. So, I got in the habit of wearing makeup. Over the years I learned how to apply a light touch that looked best on me. That's what I grew comfortable with. If you never have worn makeup and don't want to wear it, then don't. It will change your appearance and you might not like it. It's also a chunk of time every morning that you may not want to spare.

However, given that so much of our communication is mediated via Zoom or some other media device, even people who don't usually wear makeup tend to add a touch-up. The camera can make you look washed out and tired. Try some tests and see what works for you.

BE WHO YOU ARE

It was clear that I was not going to change. But before I ran for the first time I had friends, feminist friends, who said "Hey Manon, you have to get rid of your moustache, you're going to suffer, people are mean"; and I thought about it but I said no: for thirty years I've been saying to women, be who you are, you are beautiful as you are, you are strong like that, don't let the beauty industry define you. Be who you are. For me, being marginal is the story of my life, I'm a lesbian, butch, with long hair, politics wasn't going to radically change me. Except that I got rid of my

torn blue jeans. At the beginning, I did wear some scarves that seemed a bit more feminine. I did try to present so that when I knocked on a door it would not be completely closed, but nothing radical or marked. Once I got elected. I ditched the scarves. I wear jackets, but I always did that. I like them. And it took about three years before people no longer talked about my moustache,

It wasn't important because the marginalized people, who were excluded, the ones you never see in politics, these people, were very happy to see themselves in a politician. That was always my courage. My problem is that there aren't enough people like me at the National Assembly because I'm different because there is a certain uniformity in the people who present themselves in politics, but we are shaking things up, we are capable of being different and intelligent, and now there's more diversity not just culturally.

Manon Massé, députée à l'Assemblée
nationale du Québec

Hair: Decide on a hairstyle and keep it for the duration of the campaign. If you have long hair in all your photos and halfway through the campaign you decide to cut it off, voters won't recognize you. Decide on a look and keep it. If you love your grey hair don't colour it mid-campaign. If you colour the grey or add some other colour and want to keep doing that, great. Just be consistent. Whatever your hairstyle choices, be sure voters can see your face.

Tattoos: One of the people on my staff was an artist and had a few beautiful tattoos. I hadn't really noticed at first but when we went to a meeting of seniors or with certain community groups, he always wore long sleeves. He felt that tattoos were not part of my image, and he wanted to respect that. While I don't have tattoos, I think that the world now gives much more latitude to people to be who they are.

If you have tattoos, there are many people that will love the artistry. Some artwork is definitely in the eye of the beholder, so use your judgment. A few people might not like them, but would they ever be your supporters? While I do believe that we need to respect the diversity of opinions in the community, this can't come at the expense of hiding who we are. Your aesthetic choices are part of who you are. Let the voters decide.

Jewellery: No, you don't need to wear a string of pearls. These are a favourite of women politicians—I have worn them myself—but some see them as too conservative. If you like them, wear them. However, flashing expensive jewellery does not create the kind of image you likely want to offer. If you enjoy wearing decoration, then go ahead. Remember that photos are taken of people in public life. If your wild earrings are distracting during a media interview, your message might get lost in the jangle. Keep the focus on you and what you are saying.

Photos: A headshot with good lighting is essential for your campaign. There will be at least one campaign photo for your lawn or window signs and other publications. This photo becomes your trademark and for it you need to be the best possible you, the most welcoming and effective you that voters need to see. Try to make eye contact in your photo. Find a good photographer and take lots of pictures. For many voters, this photo is the only thing they will know about you, so make a great impression.

Social media: Find the best social media person you can to be part of your team. You want a great video introducing you to the community, with your personality, your values, and your motivation for running shining through. You need to provide regular content to keep your followers attuned to your work. Think about your appearance and how you want to present yourself to the community. Are you edgy and fashion forward or traditional? Casual or formal? Your appearance is part of your brand and part

of your politics. Whatever you decide it should be a conscious choice. (See also chapter 17, Social Media.)

×

While everyone can be a bit self-conscious about their appearance, it seems to particularly bother women. No question there are stereotypes about women that men in politics often completely escape. I found I quickly got over my self-consciousness and soon found I was settled into what I wanted to present, the self that I felt was authentic and made me comfortable. Now, I willingly seek out a camera to record what I do or to convey significant messages. We need to not only hear women's voices but to see their faces too.

24. Identifying Supporters— The Point of the Campaign

You can meet people by attending events and by having your campaign hold events that the community can attend. Supporters can hold house parties where they invite some neighbours, and you attend to introduce yourself and ask for support. These events can be very useful if you have volunteers with you to get people's contact information. Some of these attendees you may ask to volunteer for you, or donate to your campaign, and you want to be able to contact them again to encourage them to vote for you.

×

Here are some other approaches to identifying voters.

Your nomination supporters: Start with the people you know. Usually when you are first nominated, election day is months or weeks away. All those who are members of your party who live in your riding, even if they supported another candidate for the nomination, are likely supporters. Joining a political party is a big step for most people and if they joined, they are very likely to vote for that party. To win the nomination you signed up new members from your contacts in the community. If you got them to join the party, they will likely stick with you. (See also chapter 9, Winning the Nomination.)

Your connections: Since most people don't join political parties, many other people you know in the community are possible

supporters, willing to vote for you. Build on the connections you have made by living or working in your community. If you are a parent, you have likely met many other parents from daycare and school, as well as from cultural or sports activities. If you've spoken with parents on the soccer pitch or school concert, when you come knocking at their door, they will feel they have a good sense of who you are and often will give their support. The dog park, the running group, the community kitchen, the student union, the residents' association, your union, your employer, any community you are connected with, can mean potential supporters.

Championing issues: If you are a community champion on a given issue that has broad community support, reach out to others who hold the same views. For example, if you are a high-profile tenants' champion who has been in the forefront of fighting tenant evictions, why not put that issue to the voters of your community with a Facebook site, a petition, tweets, or Instagram posts, and link to your election campaign asking for support. People bring different backgrounds to electoral politics, but knowing someone through an issue campaign, trusting where they stand on that issue, can be a powerful motivator for electoral support. However, don't assume they will support you at the ballot box. You will only find out if you or your team asks directly for their vote.

Everyone who signs your online petition, attends your events, or likes your Instagram is a potential supporter. If they live in your riding, they can vote for you. But if they don't, they can still support you on social media, financially, or by volunteering. Building your online and mainstream media profile lets more people know about you and increases your chances of winning their support. Your campaign can be an invitation for people to become more engaged in the democratic process.

Online ads and surveys: Targeting Facebook ads by postal code and asking a simple question about you or an issue can both give you data about how much support there is and identify where that

support is located. Like most things online, you need to follow up and verify in person.

Self-identified: Some people will take the initiative to contact your campaign to express support, which is wonderful. If your campaign is showing momentum, self-identifying supporters increase, and it's a great feeling for the campaign (see chapter 26, Building Momentum). People walk in and ask for a sign, or a bigger sign, they write cheques, they offer to help, and they need to be encouraged by you and your team. These folks need to be welcomed with open arms and big smiles. Can they pull together a few neighbours to encourage them to support you? Would they like to volunteer some time to knock on doors? Don't push them. Not everyone is ready for the next step of political involvement. Each person goes at their own pace.

Canvassing: There are many ways of connecting with voters but "cold canvassing," going door to door and speaking with voters can be a powerful way to identify yourself to voters and to gauge whether they will support you. This is an opportunity to look a voter in the eye and make a connection with them. Treat it seriously. See chapter 25 on canvassing.

Phone canvassing: Calling people during an election campaign is tough work. Some people prefer it because they have mobility issues or because they don't want to engage strangers face to face. I find phone canvassing more difficult because, as with social media, people can be rude when they don't have to look you in the eyes. It's also become harder to reach people by phone because of crazy work schedules, the move to cell phones, and the tendency of many people to not answer calls from people they don't know. But phoning can be valuable, especially in addition to in-person canvassing to verify supporters. While most calls never get answered, the ones that do can be a valuable addition to the campaign.

Parties and candidates are always finding new ways to identify voters. However, it is mainly through the canvassing process, both in person and by phone, you will know who your voters are. An intention is not a vote. On election day, it is those people who say they will support you that you want to ensure get to the polls to vote. Every vote matters.

25. Canvassing

I mean, you have to love it. If you don't want to talk to people, then don't be a candidate.

— *Alejandra Bravo, Toronto City Council*
and federal candidate

"What a Way to Earn a Living!"
Knocking on thousands of doors, combined with social media, can be a powerful way of reaching the community, and it's one of the best ways to connect with voters. They get to meet you and you listen to their concerns.

Canvassing is not for everyone. You do need to genuinely enjoy meeting people or it can be exhausting. A phony veneer of likeability will wear thin. At every doorstep, with each person you look in the eye, whose issues you listen to, or whose critique you acknowledge, you are building trust. If people feel you are authentic whether or not they agree with everything you stand for, they may trust your judgment to do the right thing.

A voter once said to me: "What a hell of a way to earn a living; no thanks." But I think it is a great way to earn a living. Behind every door you knock on is a life, a story, and a potential supporter. Meeting strangers this way can be heavy emotional work, but it can also be exhilarating. You can never prejudge people by where they live, how they look, how they voted in the past. People are interested in so many different issues and topics.

Looking directly at people, shaking their hand (in non-pandemic times), presenting a friendly approach at the door, being succinct in introducing yourself can all make a difference.

Canvassing Strategy

Your goal with canvassing is to meet as many voters as possible and find out if they will or might support you at election time. You don't have to wait till an election is called or even till you are the candidate. You can canvass on an issue and gauge where you are likely to find support or just to learn more about your community.

While in theory you want to canvass the entire community where you are running, it makes sense to set as a priority the neighbourhoods that are most likely to support you, especially if time is short. If your base is tenants, focus on the tenants. Any time of day or evening, any season of the year can be productive. In the day you might get more seniors, stay at home parents, shift workers, and those who work from home. People eat their evening meal at a variety of times so don't assume you can't canvass at 6:00 p.m. for example. People will tell you if they are too busy to speak with you.

The first election I won was in January after two long months of canvassing in the bitter cold, in many dark evenings. We had very dedicated volunteers. People are often kind and offer you a warm foyer while you're speaking with them. Occasionally I would break my rule about not going into people's homes because I was freezing. I remember people saying how impressed they were that I was out in the bitter cold (or the blazing heat of summer).

To effectively reach every household, your campaign needs an army of volunteers.

I liked to canvass with new volunteers. Going door to door they hear you speaking with voters, learn your stand on issues, and get your speaking style and judgment. They would start off just documenting each interaction. After a conversation I would ask them what they heard and how they expected the person to vote. It was solid training for them. And very helpful for me to have another set of eyes and ears to assess each interaction. This on-the-job training was important for us to build a cadre of committed and skilled canvass volunteers.

Some volunteers who were nervous about canvassing, once they went out with me a couple of times, could lead their own

teams. This training and greater responsibility was a growth opportunity for volunteers.

Recording Results

Each riding is broken down into polls, from neighbourhoods of a few urban streets to vast territories in rural or northern areas. Elections Canada gives each registered local campaign a list of all the names and addresses in the area. Often this list needs updating but is generally pretty accurate. As you canvass from house to house, you are trying to gauge your support. Will they vote for you or not? You record the results of your interaction at each door with each person. But you can find out much more. What are their interests, priorities, issues? Have they voted for another party in the past but are now disaffected? Are they diehard supporters of another party and unlikely to ever change? Each door is a mystery, and I love discovering what's behind it.

Some candidates like to have a volunteer at their side to record the results of interactions with each voter. Some like to record the results themselves. You will discover what works best for you. When you and your volunteers finish a canvass, you add up where the poll lands. How many people say they will vote for you? How many say they never will. How many are undecided but leaning to another party or leaning to your party. How many will take a sign? What was the reception to your leaflet? Did you get more people to engage with your social media? All this information helps you see how your campaign is progressing and is crucial as you head to election day

Pre-election Canvassing

Long before an official election campaign, I would go door to door asking people about their priorities. It was a chance to meet people who might never come to a public meeting or contact my office. I had to go to them. You can also canvass on an issue as a concerned resident. Is there a quarry planned in your rural area? Are there dangerous chemicals being shipped by rail through your community? Is there a plan to close a neighbourhood swimming

pool? Wherever you stand on community issues, there will be people who agree. Try to get to know them. Will they sign your petition? Will they attend your event? The more they are invested in your leadership, the more likely they will stick with you in an election.

When you engage with people you need a quick verbal intro of yourself with a bit of context, such as "Good morning. I'm Peggy Nash, I live just around the corner from you, and I'm the Federal NDP candidate trying to get more funding for our city, or more affordable housing, or an effective climate plan," or whatever the issues are. Here is where you can use your public narrative to shape your self introduction (chapter 15). Beginning a conversation with an issue that might spark discussion, something that had been in the news, or a local community concern is a way to begin to get to know people.

Pets were often a conversation starter. Most dogs are extroverts, and they would often break the ice. A pet might lead to discussing isolated seniors and the importance of companionship. A dog rescued from northern Ontario might segue to a conversation about boil water advisories and Indigenous rights. A number of women, probably because they were busy, would say "I'm not interested in politics. Let me get my husband (or son or brother)." Before they disappeared, I would try to engage them on an issue: their kids, their garden, the neighbourhood—anything to begin a conversation, hoping to find out about their lives, their priorities, and letting them know something about me.

You can tailor issues to the person you are meeting. If a parent with young kids comes to the door you can discuss childcare; with a senior, pensions; or whatever concerns the person raises that you are meeting. This is not disingenuous. Everything you say must be true, but people have different needs and goals. Highlight what might appeal to the person you are meeting

Election Canvassing
While you always want to know the views of voters and their election priorities, during the actual election campaign things speed

up. You need to quickly determine where they fall on the election spectrum. Try to find out who you are speaking with and try to verify the address and phone number or email with them. Identify yourself, pass them your leaflet and ask if they have considered how they will vote in the next election.

Speed: Closer to the election, I ask first if they think they'll be voting and, if so, can I count on their vote. I ask this first to avoid a long conversation with someone who can't support you. Maybe they live in another area, maybe they are not a citizen, or maybe they don't vote for religious or other reasons. Some people can volunteer or donate even if they can't vote. If they support you, invite them to get involved. Perhaps they'll vote for you in the future.

Most important question: The second question is the most important. If they live in your area and they vote, will they support you? The people who right away say yes or no make your work easier. They will or won't support you. Some people are clear that they will never vote for you. Others enthuse about you and urge you to move on since their vote is solid. Each candidate will start off with some guaranteed supporters and non-supporters. Record their voting intention and quickly move on.

Most people are somewhere in between since they may genuinely be undecided, especially if you are a new candidate or are in a swing riding that is highly competitive and changes party preference. Early in a campaign, especially before an election has been called, most people haven't thought about their vote. Those voters who are both your target voters *and* who are genuinely undecided are the people you especially want to contact. Can you win their support by election day?

Many people are a bit cagey about their intentions. There are those who may be supporting a different candidate but want to ask you questions and debate you at the doorstep. I learned quickly not to engage in these individual debates. Sometimes people are genuine and have detailed policy questions. Tell them

you'd be delighted to follow up by phone or email. Then get their contact information and be sure to follow up personally or with a volunteer.

Especially if they seem to be voting for another party, be polite but don't get dragged into a long debate. This won't change their mind. Record their indecision, but if you have a gut feeling about their voting intentions, note it and perhaps a volunteer can canvass them again to verify. Organizers must move the candidate along to get to as many people as possible. Think about the people you haven't yet met and keep moving.

Have resources ready: While canvassing, you will meet people living in desperate conditions, and it's gut wrenching. You can't fix their concerns there at the doorstep. I have occasionally spent more time with seniors who were clearly isolated and lonely, people with mental health concerns, or those with serious housing issues like mould, bedbugs, or imminent eviction. Usually, though, I can't stay long, and this feels like a betrayal. I always carry information about resources and will try to connect people with help. When it's a crisis, often the city councillor's office would agree to assist. And I remind myself that this is why I am working for change.

Friendliness is not support: In a multiparty system it's important not to confuse friendliness with support. Once I had a great conversation with a woman who had a sign on her lawn in support of war resisters, that is people in the US who refused to fight in the Iraq war and had come to Canada seeking refugee status. I had openly supported the war resisters at news conferences and local events. When I saw the lawn sign, I prepared for a friendly conversation. The woman who answered the door was interested in international issues, had engaged in international aid work, and did indeed support the war resisters.

I finished my conversation with her by asking "Can I count on your vote?" I was surprised when her eyes suddenly looked away and she hedged. I knew right away she was not voting for me. I

questioned her, knowing that my main election opponent was a candidate who had not been very vocal on the issue. "Well, I think they will do the right thing," was her response. I had to assume that she always voted for the same party and wasn't about to change. She was right though. My opponent won and later brought in a bill to support the war resisters. But the lesson here is to clearly verify if the person you are talking to is supporting you.

Some people tell you they don't know who they will vote for, and they genuinely don't know. If someone says they don't know a day or two before the election, likely they are voting for someone else, but they don't want to say so to your face. Move on to another voter.

Respect

I recommend you don't disparage an opponent. However, you can and should contrast your stand with that of your opponents, as a reason why people should vote for you. If you support increasing taxes on the 0.1 per cent and your opponent doesn't, make that very clear.

You will meet people who have firm beliefs the opposite of your own. I remember a woman at the door telling me that she liked me, but she was concerned that the NDP was too close to unions, which she didn't like. I had to tell her that my background was as a union activist and negotiator. I thought better to be truthful and lose the vote than pretend I was something I wasn't.

Respecting opposing opinions and beliefs can lead to positive outcomes. A woman told me at the door that I wasn't going to like her views, so best not to discuss. I asked her to tell me, and she went on to talk about the sanctity of life, and I realized she was against abortion. I am firmly in favour of a woman's right to choose to have an abortion if she wishes, but I told this woman that I understood how deeply she felt about the issue, and I respected her choice. She visibly relaxed and we spoke about other concerns she raised. I left feeling that we had a good chat but that she was not a supporter. I was surprised a few days later to pass by the house and see one of my signs on the front lawn. Clearly, she felt

the same way as I had about our encounter. I found her support inspiring and wondered what I would do if the shoe were on the other foot.

Knowing the Issues

You will quickly find that you already know most of what people are interested in discussing at the doorstep. A politician is a generalist. You are not expected to know everything about everything. Relax and try to find out about the person at the door rather than reciting your party's policy book. Occasionally an issue will arise that you are unsure of. Ask for the contact information of the person and promise to get back to them and do! Speaking with so many neighbours you will become an expert in their issues and concerns. When speaking in the media or during a debate you can draw on these concerns of residents from your conversations and speak with authority about what you have heard.

Bring Your Sense of Humour

Canvassing is exhausting work, mentally and physically. Most people are very pleasant, but some will say outrageous things to you. They don't like your hair, they hate all politicians, you're too young or old. When I asked one man how he was voting, he asked me in reply how often I changed my underwear. I guess he was saying his vote was his private business. Speaking of which I've had people answer their door in their underwear, or even less. You really can't take any of it personally, and it helps to have a good sense of humour.

> ***Ball-Cap guy***: Early one summer evening my canvassing partner Bev and I were canvassing along a residential street of small single-family homes, and I headed to a house where a guy in a ball cap was sitting on his front porch just starting into a beer. I trotted up his short walkway with my hand extended: "Hi, I'm Peggy Nash. "
>
> "I know who you are," he grumbled and started to turn away.

His hostility was clear. But there was something humorous in his hostility. Maybe it was the angle of the ball cap or the Molson's Ex in his hand. So, with a big smile I said: "So can I count on your vote?"

"Whaddya think, I got a bump on my head?" he looked astonished.

Out shot my hand again, and with a big smile I said, "Come on, I know you're warming to me." He had to laugh and did shake my hand. Clearly, he was not going to be a supporter. But rather than get down or irritated, Bev and I laughed about that guy for some time after. He probably laughed about us too.

CANVASS WITH INTENTION

The process of campaigning isn't just about whether you end up on the ballot or whether you win, but it's an opportunity to invite other people to take action. One of my most memorable experiences was going to a door and finding this young woman, and I gave her my spiel. She said I'm into that. She was a young Black woman. She said nobody's ever invited me to do anything like this. And I said, well, I'm inviting you, let's go . . . and she came out and started canvassing with me.

Everything you'll need to learn about people you learn at the door. You're exercising a particular kind of leadership that creates all kinds of bridges for people to think and it challenges their assumptions. And the only way to do that in a meaningful way is to be yourself, to not bow to people's advice about how to change yourself, to not dwell on how you look or how you sound, whether your voice is too high or you aren't imposing. Just be your true self. That's the person that inspires trust in people.

Try to get one person assigned to you as a canvass handler. That person should be a comfort to you, someone you feel comfortable with, that you can show your needs

to—I have to go to the bathroom, I'm tired, I'm having a
bad day, someone has been aggressive at the door . . .
You can have a laugh. Understand the strategy—why it is
that you're hitting different doors so that you can figure
out better what role you're playing and what message
you're delivering. Otherwise it just feels like a senseless
repetitive thing. Do it with intention. Understand the rid-
ing or the wards, understand the campaign voter contact
objective. Don't think that your only job is to be fabulous.
You're actually playing an important role in a team effort.
I learned how to speak Portuguese fluently to run in this
riding the best I could . . . and that's a long-term canvass-
ing effort.

> Alejandra Bravo, Toronto City Council
> and federal candidate

Tips for Canvassing

1. Clearly identify yourself: Have a "discussion prompt"
 document with your name and smiling face on it to hold up
 at the door. Ensure your volunteers are also identified with
 your buttons or t-shirts or some other swag. You don't want
 your team to be confused for any other campaigners.
2. Nail your presentation: You may only have fifteen seconds
 to identify yourself and your purpose at the doorstep. Make
 each word count. Get your name out clearly.
3. Canvass with a buddy: It's always better to canvass with at
 least one other person. If your campaign can afford to pay for
 a dedicated canvasser who can accompany you, help your
 memory, and cheer you up, it's worth it.
4. Canvassing as a training opportunity: Whenever possible,
 invite new volunteers to join you in canvassing.
5. Faster is better: spending twenty minutes with one voter
 means ten voters you may not get to meet. Every vote counts.
6. Canvass with a team: Canvassing is the most important
 volunteer activity for your campaign. It can be daunting to

look up at a thirty-storey high-rise building that you need to canvass—start at the top and work down. A team can blast through quickly, finding out who is home and who wants to speak with you. In Toronto I found that having a multilingual team meant that we were prepared for those who were not comfortable speaking in English.

7. Canvassing alone: If the choice is to canvass on your own or not canvass, then definitely canvass on your own, but not in buildings. I once had someone in a high-rise threaten to punch me out. He didn't. More common is someone insisting you come in and visit. You can't.

8. Be respectful but firm at the door. Do not get into a debate. It just drains your time.

9. Remember to ask: Will they vote for you during the election? Look them right in the eye when you ask this last question. Many people will say they are unsure or it's too early. But their face can be a giveaway.

10. Also ask: When you find supporters, thank them for the support but then ask them to take a sign. If they already have a sign, perhaps they would like to come to an event you're holding. Perhaps they would like to volunteer. Gauge their comfort level. Indicating support is just the first step along a continuum of political engagement. Invite them to take another step.

11. Be cautious in your recording of support. Friendly conversation doesn't equal a vote.

12. Try to have fun: Canvassing is a huge part of the candidate's job during the campaign. It's important and serious but try to make it as much fun as possible. A sense of humour is a great companion during a canvass.

YOU'RE NOT THE HELP, SO WHO ARE YOU?

I remember canvassing for the first time with a dear friend who is also Black. Sometimes when we knocked at a door,

we would see the drapes close and hear the door lock. And I thought, wow, there are neighbourhoods where people don't lock their doors? Because in the neighbourhoods I've grown up in for the most part people locked their doors. Upon reflection, we realized, we needed to identify ourselves immediately when canvassing. So from then on we had literature taped on the back of our clipboards with the visibly recognizable leader of the party so people knew we were legitimate. Many people do not realize the taxing emotional labour that comes from having to decode people's discrimination and the impact it can have on ones physical and mental health.

Another time I was canvassing with a wonderful White young man who said to me "In this neck of the woods, if you had a vacuum, you'd get more reception." I didn't understand till he broke it down for me. He said they're probably wondering who the hell is this. It's not the help because they don't have any tools with them, then who are you?

So there was that side of canvassing but then there was also the beautiful side of knocking on a door and having a wonderful conversation with someone and that positive experience would take me skipping through the day.

Dr. Jill Andrew, PhD, MPP, Ontario

26. Building Momentum

You can feel it at the doorstep. People you canvassed months back who were noncommittal are now enthusiastic. You get stopped on the street and people want to just say hi. Children ask to get a photo with you. Your signs are flying out of the campaign office, and you need to order more. Donations are flowing in.

This is momentum.

Heading into the final part of the campaign, the last two weeks or so, you feel buoyed by it, and sometimes it carries you across the finish line to victory.

As a candidate, though, you also know when the momentum isn't with you. People avert their eyes at the doorstep. You pass houses where you are positive your campaign sign was there last week. In high school debates, the cheers go to another candidate. This is a terrible feeling that you just have to endure. I have felt this creeping dread going into election day. I have learned to protect myself so that it doesn't become overwhelming. If you think you're going to lose a campaign that you desperately want to win, it's a terrible feeling. Prepare ahead of time to plan for election day so that you are getting the support you need.

Things can turn around quickly—either in your favour or against it. Your campaign team is responsible for managing your campaign to maximize the momentum when you need it.

Maximizing Momentum

Signs: Signs are a good indicator. When I first ran, my team had a strategy of blasting out of the campaign gate with as many campaign signs with my picture as possible. They wanted to send the message that there was a new candidate who had momentum

right from the start. It worked. We were immediately part of the conversation and, while I didn't beat the incumbent the first try in that election, it was fairly close.

We've had a variety of sign strategies to show momentum. Normally a campaign wants to increase the number of signs as the campaign progresses. You can upscale signs from small to large, you can add "toppers" to a sign with an important campaign closing message. In an election when fighting for a better deal for cities was a key issue, we topped my signs with "Fighter for Toronto." In one campaign where rail safety was an issue, we topped signs with "Clean Trains Now." Anything that catches people's eye as new can help build momentum.

Endorsements: Endorsements can be important early in a campaign to signal who is behind you. This helps build support. However late in the campaign some important endorsements can swing people over to your side. In an election, former UN Ambassador Stephen Lewis endorsed me. We put a picture of him and me on the cover of one of my leaflets. As I went door to door, I led by handing out this leaflet saying I'm so thrilled to have Stephen Lewis's endorsement. I remember one woman saying: "I don't know you, but I know who he is. And if you've got his support, then you've got my support." Wow, that was impactful.

Endorsements don't need to be high-profile people. A local businessperson, residents' association chair, or community leader can be very meaningful in a neighbourhood. Think strategically about who and when to profile endorsers to maximize their impact. In the closing days of a campaign, an influential endorser can signal that the community is turning your way and sway undecided voters at the last minute.

Young activists: Young activists can be a powerful force in a campaign if they are motivated to support you. Their excitement and presence generate energy that can persuade their parents and grandparents. Never underestimate the power of a swarm of kids

with your signs, pulsing down the main street of a neighbourhood on a Saturday morning.

Media: When the media start to assign reporters to cover your campaign you know you are in a tight race. Sometimes a journalist will shadow you while you canvass door to door. Sometimes they will do a profile or invite you more frequently to comment on stories of the day. When you start to get more media attention, you may have momentum.

Debates: Most campaign managers believe that local debates do not add momentum to the campaign. I agree that many who attend local debates are already committed to their candidate. However, I have knocked on doors where people have told me that they were undecided until the debate but were then voting for me. When you have momentum though, you can feel it during local community debates. You are warmly received when you arrive and get more applause and cheers for your comments. I looked forward to debates in schools during an election because usually the NDP platform was the most student friendly. However, I remember in one losing campaign, an opponent got the most cheers, no matter what I said. That was one of my clues that things were not going well. See chapter 27 on debating.

In a campaign when you have momentum you can feel it, It buoys you along to the finish line and is a wonderful experience. If it happens, thank your campaign team, thank your leader, and, whatever the outcome, understand its importance.

SIGNS SIGNS SIGNS!

Campaign signs are not allowed on public property, only on private property. Our ground game is what got us the signs. What helped with name recognition was knocking on doors. We started in May, June of 2018 shortly after the provincial election. Every single day, four to five hours a day we knocked on, I would say, at least 20,000 doors.

There are 30,000 households in Wards one and five. So Paul and I ran as a team in Brampton and we personally knocked on almost all of those doors. We also had a large number of volunteers who helped get to the doors we couldn't get to personally.

The night that we were allowed to put up signs, we launched midnight madness! It is called midnight madness because as soon as we were allowed, at midnight, we had a team go and put up signs at as many identified sign locations as possible. At that point we had knocked on a significant number of doors and identified hundreds sign locations . . . and that certainly put our name out there when people woke up in the morning . . .

Towards the last few weeks of the campaign, it was just an all out sign war. We had opposition candidates taking our signs down, stealing our stakes. People were moving our signs to different locations, so we would get in trouble. It was just a dog's breakfast with signs in Brampton.

Rowena Santos, Regional Councillor, Ontario

I do think it matters where your signs go. People know their neighbours, so if your neighbour has a sign with my name on it, they know that that person supports you. I think that matters more than people give it credit.

Jessica Bell, MPP, Ontario

27. Debating

Public debate is an important part of the democratic process. It's where the community is able to hold candidates to account. So while debates may not be the most important part of the campaign they do matter.

Debates Matter
Leaders' debates can matter a great deal. Then prime minister John Turner looked very weak when Brian Mulroney told him "You had an option, sir," referring to when John Turner, as the new prime minister, had accepted a multitude of patronage appointments made by his predecessor Pierre Trudeau. Mulroney won. In 2011, Jack Layton went after then Liberal leader Michael Ignatieff for his poor attendance record in the House of Commons, with "most people when they don't show up for work, don't expect to get a promotion." This was devastating for Ignatieff and gave an immediate boost to the NDP national campaign as well as all our local campaigns.

You will be expected to debate your opponents. This can start during the nomination campaign but gets going in earnest during the main election. Some electoral districts might have one or two debates, but some have many. One campaign I was expected to debate nearly twenty times. It was insane.

Who Organizes Debates
Different organizations can arrange debates. The media might invite you to a debate with the other candidates from your district or from different districts on a given topic. For example, *Goldhawk Live*, a popular Ontario cable TV news show, would usually invite

the main candidates from each district for a debate. Online media organize debates, usually on a specific topic. In our district, each area residents' association was expected to organize a debate. Eventually, we told them that they had to come together to organize fewer larger debates. The big seniors' homes would organize debates and argue that their residents couldn't get out to attend other debates, so we needed to go to them. In addition, locally, there might be a debate for post secondary students on environmental issues or about housing. When the high schools in the province organized student votes, they would invite us in. I have attended dozens of debates.

Decided Voters

Most campaign organizers will tell you that the people who show up for community debates have often already decided, and they attend to support their candidate. Organizers complain that debates take candidate away from their most important job, which is to meet voters, persuade them to support you, and to identify those voters.

It is true that lots of debate attendees have already made their decision. Some come to ask a specific question or highlight an issue. Some come to oppose a candidate they don't like. I know candidates who are so underwhelmed by debates, so confident in their own skills, and so convinced that debates don't sway votes, that they insist on going to debates alone so that their canvassers can keep contacting voters in their homes.

Pre-debate Nerves

No amount of reassurance that debates weren't really important calmed me down. I found debates, especially those right in the electoral district, very stressful. I'm not usually nervous about public speaking, but I would imagine beforehand that those in attendance wouldn't be welcoming to me, or worse that I would make a huge mistake and be humiliated. Surprisingly, after this build-up of fear, I often enjoyed the debates.

What to Expect

The rules can change depending on the decisions of the organizers. Sometimes people from the audience line up at a microphone to ask questions. Sometimes the questions are written and selected randomly from a hat. Sometimes the organizers preselect the questions.

You must be prepared for anything. Questions get flung at you on the total range of topics, from international relations to the nitty gritty details of environmental policy effectiveness to plans for reducing the federal debt.

Canvassing helps you field a variety of questions, even those outside your expertise. At the doorstep I was never shy about saying that I didn't have the answer to something off the top of my head but that I would get it. And I ensured I did. It helped me learn what the party's policy was on some issues. I think people understand that you don't know everything and most respect your honesty.

Tips for Debates

So, whether you love debates and relish the thought of skewering your opponents' bluster, or whether you are terrified of being treated like a duck in a carnival shooting gallery, here are some tips to help you do the best you can.

1. ***Limit the number of debates***, if possible: Yes, debates can be a wonderful part of democracy. They engage neighbours in democratic discussion; but, no, you don't have to attend dozens of them. Ask your campaign manager to meet with the other campaigns in your district to try and get agreement on the number of debates that are sensible for the area. This is a judgment call. Rather than show up for a group of ten cyclists who want the specifics of your cycling policy, perhaps, it's more useful to send them the policy and then encourage them to come to a larger meeting to ask a question about cycling to inform their neighbours. However, think

about accessibility. If seniors in assisted living, or newcomers in subsidized housing who likely can't travel far, want to hold a debate, try to show up. In general, encourage smaller, single-issue groups to pool with larger meetings. Your campaign manager should handle all this, not you. If voters get angry and say you're hiding from them, you may need to attend a smaller meeting so that you don't turn them off. But remember, every few hours you spend preparing for and attending debates is time you can't meet uncommitted voters at their homes.

2. ***Get as much information about the debate as possible***: This is another job for your manager. Don't delegate it to a junior person. You want to know:
 › Who is sponsoring the debate?
 › Which candidates are invited, and which have confirmed?
 › Who will be in the audience and how many people do they expect?
 › Where will the debate be held?
 › What will the room setup be?
 › What will the candidates set up be?
 › Will there be a podium? A microphone?
 › What is the timing of the debate? Who will chair the meeting?
 › Specifics: will there be opening and closing statements? Will there be questions from the front from the organizers? How many questions? How long for the answers? Will all candidates answer all questions?
 › How will audience questions be handled? Who will moderate that portion?
 › Will there be a hard start and stop time for the meeting?
 › Will signs and campaign literature be permitted outside the hall, at the registration area, in the debate hall?
 › Will there be any security to deal with disruptiveness (that is, if you expect any)?

You can see from these questions that I have attended some wild debates. Believe me, the more you know in advance, the better prepared your campaign team will be. I have been ambushed by media set up by my opponent, I've seen my main opponent saunter into the hall in a blaze of flashing photo-taking, all set up by the opposing campaign team to make it look like their candidate was a super star. I've seen debates where the organizers were not quite neutral where I sat steaming in furious silence at my opponents' preferential treatment, all while smiling engagingly, determined not to appear rattled. I liked bringing some volunteers with me to ensure my answers at least got some support.

3. ***Make each debate a social media megaphone***: Your volunteers can carry your voice far beyond the limits of the debate room via social media (see chapter 17). So by all means take pictures, video, and quote remarks. While you can compare and contrast with your opponents, I always prefer to focus on the positive of my campaign rather than on the negative of my opponents.

4. ***Prepare for debates***: You have your public narrative (chapter 15). This is who you are, your values, and your goals. Think about what you have heard from voters. What are the questions on their minds? What are the best arguments to advance your campaign? What are your key messages? What are the thorniest issues that community members or your opponents might throw at you? What are the policy areas that are important but that you have a shaky grasp of? Pull your core team together to brainstorm the answers to these questions. Review them, refine them and practise them. Better that you have prepared for your opponents' attacks that don't arrive, than being unprepared and stumbling during the debate. Conversely, what are the zingers that you want to have in your back pocket that can best push your opponents off their messages?

5. ***Practise***: I used to mistakenly think that I was experienced
 enough not to need to practise before speaking in debates.
 Painful experience taught me lessons time and time
 again. Stumbling while trying to deliver a witty rebuke to
 your opponent is a #fail. Some women stand in front of a
 mirror and deliver their remarks again and again. Some
 like to practise with the team launching questions and the
 candidate shooting back lines over and over. When someone
 has not only prepared but practised, it shows in a debate and
 in front of the media.

6. ***Make yourself as comfortable as possible***: Some of us like to
 sail into a debate without a sheet of paper. Some of us need
 to bring a massive binder to debates even if we don't open
 it once. I was reminded after a debate that if I'm reading my
 notes the audience just sees the top of my head instead of
 my face. Better they see my face. A debate is a performance.
 Without question, people perform better without notes. But
 confidence is important. If you need to clutch that binder,
 and I often did, then reassure yourself and clutch it.

7. ***Be pro-active in meeting community members*** before and
 after the debate: Arrive early enough to go around the room
 and greet those in attendance, including your opponents and
 their supporters. Goodwill is never wasted. After the meeting
 you may be weary, but try to stick around and answer
 questions from those who didn't get a chance to ask during
 the meeting. Keep one of your volunteers nearby after the
 meeting to take notes in case someone raises an issue that
 needs follow up.

8. ***Best advice? Relax***: Do whatever you can to appear calm,
 relaxed, friendly, and open—this will help you. You may be
 super stressed or exhausted, but you're wise not to show it.
 Whether it's deep breathing, a nap, or canvassing right up
 to debate time, know what you need to relax. After greeting

community members and the other candidates, take your place and get ready. For opening statements, I like to take the microphone if there is one, and get out from behind the tables or the podium to speak directly to people. I don't want a barrier in between. This is not what I do to relax but to appear relaxed. I want to make eye contact, to be emphatic, and friendly.

9. ***Enjoy meeting your constituents***: If you genuinely like people and are in politics to make their lives better, this is a chance to meet many of them in one place. Yes, some are already committed to another candidate, but that doesn't mean they won't reconsider. Genuinely listen to and enjoy each person you meet. They are a potential supporter and a future constituent once you are elected.

28. Taking Care of Yourself

The life of a politician can be exciting and satisfying. It can also be stressful, lonely, and draining. In this chapter we'll look at some of the realities of day-to-day political life and some ways to help you stay healthy and confident in your role.

In political campaigns you're constantly meeting people, answering questions, you're often in the media and in debates with political opponents. Your days are long, and every day is different. I loved almost everything about campaigning and elected life. I thrive on being with people, learning new things, and constantly being challenged. Campaigns, though, I always found stressful. Everything is on the line. Every media interview or public debate holds the possibility of disaster. People want to know if you're the right person for the job. Do they like the look of you, your voice, the way you dress, how you shake their hand, whether you look them in the eye, and, of course, how you answer their questions. Do you spend enough time with them or too much? Are you calling or visiting people too often or not often enough?

You work so hard, and everything comes down to one day and the final count of the votes. And so much is out of your control. Do they like your leader, your party's issues, your ads? Some people just vote the way their parents did, or the way a relative tells them to, or they don't vote at all. Sometimes it's so random.

The first campaign I ran in, back in 2004, there was a media story about an item that was in the NDP policy book calling for

an inheritance tax for amounts over one million dollars. I was canvassing in the west end of Toronto where real estate prices had taken off. People were hostile to me at the entrance to the subway stop where I was handing out leaflets because so many houses nearby were valued around that threshold. People tossed leaflets back at me and said I would never get their vote. I hadn't even been aware of the policy. We narrowly lost that campaign in my riding. There were a number of factors, but this was certainly a big one in that area.

When canvassing or out in the community, I found most people friendly and respectful. Even those who were facing tough problems, such as poor housing, low pay, or immigration concerns. Every so often, though, someone would be rude and antagonistic. I had one person spit at me, and I had some people look at me with disappointment and tell me I was much better looking in my pictures. One woman told me I looked too old to be in politics. But these were rare exceptions.

There's no great way to deal with rude people. I developed what I called the hide of a rhino. I never let it show if comments bothered me. I would smile and move on. Comments that are harassing, threatening, overtly racist must not be ignored. See chapters 19 and 20, Eyes Wide Open and Holding the Community Close. But for garden variety ignorance and disrespect, my motto was never let them see if it bothered you. But, of course, sometimes it does bother you and, periodically, you need time to reground yourself. No one deserves this kind of disrespect, and some people are just mean.

I've known politicians who are introverts. Whereas I thrived on knocking on doors and meeting new people, an introvert finds this exhausting. For people with this personality type, building in time to just be alone in a quiet atmosphere is essential. They can deal with all the intensity but need time to decompress. Sometimes, I felt this way as well.

Tips for Self-Care
While time is short during an election campaign there are some

ways to care for yourself. Everyone has their own needs but here
are some ideas.

- *Humour:* Find ways to laugh at the pressures of a campaign.
 My campaign sidekick Beverly Taft is funny, smart, and just
 a pleasure to spend time with. Being multilingual, whether
 we met someone who spoke Japanese, Portuguese, French,
 or Italian, she was able to connect with them. She also has
 an amazing memory that came in very handy. But most
 importantly she made us both laugh. If someone was rude
 to us, she'd crack a joke after we left, and it just kept us both
 upbeat. Surround yourself with people who are helpful and
 make you feel good.
- *Be prepared*: Sort out as much of your life as you can before
 the campaign. This is not the best time to buy a house,
 renegotiate a mortgage, or get divorced. Prepay bills, if
 possible, decide how to handle chores at home, organize
 childcare—whatever the important tasks are in your life.
- *Circle of support*: Create a supportive group who can help
 with childcare, household chores, or supporting you if you
 face the oppression of transphobic or racist comments.
 This needs to be a group of people supplying unconditional
 support and love. This is your personal team.
- *Family and friends*: My partner Carl has always been very
 supportive of my decision to take on a crazy schedule and
 heavy workload. He has always taken on more than his
 fair share of parenting, meal preparation, and housework.
 He even ended up taking on the job of walking the dog I
 had promised him he wouldn't have to walk. Have a frank
 talk with family and friends about what they can expect
 in a campaign. Do what you can to have them prepared
 and helping you. Best to avoid big family blow-ups mid-
 campaign. Keeping the family lines of communication open
 are more important then ever during a campaign.
- *Schedule*: There is never enough time to do everything, to
 knock on every door, to attend every meeting, to answer
 every question. I would ask my team to fill up my schedule

so that I worked full days seven days a week. Full days
are important but setting priorities will keep you from
unproductively running from event to event. Your main job is
contact voters.

- ***Rest and sleep***: Block out the time to get a good night's sleep.
 I can't function without enough sleep. I trained myself to be
 up by, at the latest, 6:00 a.m., which meant I needed to be in
 bed by 10:00 p.m. Every so often I broke the routine, but very
 rarely. Sleep is a priority.
- ***Food***: It's easy to eat badly when you're on the run. During
 campaigns, I often lived on protein bars rather than stopping
 for meals. Missing the odd meal is not a big deal, but just like
 sleep, diet is important. Your teacher was right—breakfast is
 the most important meal. It doesn't need to be huge. Try not
 to eat too late at night.
- ***Exercise***: Knocking on thousands of doors during a campaign
 might seem like enough exercise. I need to get additional
 exercise both to keep in shape and to get rid of stress. I
 usually ran a few mornings a week. I didn't go far, usually
 five kilometres, and I didn't go fast, but the act of running
 was very soothing for me. A bit of running and a few weights
 exercises was all I needed. Some people swear by yoga,
 others by mindfulness, boxing, or going for long walks.
 Whatever your preference, it's important to get out of your
 head and into your body. In politics it can be hard to find
 time to think. For me, exercise was a time for my thoughts to
 roam, plan for the day, write a speech in my head, whatever.
 It was always refreshing.
- ***Appearance***: Being in the public eye means that you need to
 look after your appearance. Whether it's regular hair cuts or
 taking the time to ensure your clothes are clean and pressed.
 You work out a system based on your own needs. The last
 thing you want is to be in front of voters or the media with a
 stain on your shirt. Have whatever appearance suits you but
 make that appearance the best you can.
- ***Breathe***: See chapter 16 on public speaking. There will be

stressful moments in a campaign. Remember to breathe deeply a few times, go to your calm place in your mind, and remember why you are running. Pull out your public narrative statement. This isn't about ego. You are running to make real change. Power hates a challenge. You are running for the community. Bring them and their struggle with you.

IF YOU'RE AN INTROVERT

I think I am both. Although in many ways I am extroverted, I find that I need a lot of alone time to re-energize. I am extremely sensitive to other people's emotional energies and often find it impacts me personally. I think my emotional intelligence allows me to connect with others and, although I feel that it is a gift, it can take a tremendous toll on my own wellbeing. That is why I make sure to spend a lot of time alone.

I also workout almost every day and do weightlifting. It really helps with clearing my mind and managing my stress in addition to writing. I'm also a big fan of cooking and find that in free moments I can get lost in the kitchen creating new dishes. Most importantly, I am blessed to have a very small circle of people that includes my family, partner, and friends who feed my spirit. I am very blessed.

Leah Gazan, MP, Manitoba

BE PATIENT

I am a true introvert. It makes no sense. I'm one of those people where you could say "here's a crowd of a hundred thousand, go talk to them." I'd say, "Okay, cool, I can do that no problem." But here's five people in a room, "Go say hi." I'd think, "Oh my God, I can't do it." I'm not good at small talk. So I struggle with that. I've had to learn to just be patient with the process.

Rachel Blaney, MP, BC

Part 6.
The Election

29. Ensuring Voters Vote

All through your election campaign you are meeting with voters who are potential supporters. You are connecting through social media, and you are getting your message out through all the media outlets. Your volunteers are also connecting with voters in your name, persuading them that you are the best candidate to fight for their issues and to be their voice at city hall, the provincial legislature, or in Ottawa. People will come into your campaign office to express support, make donations, take signs, and offer to volunteer. But most of all, you need them to vote.

In an election campaign, you must persuade people that you are the one, *and* you need to reconnect with them for voting. Everyone who says they will vote for you is recorded in your database, and on election day your team will help you to go find them.

In the lead up to election day, as hard as you have been working, you need to work even harder. Imagine losing an election by ten votes, ten doors you didn't knock on, ten people you didn't feel like talking with, ten minutes of your time. Anyone who has run a marathon will tell you that you pick up the pace in the last few kilometres. In an election, you need to pick up the pace. Leave no voter unpersuaded.

However, on election day, your job convincing voters to support you is done. Now voters need to vote. As the candidate you are not usually involved in organizing the election day or advance polls operations. Your team will do this. I would keep canvassing during the advance polls to reach as many voters as possible. On election day, I made myself visible in the riding by visiting zone houses, polling stations, and our main campaign office. But campaigning is officially over.

Pulling the Vote

Your campaign team will organize for election day like a military campaign. They will already have distributed "vote at" cards telling voters where and when they can vote. On election day, another card is distributed that reminds voters that it is election day, and when and where they can vote.

"Pulling the vote," reminding voters to get out and vote on election day is a massive job. Your campaign will only want to encourage those who said they were definitely or very likely, to vote for you. This support will be tested by phone several times before election day.

Volunteers will go door to door to urge voters to vote. Many will not be home or say they will vote later. The volunteer may return many times to remind the voters. At the polling stations your volunteers will be scrutineering, observing the election, ensuring that all procedures are properly followed, and tallying which of your supporters have voted. This process continues all day. At the end of the voting, the scrutineer observes the counting process to ensure that it is fair and according to the rules.

Zone Houses

Some campaigns will have a system of zone houses or sub-campaign offices. The riding or electoral district will be broken into zones responsible for several polls. Zone houses are offered by supporters who open their homes to create a space where volunteers can go to rest, recharge, and fuel up. Candidates often visit their party's zone houses to thank and encourage volunteers, and to offer snacks or a slice of pizza.

Problems with voting often surface first at zone houses, which then keep in close communication with the main campaign office. For example, reports of signs getting torn down or defaced, voters who are barred from voting, campaigning by another candidate around the polling station, all get fed back to the campaign, usually via the zone houses.

Some ridings choose different systems to break down the

riding. For example, where I was the representative, there was a part of the riding with a high proportion of many different languages spoken. It was fairly far from the main campaign office. We usually had a sub-office in this neighbourhood where the volunteers who spoke multiple languages would be based. Then on election day they were based in that sub-office to conduct their area "get out the vote" operation. They would often go in multilingual teams through some apartment buildings to be able to connect with voters, no matter their language.

Advance Polls

In my first election, I believed, as do many first-time candidates, that I would win. Most don't and I did not. But the buzz was incredibly positive at the time of the advance polls. We had run a strong campaign, and some media were speculating that we would take it. Two weeks before the vote I canvassed a large social housing complex in the northwest of the riding. We spoke to many residents who were positive in their intention to support my candidacy. We put our literature in every mailbox. We had many pledges of support and many residents wanted to take signs. Two weeks later I lost the election and lost that poll.

At a national level, I noted with a heavy heart that Paul Martin, leader of the winning Liberal Party, came out strongly in the Toronto area denouncing the NDP, saying that votes for the NDP would ensure a Conservative victory. This is a common tactic, and it was a powerful argument. The Conservatives were not very popular in the city at the time. After the election I revisited the people in the social housing complex and asked them what had happened. They said that Liberal canvassers had come through the neighbourhood right after me and had persuaded people that voting for me would be a big mistake, that they would end up with the Conservatives. The Conservatives hadn't won in our area for decades and aren't likely to in the near future.

What I learned from that experience is that advance polls can be very important. If we had pushed our supporters to vote early,

they would have voted before the closing Liberal message. If you think you are winning, encourage your voters to get out and vote in the advance polls. Things can change before election day.

We began to treat the advance polls like election day sending our organizers into every poll, leaving reminder cards at each door that detailed where to vote. We would have scrutineers at the polling stations and follow up with voters if they were not voting early.

E-day for You: The Candidate

Some candidates rest on election day, knowing that the results may not come until well into the night. Some candidates spend much of E-day visiting with volunteers at the campaign office, zone houses, or on the street, thanking them, encouraging them, motivating them. Some campaign managers like to keep the candidate busy so that they don't get too nervous.

You judge how busy you want to be on election day. I usually preferred to be with people, visiting zone houses and being visible in the riding. Being alone would have been too nerve wracking for me. The exception is when I know things are going badly. I remember one election where on E-day I went home and curled up in a ball under the covers, because I already knew the outcome of an election that I desperately wanted to win. The only way to get over that pain was to run and win in the next election, which I did.

As the candidate no matter how you are feeling, a major part of your role is to motivate your volunteers. They believe in you and have been giving up their time to make your campaign the winner. You owe them your total commitment to the campaign and to keeping up their spirits even if the outcome isn't what you had hoped.

30. Election Night

I think the toughest thing is . . . most people do it because you really believe in something, and you have to put your own name and your own values out there. It's my name, it's my picture, it's me. Putting myself out there and not winning is personally devastating, and I remember somebody told me this once that although politics is so personal, you can't take it personally. And that is so hard.

—*Niki Sharma, MLA, BC*

A Tale of Two Elections: My First Loss

My first election night was painful. My manager had asked me where I wanted to wait for the results. It was late in the campaign, and I was focused on working as hard as possible to win support. The local polls and the media gave me a good shot at taking the seat, but it is very hard to take an incumbent seat and very hard to win on your first time running. Maybe he did tell me, but I was determined to win.

Our campaign had focused on me as a community activist, a champion for my riding, and my city. So I answered impulsively that I would wait for the results with all the campaign activists and volunteers, in the hall we had booked for the celebration. My first election fell on my birthday, June 28, 2004, which I thought had to be a good omen.

We gathered at the Lithuanian Hall, on Bloor St. West, a large, windowless, space with lots of dark wood and dim lighting. I invited my parents to be there to witness this important event in their daughter's life. As volunteers finished their tasks

they gathered in the hall, which began to fill as the results trickled in almost immediately after the polls closed. Very quickly the trickle of results turned into a flood. Each time we won a poll the cheers rose up. When we lost, the room went quiet. Soon it got very quiet, and with each losing report eyes sneaked glances at me. A weight began to settle in my chest. Each poll was like another dagger. I was in agony.

Julius, my manager, asked me along with my campaign assistant Bev Taft to step out of the room into a stairwell for some privacy. The cold, barren concrete steps and bright fluorescent lighting felt like a morgue.

"It has been my lot in life to often be the bearer of bad news," Julius told us with his big, sad eyes. "And my dear, I'm afraid tonight will not be your night to win."

The finality of it, the abrupt obvious truth of it, caught me off guard, and I gasped a sob. A couple of tears escaped down my cheeks. Bev merged our pain in a long close hug.

"Now," Julius said, "you need to get back out there to inspire the team and show them why all their hard work for you was worth it."

That brisk instruction snapped me back in control of myself. I shrugged off the negative emotion and jumped on the stage. With all the positive energy I could muster, I announced: "We didn't lose tonight; we just didn't win yet. But make no mistake, we will win."

There was a roar of support. So many people had worked so hard. And we almost did it. What an achievement. Next time. The activists stayed with me and the next election we did, indeed, win.

My First Win

The thirty-ninth General Election, my second, fell on January 23, 2006, after a long, dark, and very cold campaign period. Campaigning had been difficult, since we operated strictly with paper canvass sheets, which after about 5:00 p.m. were impossible to read. Some kind people opened their doors

to allow us to warm up while we chatted. Often people were nervous about opening their doors to a stranger in the late evening.

The dedication of some of our volunteers was remarkable. Young activists would go knocking on doors with me several times a week. In the bitterest cold, we canvassed high-rise apartments till 9:00 p.m., and then we'd be back out leafleting at a subway stop at 7:00 the next morning.

For election night, we had booked Hugh's Room, a popular music venue on Dundas West. It was smaller than the Lithuanian Hall but felt more in keeping with our campaign. I had learned my lesson from two years earlier. This time I watched the results at my home with my family and a few allies, including Mayor David Miller. I had advised my parents to stay home to spare them the pain of a second loss—just in case.

I had been so focused on the campaign that when the close group came by to watch the results come in, I realized I had no refreshments to offer them. Being a good host was the last thing on my mind. But when we bundled into our tiny TV room, that didn't matter. Quickly, it was apparent that the tide had turned. We discussed when to head to Hugh's Room and decided to wait till the media called the results in our favour. Then we floated on a cloud of excitement right into the hall that was packed solid and ablaze with media lights to catch our entrance.

I was so excited I actually don't remember a lot. I answered some media questions as I made my way to the tiny stage. I'm sure most of the people there couldn't see me for the crowd. But I gave my thank-yous to our incredible team and the volunteers and then pledged to be a different kind of politician who would make our community a priority.

Frankly it was all a blur. What I remember distinctly is later that night, around 3:00 a.m., with Carl, my husband, in our living room. We sipped a drink, something strong. There was no way I could sleep, and maybe I was a bit afraid that I might

wake up and find the win was all a dream. We just sat there try-
ing to let the events sink in. I was from a working-class family
where everyone had struggled. Both my grandmothers had
done domestic work. This was the last thing I was expected to
do with my life. We won. I would be the MP and would go to
Ottawa to represent our community. Our lives would change.

Things to Remember

I could go on and describe each election night, which I remember
as vividly as the births of our kids. Sadly, Julius was not there to
manage all the future campaigns and missed the NDP Orange
Wave in 2011. My dear friend died too early in life.

Each of my five local election campaigns were very different.
Experiences on election night can vary widely. If I had only one
recommendation, it would be to plan that night carefully. But
there are other things to consider.

Your team and volunteers: Just as you have been working your
heart out, so too have your team and volunteers been giving it
their all. On election day, they have been pulling the vote, getting
your supporters to the polls. They have been scrutineering at the
polling stations, ensuring the voting process is fair. They have
been the engine of your campaign, dealing with problems and
ensuring volunteers fulfill their tasks. Your main priority, win
or lose, is to keep them with you so you can build for the future.
Welcome them to the hall, thank them profusely, make sure they
get food and drink, and, most importantly, keep them inspired for
the future.

Venue: I became superstitious about venues, which was a winning
venue and which were likely to denote a loss. Find a venue that is
easy for your volunteers and activists to get to, such as near public
transit and with parking, has an accessible entrance and wash-
rooms, and is roomy enough to accommodate a crowd but not
depressingly cavernous. Don't delegate this completely to your

team. Make sure the venue is comfortable for you. A good venue doesn't need to be fancy. Many activists will have been pulling the vote and scrutineering all day. They may be scruffy, sweaty, and hungry, but they should feel comfortable.

Refreshments: Many volunteers will be hungry and thirsty. Make sure there are refreshments for them. We used to offer free food and non-alcoholic drinks and one ticket each for beer or wine. The last thing you want is someone overindulging at the party.

Sound system: Nothing irritates at a big gathering like not being able to hear the speakers. I've been at many events where the disaster of no sound became a reality. Win or lose, this is your moment. Entrust someone reliable to ensure the sound is as good as it can be. Have back up microphones just in case. Also consider if you want a podium or not. If you have a lot of notes and you need to look at them a podium might be handy. Or you might be more comfortable being able to roam the stage just glancing at a few notes occasionally. A podium can be a security blanket or a barrier between you and your people. You decide which.

Stage decoration: There will be many pictures of you on stage that night. Think about the images. Do you want to fill the stage with activists who will be behind you or are you more comfortable with your family, your campaign team, or just being by yourself? At least you want some signs and some stage decoration. This is a personal decision but do consider how you want things to look.

Program: The program doesn't need to be more than you hopping on stage and speaking to the crowd. But I usually want someone to call the crowd to order and then introduce me. Once you speak, people are unlikely to continue to pay attention, so if you do have someone else to speak to close the event, keep it brief, such as encouraging people to enjoy themselves. Keep watching the returns come in or switch to party music.

Your speech(es): I have learned to always prepare two speeches for election night. I have seen the most confident politicians lose their seats. I always consider the possibility of a loss, but since you campaign to win, you need to prepare for that as well. Both speeches need to include thanks to those who need to be thanked, including your opponents. Write down the names of everyone you need to thank or thank in generalities and don't name people. There is enough emotion on election night. You don't need drama because you forgot to acknowledge someone or some group. Write it down.

Winning speeches are more fun. They are jubilant and exciting. Reinforce the key pledges of your campaign. Vow to be great in office. Remember to give lots of praise to those who made the win possible. You are the leader of a team, but it's the team that won.

Losing speeches can vary widely. I have given losing speeches vowing to be present in the community fighting for people every day. I have been a bit emotional sometimes, but I hate it when I'm on the verge of losing control. But still the team and the community come first. You can have your cry privately at home. The campaign wants to see the fighting you, win or lose, putting the community first.

On election night it always felt appropriate to remember why I was running in the first place. What were the priority issues? What change did I want to make? Who needed help that I believed I could benefit if I were elected? Remembering that it was always about the movement and not just about me personally really helped ground me, win or lose.

Personal support: On election night you will likely feel very vulnerable. There are few times in life where your endeavours are so public and the score so definitive as an election campaign. For you personally they are like the World Cup and the Olympics rolled into one. You have made yourself a public figure, taking all

the plaudits and criticisms that entails. And the public reckoning is on election night.

Spend that night with the people you most trust and who care most about you. I have spent election night with family and friends or with my campaign team. Any option can work. In 2011, I waited for the returns in our campaign office. I wanted to micromanage and see each poll as it came in. It felt good at that point to be with my central advisers. Once I saw that we were winning polls we had never won before, I knew it would be a good night.

Media: You may face media on election night. If you win for the first time, especially in a close race, there will likely be reporters at your celebration. In a few races, one or more local TV stations went live from our gathering. Prepare yourself as you would before any media interview. What will be your key message? Thinking this through ahead of time gives you the chance to compose your message free from the emotion of defeat or victory.

In one campaign, my opponent, who lost unexpectedly, had a meltdown in the media and made some unfortunate statements. I felt sad that the candidate was not shielded from making media statements when, clearly, they were not in a good frame of mind.

In 2011, I got to our victory bash, and I was shocked when a TV reporter went live with the question, "So how do you feel about Canadians electing a Conservative majority government?" I had been so hyper focused on our local campaign, and so jubilant when we won locally, I completely missed the bigger picture.

×

Whatever the outcome, enjoy the satisfaction of having run, or having put yourself out there and leading so many people who were inspired by your message. What an achievement. It's something many people think of doing but few actually step up and do it. You deserve to reflect on all you have accomplished. Bravo.

31. The Day After

The day after an election can sometimes be as gruelling as the campaign itself. If you lose, there are a lot of tears and cleaning up to do. If you win you have a lot of decisions to make. You can't relax. Here are some of the things to consider.

Media

Whenever I lost an election, without fail, a local radio station would phone our house around 5:00 a.m. asking if I would do a live interview an hour or so later with the morning show host. "How do you feel?" they would always ask. It was brutal, and I felt they enjoyed torturing me. I called it "picking the wings off a fly." But really "How do you feel?" is a standard question from the media to both the winners and losers.

But win or lose, it is important to do media. Prepare your message ahead of time. No matter how devastating a loss can feel, I was always determined to present myself as in control and still fighting for the important issues. Sometimes much of the day after an election would be taken up with media. Their job is to get as much analysis as possible about what happened and why Canadians voted as they did. Add your perspective to help present a full picture. If you lost and you are feeling down, your job is still to be positive for your activists.

And if you won, then you can enjoy savouring your victory in all these interviews. Be careful not to kick your opponent when they are down. Be positive and humble, but so happy. Remember why you decided to run. Every media interview is a chance to champion the issues that are important to you. Depending on

your riding or ward, you might find yourself in high demand for media the day or days after an election.

The Signs

All those amazing signs with which you blanketed the riding now have to be picked up. Once the election is over, people want the signs gone as quickly as possible. Swift retrieval of signs shows that you and your team are efficient and respectful. Usually your sign crew will do the sign collection, but if you have some time, helping them with this task is always appreciated. It's a great boost for your volunteers to see that you appreciate all their hard work. Those signs helped you to get elected. Ensure your signs are safely stored for the next campaign. Your sign crew has been a vital part of your campaign, but they often don't get enough recognition. You can correct this by lending a hand the day after the election.

Thank Voters

I enjoyed going out to meet voters the day after the campaign, especially a winning campaign. Some volunteers would bring a few campaign signs to jog people's attention when we visited central intersections or gathering places. We always got a great reaction. I loved going to transit stops or strolling along main streets and shaking hands and greeting people. The day after you win, it seems like everyone voted for you.

The best wins are those that feel like community wins, when people on the street say "We Won!"

If you lose, you may not feel like doing any of this. If you lose you may feel more determined than ever to win the next time. Or you might feel that you never want to run again. You likely will still want to champion issues and wonder if politics is the most effective way.

The last time I lost an election, meeting community members in the days and weeks afterward was like attending my own funeral. People would say how sorry they were, some people cried, and I had to console them. Some people were angry. Some

smiled with phony sad eyes. The reality is that sometimes, in fact most of the time, candidates lose. If it's a very tough loss, there is a grieving process. I tried to keep busy and stay connected with others who had faced the same process of running and losing. Like a funeral, talking helps, and it can take a while to get over it.

The Office

If you lose, your campaign office can be a bit sad the day after. To save your riding association money you usually need to clear out of the campaign space as quickly as possible. Records need to be stored, furniture stowed, and the floor swept. This is a big job and needs many hands. As with the sign collection, if you show up and help out, your campaign team and volunteers will appreciate it.

A word of caution: The first time I won, I was the only person from our party elected to any level of government in our area. So, when our incredibly efficient campaign team cleared out of our campaign office within a couple of days of the election, it quickly became clear that, as the new MP, I had no office to meet with constituents.

If you think you have a shot at winning, be sure to consider where your constituency office will be located. Will you take over the existing MP or city councillor's office? Will you join with a counterpart at a different level of government from the same political party? Will you get a new space that your team has already scouted out?

The constituents will come fast and furious. The local casework begins immediately. With that first win, I was reduced to meeting with constituents in coffee shops, the library, in any space I could get. When I did finally get the constituency office, it was at street level, accessible and welcoming. But it took a ridiculous amount of time to get it, to get the furniture from the former MP, get the phone lines installed to the specifications of the House of Commons, and even to get our internet properly set up. It was a painful lesson.

Plan for where your constituency office will be and know that there are rules from the city, province, or federal government

about where and how an office is set up. To get public funding for your work you need to follow all the administrative rules.

Plan to Win and Prepare for It

Before the election you need to seriously consider the possibility of winning and what preparations you need. Some considerations include:

- naming a small transition team (keep this confidential)
- handling media and social media
- instructions from the party such as about media and hiring staff
- office space for meeting constituents
- requesting casework from the previous official
- legal requirements to follow as an elected official
- getting mail forwarded to your local office

Financial Report

Win or lose your campaign will need to file the financial report for your campaign. I didn't get much involved in this but you ultimately are responsible for following the financial rules and reporting within the required timeframe.

Plan Volunteer and Donor Thank You

Your team played a huge role in your campaign success, and win or lose, they need to be recognized. We always did a volunteer and donor appreciation evening within a month or two of the election. You could strike a committee to begin planning as quickly as possible. This is one important detail that can slide off the agenda if you don't get moving on it right away. Whether or not you plan to run again, you need to leave the electoral district in good shape for the next campaign.

Take Care of Yourself

Campaigns are stressful and by the end you will be exhausted. There's a lot to do the day after the election and follow up for some

weeks after. But you're only human. Plan for something fun or
something chill and soothing. You're a public figure now. Find
some time for you.

Part 7.
Afterwords:
One Piece of Advice

32. Lead Like a Woman and Be the Change You Want

Transformational political change can look very different to different people. Certainly, moving past the elitist, exclusionary, homogenous governments of our past would be a good start. But as Mona Lena Krook, who made a worldwide study of quotas for women in politics, says, diversity doesn't automatically mean justice or even fairness. New faces in old structures replicating the old decisions doesn't cut it.

Progressive legislative changes and outcomes are essential. Whether on racial justice, Indigenous rights, workers' rights, environmental sustainability, reducing inequality, economic justice, whatever it is, those of us who get into elected life to *do* something, as opposed to wanting to *be* something, want to see real outcomes.

How we achieve change must also be a priority. Welcoming diversity into governments and then leaving people to fail or exit in frustration sets us back. So, while the "what" is important, the "why," the "how" are also vital.

Competition and opposition may be endemic to the fabric of politics, although there are some cooperative examples that we have much to learn from. After all, politics is a competition for power to achieve change or prevent change. However, nothing prevents us from creating a politics that also provides for respect, inclusion, and accessibility. If political parties decide that greater inclusion and better representation is in their best interests, they can make it happen from one election to the next. Much depends on party nominations, who knows how they work, and who "gets"

to run. Knowing how difficult it can be for women to make the leap into politics means that discussions with them have to begin long before elections, long before nomination meetings.

Bring Activism Inside

Why can't politicians of the left bring their outside political activism inside to the corridors of power? Why can't elected political representatives maintain their links to activist movements, organizing and educating to broaden the engagement of those communities and individuals affected by political decisions? Why can't the energy of activists who are elected to political office be channelled into opening up the windows and doors of politics to provide for better information and accountability?

We don't know what we haven't yet created. Imagining a better world, a world of economic, environmental, and social justice allows us to set our sights on where we want to go. Getting there is not impossible; it just hasn't happened yet.

33. One Piece of Advice

If a progressive activist came to you and said they were considering electoral politics, what would your advice be? From the women I interviewed for this book, here are some ideas. As with all of their comments in the book, they have been edited for clarity and length.

Dr. Jill Andrew, PhD—See where you best fit
Being a party politician and being an activist, I've come to realize, they can compliment each other but they are separate. As an activist thinking of getting into politics you should speak to people who are elected. Get a sense of their experiences. Review the platforms of all parties, see what the barriers and opportunities are and see where your values best align. Remember, decisions you make as an elected official will be collective and influenced by many factors. Your voice as an individual matters but now the decisions are bigger than you and your unique vantage point. There's a party identity and vantage point now to consider. The other piece to remember is progressive political change can happen outside of politics too, and one can argue that sometimes it's faster and more credible on the outside. In an ideal world both spheres would be inextricably linked and always working in tandem with each other.

Member of Provincial Parliament, Toronto–St. Paul's, Ontario,
founding member of Ontario NDP Black Caucus, and Official
Opposition Critic for Culture, Heritage and Women's Issues

Jessica Bell—Start early

My best advice is start early, choose your riding that suits you, and raise the maximum, because you've got to do everything you can to increase your chances.

Member of Provincial Parliament, University-Rosedale, Ontario, and NDP critic for Housing, Urban Planning and Tenant Rights

Rachel Blaney—Keep good supports around you

Do it. Make sure you have some good support around you and ask somebody who's done the job what it's like. One of the best things that ever happened to me when I was considering running for the nomination, was I phoned (former MP Jean Crowder) and had a 45-minute conversation with her. And she talked to me about how many hours I really would work, how long I would be in Ottawa, how exhausting the flights were back and forth, what it meant for her life. Then, I talked to my family, my husband and two sons, individually in lengthy detail about her experience. So when we first got elected it was hard, but they all knew what they were expecting. . . .

If you're going to change the system, you need a whole team of people behind you and you have to do it your way and not get distracted. It's hard. You get pushed to be things that you may not want to be. So you have to decide who you're going to be in this job, and stick to that even when it's hard.

Member of Parliament, North Island-Powell River, BC

Alejandra Bravo—Political space

Just by being in the political space you're subverting these rules that are against you and the more we've come forward and the more that we do it unapologetically the more we're kind of defeating exclusion. . . .

I always tell people, when you're the candidate, you're just

like the number one canvasser and you're part of the team and your team has your back so don't take it all into yourself. I've never had a problem losing because we ran our campaigns as a collective with so much integrity.

Director of Leadership and Training at the Broadbent Institute and was a Toronto City Council candidate and a federal candidate, Ontario.

Katrina Chen—Encouragement

The simple answer is to be confident but that's not an easy thing to do. It took me years to build my confidence. So I would say surround yourself with people who are activists or who are passionate or who share the same values with you and who can encourage you.

Member of Legislative Assembly, Burnaby–Lougheed, BC

Laurel Collins—Circle of support

The most important thing is having, it's more than having a team, I think it's like having a circle of people who share your values, who support you, who are interested in the same work that you're doing, who are committed. I just think about all those different kinds of supports that you get when you're deciding to run, and then running, and it's everything from the family, friends, to the campaign team, to the people who, at least for me, at the municipal level, having that group of people who are organizing together and fighting for the same things. It's created this little bubble. That, no matter what, politics can be hard and toxic and awful, but having that circle of people around you is this amazing bubble buffer that can make it a joy. And so, for people interested in getting into politics and interested in running, find your people, find that bubble. That will be your safe haven amidst what can be a really, really hard slog and sometimes a really toxic environment. Make sure you find your circle of people.

Member of Parliament, Victoria, and former City Councillor, BC

Leah Gazan—Humility

Just don't let anybody tell you it can't be done. I had to take down two men in power to become the first woman elected in Winnipeg Centre as the Member of Parliament. The trick is to not give up who you are in the process. You need to always make sure that you stay true to your values and let your values be the guiding force for decisions and positions you take. Just as important to maintaining your values, is leading with courage, humility, truth, kindness, and respect. For so many people, power and privilege can be blinding, so remaining grounded in who you are and what you believe in rather than getting lost in titles, which are so irrelevant, is critical. That may mean that sometimes you will have to stand alone. That can be a struggle. So always take time to care for yourself and those you love. We are all in this circle together.

Member of Parliament, Winnipeg Centre, Manitoba, Member of the Wood Mountain Lakota Nation

Jen Hassum—The why

Think about why you want to do it. And then carry that with you.

Executive Director, Broadbent Institute

Jennifer Hollett—Reach people

I was known for going door to door, I was also known for being everywhere and I was known for being an approachable candidate who people could come up to and ask questions and be in conversation with. But when you can't do that, social media is such a gift and fills a void, to help you do what you need to do in the campaign period, which is reach people where they are, and persuade them to vote for you, to become a volunteer, to be a donor or to at least get the word out that you exist and there's an election.

Federal NDP candidate, Ontario

Michal Hay—Create a team

Create a team and build them up and build them up for the long term. . . . I think the biggest thing that you can do if you want to win on anything, an issue-based campaign, running for office, anything, is building a big team of people and investing in their capacity, and building that like a real team. Not just these individuals that relate only to you, but people who relate with each other and function as a team.

Executive Director, Progress Toronto; campaign director for Jagmeet Singh's NDP leadership campaign; former chief of staff to Toronto City Councillor Mike Layton; field director for Olivia Chow's Toronto mayoral campaign

Laura Mae Lindo—Activist history

I would advise you to watch some of the debates, watch some of the things that we have been able to say and have inserted into the cockles of history. I would strongly encourage you to pull on some of the activist members that you've seen over the years and read what they've said. Because that's our history and it's not the political history that gets taught, right?

So I think that you can find different ways to bring your whole self into it. I think that one of the barriers is that we are doing this work on the outside—who wants to sign up to do something where you feel like you have to hide part of yourself? Especially the part of yourself that you love the most because it is your authentic part, and you don't have to. You can find ways to insert, you can find ways, you can. You don't have to put it all out there either, but when you are ready, as Beyoncé says, for that jelly. Oh, my goodness, you can find ways—I even have that in the cockles of history!

Member of Provincial Parliament, Kitchener Centre, Ontario, and Official Opposition Critic for Anti-Racism and Colleges and Universities, ONDP Black Caucus

Ausma Malik—Keep fun alive

I believe you have to have fun. There has to be joy in this work and in this movement. I ran for city council and the rules changed (when Premier Doug Ford cut the number of council seats in half during the election). My ward was eliminated and I didn't end up being able to make it onto the ballot on election day. We were angry and we were heartbroken, but I also remember someone who volunteered on my campaign say to me, "You have a real commitment to fun." It meant a lot.

Such an important part of making a difference is the way that we stay connected to each other. The ways, even in facing the worst challenges, we won't let them get us down. We're very determined, and there is a way to be determined and also to have fun. Joy is an act of resistance as well. Sometimes the magnitude of the systems and the structures of injustice and oppression can be so overwhelming that it seems impossible to transform them. They have a way of trying to extinguish our joy and to make us just very focused on the absolute bare minimum, that really doesn't allow us to expand and live into that kind of imagination and creativity that is required to make the kind of difference that we want to make. So even if it's just small ways to keep the fun alive, it's absolutely worth it

Toronto District School Board Trustee (2014–2018) and Toronto City Council candidate

Manon Massé—Power to make change

Women have a thirst to know if it's worth it to run for office because there's a will but a lot of doubt. My job as a leader of a left party is to remind people that today the issues people face such as climate change are the result of decisions taken by those in power. If you want change, then you have to take that power.

Porte-parole de Québec solidaire et députée à l'Assemblée nationale du Québec, Sainte-Marie–Saint-Jacques

Tracey Ramsey—You have more tools
As an activist, the things that you're frustrated about, the things that you want to see changed, when you're elected, you get to participate in pushing for that change, you have more tools available to you as an elected person than any citizen. You know you're able to bring attention to it. You're able to attempt legislation, to bring it to committee, you just have so many more ways to push for the things you care about, and you just simply don't have those things at your fingertips, when you're in the trenches.

Member of Parliament (2015–2019), Essex, Ontario

Tracey Raney—We need you!
We need more women in public life who have your expertise, skills, and experiences. Just do it!

Professor and Director of the Master in Public Policy and Administration Program, X (soon to be renamed) University

Andrea Reimer—Team You
What I tell every woman who gets into politics, and particularly those coming from non-traditional, lower income, non-white, whatever background is not of the dominant culture, is to have a team that is Team You. That is what they're there for. They are not there for your party, they're not there for power, they're not there for anything other than you, your mental health, your sanity, your moral compass. They're there to make you accountable to you and remind you what that looks like . . .

If people ask me if they should run, I will send them to Stacey Abrams's TED Talk, where she has "The three questions to ask yourself about everything you do." It's brilliant and I like it because if you don't know why you're running, I sure as hell don't know why. You must know that.

City Councillor (2008–2018), Vancouver, BC

Ann Marie Sam—Campaign manager

I think we need more young voices and more perspectives from people living in small rural northern communities in this system that we know needs to adjust and change. But also, be prepared that change is sometimes slow—how long has the Indian act been around? So you need to have your team and people that support you and you need to have the energy and the interest. I see it as this great opportunity for people to get involved, and to have a chance to bring forward their perspective, and also an opportunity to learn.

Member of Lhts'umusyoo (Beaver Clan)—Nak'azdli
Whut'en, NDP candidate for Nechako Lakes, BC

Rowena Santos—Take your place

I say this every International Women's Day: take your place, own the space. And do it with style, humour, smarts, and grace.

Regional Councillor, Brampton, Ontario

Nikki Sharma—Make change

Having the idea of wanting things to change and then actually seeing the system change, you can do that when you are in politics and in a role where you can make the decisions or work together with people to make the decisions.

Member Legislative Assembly, Vancouver-Hastings, BC;
Deputy Caucus Chair and Parliamentary Secretary for
Community Development and Non-Profits

Marit Stiles—Kitchen cabinet

Pull the people together that are your best friends and your best advisers, the mentors you've had, people you really, really trust, family members, whatever, but the people that you trust the most. Make them your kitchen cabinet. Because you know you'll learn,

you'll grow, you'll have lots of other people that you can rely on, but those people who really have your best interests at heart, are going to be super important to you in winning an election, and organizing around an election, and in surviving if you get elected, but in the end, if you lose. Because that's the other piece, we lose more than we win, and that is part of it. I know that from experience, too. So having those people around you is super important and keeping them close to you. I sometimes personally forget that, but I think it's a really important piece that I keep coming back to.

Member of Provincial Parliament, Davenport, Ontario

Lindsay Mathyssen—How will this impact you?
I think that women are under a great deal of pressure already so I wouldn't want to say, do it, or don't do it. There are pro lists; there are cons lists. How is it going to impact your family, your job, your future? I speak to a lot of women in ridings where there might be a possibility, but it's not a guarantee. And it's hard to find a guaranteed seat, especially as a New Democrat. I give them the lay of the land, to have those honest conversations on their expectations. I've always said, I'm here to listen, whatever you need.

There have been a few tougher conversations, where women have higher expectations of what they deserve, or to be made available to them to run. I find those conversations very difficult. Again, especially when they're not in ridings that are considered priority, those top ridings. And it's not that they shouldn't ask for those things. It's hard for women to ask for things, to say I deserve this support. It's very difficult. It's far more difficult for women to do that and to receive it. But there is a financial reality within the party that we can only do so much with what we have, and that needs to be managed really carefully. But there's also a reality to those finances, and those priorities need to be made for women. They are not easy conversations.

Member of Parliament, London–Fanshawe, Ontario

Appendix:
Twenty Questions to Ask Yourself If You Are Thinking of Running for Elected Office

1. Why? What is your true motivation?
2. Why now? What is the urgency of the matter now or why is this the opportune moment for you to act?
3. Do you know what needs to be done to address the challenge that is motivating you?
4. Why you? What makes you the right person to seek elected office? Are you the best person because you don't go along with the mainstream message, but you are more in line with the majority of people?
5. Is this the right time for your family, career, and finances?
6. Will your family support this choice?
7. Are friends and colleagues encouraging you to run? If so, will they help your campaign?
8. Where? Which level of government—local, provincial, or territorial, national? Which area? Which party, if any?
9. How? What are the rules both formal and informal for nominations and formal elections?
10. Do you have a campaign manager who can lead a winning campaign?
11. Do you have networks of supporters who can help you win a nomination and volunteer for your campaign?
12. Can you work long hours under pressure?

13. Do you enjoy public speaking, and can you be comfortable with public scrutiny?
14. Can you motivate or inspire others to action?
15. Do you have fundraising networks so you can fund your campaign?
16. Can you take the intensity of a campaign which could include strong opposition or even harassment and hate?
17. Do you have a trusted "kitchen table" team who are there for you?
18. If you choose to run with a party can you stick with them even when you disagree?
19. Can you live with losing?
20. Can you handle winning?

Acknowledgements

Thank you to all the activists, volunteers, supporters, and allies for getting involved to build a local movement for political change with countless hours of activism. You continue to inspire me. Together we built a transformative movement that helped propel me and others into office. Julius Deutsch, Winnie Ng, Jane Armstrong, Jill Marzetti, and David MacKenzie helped guide me through campaigns.

I am also so grateful for the strong tradition of labour leadership and the courage of union members to stand together to advance their rights and take on the powerful, especially at my union UNIFOR (formerly CAW). The many sisters in the women's movements, Julie White, Wendy Cuthbertson, Paulette Senior, Carolyn Egan, Wendy Kemiotis, and many others helped me develop a language and practice of equity and to challenge the intersections of power and oppressions. Thanks to Rosemary Speirs for her leadership in creating Equal Voice.

Former NDP leader Jack Layton repeatedly encouraged me to run. His relentless encouragement of Canadians to embrace a social democratic vision, "never let them tell you it can't be done," led to the best federal NDP showing ever. Had he not tragically died prematurely, could Jack have made that vision become a reality? I owe a debt of gratitude to all former NDP leaders; Alexa McDonough displayed a model of leadership filled with empathy and kindness, both publicly and personally and I am indebted to her.

I was very fortunate to work with many talented staff and advisers on Parliament Hill and in our riding. Riccardo Filippone joined my team when I became a parliamentarian and remains a

good friend. He later headed up my leadership campaign, bringing along staff and activists who made long hours of work so much more fun.

Libby Davies and Linda McQuaig helped me understand the process of getting a book into print. Sheila Matthen, Greg Denton, Jane Armstrong, Dr. Tracey Raney, Spencer Higdon-McGreal offered advice along the way. The women who agreed to be interviewed for this book didn't hesitate to engage in long interviews with a novice author. Thank you for your inspiring political leadership.

I also want to thank Stephen Lewis, Irene Atkinson, Cheri DiNovo, Sarah Doucette, Gord Perks, Jim Stanford, Tom Parkin, Sheila Koffman, Beverley Taft, ACORN Canada, Shannon Devine, Carolyn Egan, Marshall Ganz, Linda Jolley, David Miller, and Pam Sugiman.

The team at Between The Lines has guided me each step of the way to get to publication. Editor Mary Newberry was a real pleasure to work with and made the book much clearer and better organized. Errors and omissions are mine alone.

Most importantly Carl Kaufman is my best friend, closest confidant, and biggest supporter without whom nothing would have been possible. Our sons, Nick, Colin (with Jen), and Thomas know what life is like for a political family. They didn't choose it but they accepted and supported it. You, my family, are the very best in my life, and I owe you so much.

Index

Abrams, Stacey, 2, 43, 131, 253
accessibility and accountability, 39, 96, 115, 159–60, 169–70
accommodations, 96, 103. *See also* self-care
activism: overview, 10–11; history of, 251; inside government, 37, 43–5, 246, 247, 252–3, 254; limits to, 40; motivation, 124; and Nash, 9, 29–33; outside government, 37–40, 43, 45, 247 (*see also* movements; *specific movements*); young activists' support, 208–9
ads, 109, 127, 139, 192–3
advance polls, 229–30
advice from women in politics, 247–53
ageism and gendering age, 50–2
Air Canada, 30–2
allies, 161–2, 165–6
ambition, 7
Andrew, Jill (MPP), 29, 34–5, 184, 205–6, 247
anger, 34–6
Anlar, Brittany, 137

appearance: clothing, 185–8; hair, 154, 188, 221; jewellery, 186, 189; makeup, 154, 187; tattoos, 188–9
Ardern, Jacinda, 51–2, 132
Armstrong, Jane, 31, 81
authentic self: in campaigns, 184–90; hiding, 251; in media interviews, 154; and power, 1; and public narrative, 123–4, 132; in social media, 142, 143, 146; and values, 249–50

backlash, 7–8, 158–9
barriers: and calcified cultures, 24; electability as, 76; hiding yourself, 251; lack of, 59; lack of childcare, 22, 36; political parties as, 22; support of diverse candidates, 22–3. *See also* hate
being seen, 108–9. *See also* debates
Bell, Jessica (MPP), 64, 90, 120, 210, 247
Biden, Joe, 51
Black Lives Matter (BLM), 39, 43

Black women, 29, 43, 76, 156, 164, 167, 184, 203. *See also* Abrams, Stacey; Andrew, Jill; Lindo, Laura Mae; racialized women; racism
blackface scandal, 151–2
Blaney, Rachel (MP), 248
branding, 60, 62, 184–5, 189–90, 204
Bravo, Alejandra (political candidate): on authentic self, 1; on canvassing, 195, 203–4; on clothing, 186; on collectives, 248; on donations, 117; elected officials from movements, 41; on harassment, 157–8; on relationships, 86; on representation, 25; running as grassroots, 12; on timing, 53
breathing, 221–2
Brosseau, Ruth Ellen, 54, 55
building profile, 108–13
button-making, 98

calcified cultures, 23–4
cameras and phone videos, 140
campaign managers: overview, 87–8; candidates on E-day, 230; and debates, 213, 213–14; on election night, 231–2; as important, 118–19; as managing, 180–1, 182–3; and media requests, 152; as paid position, 118; time off, 183
campaigns/campaigning:

overview, 179–80; announcing, 77–8; and the best you, 184–90, 221; building momentum, 207–10, 227; building teams, 82–91, 97–9; candidates' jobs, 179–81, 183; canvassing (*see* canvassing); clothing, 185–8; confidence, 175; debates, 211–17; finances, 56 (*see also* finances); fundraising (*see* fundraising); identifying voters, 191–4, 199, 200–1; and issues, 192; loving, 182–3; office after, 240; and other work, 53–4; outcome preparation, 54–5; pre-organizing life for, 56, 57; public narrative, 123–7, 132–3, 138; public speaking, 127–36; pulling the vote, 228; self-care, 218–23; signs, 98, 118–19, 207–8, 210, 239; speeches, 130–5, 235–6; volunteers (*see* volunteers); and waiting to be asked, 58–9
Canadian Auto Workers (CAW), 32
candidate aides, 88–9, 99
canvass coordinators, 89
canvass handler, 203–4
canvassing: overview, 193, 195; and advance polls, 227, 229; and branding, 204; and clothing, 187; and debates, 199–200, 205; election, 198–9; identifying voters, 199, 200–1,

205; identifying yourself, 204, 205-6; with intention, 203-4; and issues, 202; and likely support, 196; with new volunteers, 181; and pets, 198; pre-election, 197-8; presentation, 195-6; and questions, 213; and ready resources, 200; recording results, 197; respecting differences, 201-3; and rude people, 219; safety, 161; strategy, 196-7; tips for, 204-5; as work of volunteers, 97

capitalism, 43

CAW/UNIFOR, 32

censorship, 10

change, 20-1, 22, 23, 99, 245

Chen, Katrina (MLA), 35-6, 129-30, 249

childcare, 22, 36, 40-1

Chow, Olivia, 67, 145

citizenship, 96, 114, 199

Clark, Helen, 33

Clinton, Hillary, 11

clothes, 185-8

Collins, Laurel (MP), 17-18, 22-3, 126-7, 182-3, 249

comfort, 185-6, 216-17, 235

"Common Sense Revolution," 21

communications: headshots, 189; for nominations, 79; public narrative, 78, 123-7, 132, 136, 138; team members, 89; as volunteer position, 98. *See also* social media; videos

community champions, 111

community leaders, 109, 110

competition, 7, 72

confidence: during campaign, 175; and encouragement, 249; learning in activism, 11; in public speaking, 136; vs. self-censorship, 10

confrontation, 7-8, 22. *See also* hate

connecting where you live, 67-8

conservatives, 20-1

constituency offices, 228-9, 240-1

contested nominations, 72-4, 81. *See also* political parties

control, 61, 63-4

conversations about running, 83-5, 248, 255

cooperation, 245

corruption, 115

COVID-19 pandemic, 15-17, 52

creativity, 142

critical actor model, 24

criticism, 169-75

cross channelling, 142

Crowder, Jean, 248

culture of political institutions, 22, 23, 24

data entry, 89-90, 97

debates, 199-200, 205, 209, 211-17, 251

defeat. *See* losing

defining oneself, 124–6. *See also*
 public narrative
defunding police, 39
deregulation, 30–1
Deutsch, Julius, 83, 231–2, 234
digital media outlets, 147–8. *See
 also* media
DiNovo, Cheri, 165–6
disabilities, people with, 96
discrimination. *See* criticism;
 racism
diversity: in campaign team,
 85–6; equity candidates, 74,
 164–5; as increasing, 188; and
 numbers, 156; political par-
 ties as barriers to, 22; politics
 as opportunities, 253–4; and
 power, 166; representation,
 164–5 (*see also* representa-
 tion); and support, 245
donations, 112, 117, 118,
 119–20, 241; rules governing,
 114–15, 119. *See also* finances;
 fundraising
double binds, 130–1
drop-in events, 112
Dubow, Sharmarke, 17–18

early starts: Bell's advice, 247;
 endorsements, 208; nomina-
 tions, 77–8; raising money,
 90, 118, 120; voting early,
 229–30
electability, 76–7, 80
elected officials: and
 homeownership, 17–18; as

mattering, 41, 43–4; as tied
 to movements, 37. *See also*
 government
election day coordinators, 90
elections: advance polls, 227,
 229–30; candidate's job
 on E-day, 230; canvassing
 (*see* canvassing); day after,
 238–42; election night,
 231–7; Nash losing and
 winning, 231–4; voters
 voting, 227–30
electoral systems, 21. *See also*
 voting
endorsers, 79, 208
engagement in social media,
 142–3. *See also* social media
envelope stuffing, 99
environmental crisis, 40, 43
Equal Voice, 33
equity candidates, 74, 164–5;
 electability, 76–7, 80. *See also*
 diversity
events, 99
excitement, creating, 79, 93,
 129, 208
exercise, 221, 222
expectations, 218, 255
experience as trap, 11–12

Facebook, 109, 127, 139, 161–2,
 192–3. *See also* social media
failure, 174. *See also* losing
fear: overview, 172–3; embrac-
 ing, 171; of failure, 81, 174;
 public speaking, 128–9;

publicizing campaign, 73. *See also* self-criticism

federal elections, 61, 66

finances: accountability, 115; analysis for strategy, 102; donations, 112, 114–15, 117, 118, 119–20, 241; financial report after campaign, 241; fundraising, 90, 115–16, 118; importance of, 90; before running, 56; and school board trustees, 111.

financial officers, 88

Floyd, George, 39

food, 98, 221, 235

francophones, 54, 55

free trade agreements, 40

friendliness, 200

friends/family: as bubble, 249; communication before running, 248; communication during campaign, 220; on election night, 236–7; and harassment, 160–1; kitchen table meetings/cabinets, 84–5, 254–5; making, 94–5; strength in, 171–2; on team, 87

fun, 143, 175, 205, 251–2

fundraising, 90, 112–20. *See also* donations; finances

Ganz, Marshall, 123, 124, 138

Gazan, Leah (MP), 29, 37, 101, 222, 249–50

"Gender and Political Leadership in a Time of COVID" (Johnson and Williams), 17

gender socialization, 22

gendering age, 51–2; ageism, 50–1

Gillard, Julia, 132

Gordon, Jessica, 38

governments, 15–17, 18–19, 40. *See also* elected officials; political parties/partisanship

grassroots organizing, 12, 106–7. *See also* activism

guide to book, 2–3

hair, 154, 188, 221

harassment. *See* hate; racism

Harris, Mike, 21

hashtags, 143

Hassum, Jen (Broadbent Institute), 76, 135–6, 145–6, 250

hate, 22, 144–5, 156–62, 219. *See also* racism

Hay, Michal (Progress Toronto), 65, 95–6, 250–1

headshots, 189

high schools, 212

Hollett, Jennifer (political candidate): advice from Layton, 83–5; on building profile, 108–9; on creating excitement, 93; on list making, 87; and McCuaig, 80; on proud campaigns, 182; and racism, 145; on reaching

people, 250; on social media, 137, 139, 144; on timing, 49; on volunteers, 94; on volunteers and donors, 139
hub-and-spoke processes, 112, 181
humility, 249-50
humour, 172, 173, 175, 202-3, 220

identity as political, 29
Idle No More movement, 38-9
Ignatieff, Michael, 211
imposture syndrome, 173, 174
independent candidates, 60-2, 72
Indian Act, 9, 29
Indigenous women, 7-9, 13-14, 29, 42, 65, 143. *See also* Gazan, Leah; racialized women; Sam, Ann Marie
Instagram, 140, 141
introverts, 219, 222
investigative journalism, 147-8
Islamophobia, 167. *See also* hate
issues, knowing, 202

James, Carol, 8-9, 65
Japanese people, 30
jewellery, 186, 189
Johnson, Carol, 17

Kaufman, Carl, 32, 220, 233-4
Kharpoche, Bhutila, 70-1
kitchen table meetings/cabinets, 84-5, 254-5

Klein, Naomi, 43
Krook, Mona Lena, 242-3
Kryzaniwsky, Cheryl, 31

languages, 129-30, 205, 229
laughing, 172, 173, 175, 202-3, 220
Layton, Jack, 50, 67, 83-6, 211
leaders: in activism, 10-11; building list of, 109, 110; and change, 99 (*see also* change); criteria for, 13; as diverse, 7; as engaging, 123; in movements, 42; and personal experiences, 13-14; planning for power, 20; in political parties, 63-4; reaching out to, 109, 110; and speeches, 130
leaflet dropping, 97
letter of intention, 78
Lewis, Helen, 18
Lewis, Stephen, 208
liminal times, 59
Lindo, Laura Mae (MPP), 14-15, 45, 164, 251
literature, 118
live fundraisers, 118
local strategy, 101-4. *See also* strategy
losing: Bravo on, 248; and day after election night, 239-40; fear of, 80, 81, 174; Nash's first, 231-2; preparation for, 207; recovering from, 230; speeches for, 235-6; taking it personal, 231

makeup, 154, 187

Malik, Ausma (political candidate), 166–8, 251–2

Mandela, Nelson, 51

Marin, Sanna, 51

Martin, Paul, 229

Marzetti, Jill, 83

Massé, Manon (députée à l'Assemblée nationale du Québec), 37, 42, 92, 188, 251

Mathyssen, Lindsay (MP), 82, 255

May, Elizabeth, 63

McAdam, Sylvia, 38

McCuaig, Linda, 80

McDonough, Alexa, 51

McLean, Sheelah, 38

media: ambushing, 154–5; "on background" meetings, 149–50; being on camera, 154, 184, 187, 189; while campaigning, 209; creating your own, 141; day after election night, 238–9; and debates, 211–12; earned vs. paid, 148; on election night, 237; investigative journalism, 147–8; list of contacts, 148–9; off or on the record, 150; paid media, 148; and party affiliation, 61, 62–3; prepping for, 151–3; being a presence in, 111; questions to ask, 152; relationships with, 149–51. See also social media

membership conditions, 62, 75

micromanaging, 180–1

microscope of public life, 22

Miller, David, 66, 83

misogyny, 157. See also sexism

moderators, 214–15

money. See finances

motivation, 33–4, 123, 124, 125, 230

movements: as cornerstones of resistance, 38–9; elected officials tied to, 37, 45; relationship building, 38; women as leaders in, 42. See also activism; specific movements

Mulroney, Brian, 211

municipal elections, 60–1, 65, 74

narratives. See public narrative

Nash, Peggy: as activist, 9; canvassing, 198, 219; contested nomination, 81; and Deutsch, 83; history in politics, 1; losing, 231–2; on media ambushing, 155; as micromanaging, 180; motivation of, 33–4; public speaking, 128–9; self-care during campaigns, 219–21; and social justice history, 29–30, 33–4, 38; strengths and weaknesses, 104–5, 106–7; union work, 9, 30–3, 104, 128

negative comments. See hate

nervousness, 212, 230

networks, 102–3, 115–16, 191–2

New Democratic Party (NDP), 44, 49–50, 54–5, 74–5
newcomers, 96
Ng, Winnie, 83
nominations, 62, 69, 116, 191, 245–6; winning, 72–81. *See also* political parties
Notley, Rachel, 13

Obama, Barak, 124, 125
"Obstacles for Women in Business: The Double Bind" (Turner), 130–1
Ocasio-Cortez, Alexandra, 51, 131, 134, 143, 144
office administration, 98
offices, 228–9, 240–1
older people running, 51
open houses, 112
opponents: analysis for strategy, 102, 103, 106; and debates, 215 (*see also* debates); and issues, 104, 111; in nominations, 80; and your public narrative, 124–5; respecting, 201, 238; thanking, 236. *See also* political parties
opportunities. *See* Strengths, Weaknesses, Opportunities, and Threats
Orange Wave, 54–5
outcome preparation, 54–5

paid media, 148
paid positions, 86, 118, 119

passion, 134
patience, 223
Pelosi, Nancy, 51
perfection, 170, 171, 173–4
performance, 216
persuasiveness, 147
pets, 198
phone calls and canvassing, 120, 193
photos, 140, 189. *See also* signs
places to connect with community, 108, 192. *See also* debates
podiums, 235
polarization, 159
political homework, 68–9
political landscape, 57–8
political parties/partisanship: analysis for strategy, 102; as barrier to diversity, 22; branding, 60, 62, 184–5; control of platform, 62–4, 151, 218–19; as counterproductive, 22; electoral district associations, 69, 74; finances, 62; as important, 92–3; joining, 60–5; levels of government, openings, 68; membership conditions, 62, 75; nominations, 62, 69, 72–81, 116, 191, 245–6; rules, 74–6; shelf life in power, 57; vetting candidates, 75–6
politicizing people, 92
positivity, 232
Potts, Sarah, 17–18

power: and accountability, 39; of authentic self, 1; and delay, 11; governments during pandemic, 15–17; and language, 20; and masculinity, 130; as mattering, 39, 43–4; of narrative, 123–7, 136; planning for, 20; protecting itself, 20–5, 157, 163; of underdogs, 103–4; used against powerful, 103

pregnancy/parenthood, 52–3. *See also* childcare

presentation of speeches, 134–5

privacy, 67

profile, building, 108–13

protection, 145, 160–1, 165, 249

provincial elections, 61, 64–5, 69, 74. *See also* political parties

public account of yourself, 124–6

public life, microscope of, 22

public narrative, 78, 123–7, 132–3, 136, 138

public speaking, 127–36, 171, 212, 216–17, 223, 235–6. *See also* debates

pulling the vote, 228

Puwar, Nirmal, 13, 159

Qaqqaq, Mumilaaq, 131–2

questions, 213. *See also* debates

racialized women, 7–8, 29, 43, 76, 156, 158–9, 164, 167, 184, 203. *See also* Indigenous women; racism; *specific women*

racism: amplification of anti-racism, 166; as barrier, 156; and canvassing, 205–6; community support, 166–8; and electability, 76; as hidden in system, 29–30, 164; hypocrisy, 163; in political parties, 151–2; and power, 21, 22; being prepared for, 165; recruiting candidates, 164–5. *See also* hate

Ramsey, Tracy (MP), 117–18

Raney, Tracey: activism and winning, 252–3; on harassment, 156, 158, 159; on representation, 23–4; on women, 253; on younger generation, 15–16, 19

rebates, 114, 117

recklessness, 143

recruiting candidates, 164–5

Reimer, Andrea (city councillor), 20, 59, 253

relationship building, 38

remote areas, 114

representation: electability, 76–7, 80; as mattering, 41, 56; and message about leadership, 25; and party priorities, 164; and policy outcomes, 23–4; vs. tokenism, 165; in unions, 30–1, 33

resources for marginalized, 200

respect, 201–3

rest and self-care, 103, 218–22,
 242–3. *See also* protection
retirees, 96. *See also* seniors'
 homes
riding associations, 69, 74
riding boundaries, 67–8
ridings, 68–71, 197
role models, 131, 156, 185
running independently, 60–2,
 72

safety, 161
Sam, Ann Marie (political can-
 didate), 8–9, 65, 163, 253–4
Santos, Rowena (regional
 councillor), 115–16, 161–2, 210,
 254
school board trustees, 110–11
second languages, 129–30
security, 214
self-care, 103, 218–22,
 242–3; shoes, 187. *See also*
 protection
self-censorship, 10
self-consciousness, 190
self-criticism/doubt, 72, 73, 170,
 172–5. *See also* fear
senate, 23–4
seniors: debates organized for,
 212, 213–14; as volunteers, 96.
 See also ageism
sensitivity, 142
sexism, 22, 76, 157. *See also*
 misogyny
Sharma, Niki (MLA), 73, 231,
 254

shoes, 187
shyness, 58
signs, 98, 118–19, 207–8, 210, 239
social assistance, 15–16
social media: overview, 137–8;
 and accessibility, 159–60;
 ads, 127, 139, 192–3; and
 debates, 215; for fundraising,
 115–16; guidelines, 141–4; hate,
 144, 158, 159–60, 161–2; as
 important, 138–9; as inter-
 active, 139; list of important,
 140–1; as quick story method,
 150; and reaching people,
 250; setting limits, 144–5; as
 strategic, 139; and strengths,
 145–6; and teams, 89; vs.
 traditional organizing, 138;
 and vetting nominations,
 75–6; videos, 109, 140–1, 189;
 as volunteer position, 97. *See
 also* media
sound systems, 235
*Space Invaders: Race, Gender,
 and Bodies Out of Place*
 (Puwar), 159
speeches, 130–5, 235–6
Speirs, Rosemary, 33
status quo, 20–1
stereotypes: and canvassing,
 198; as expected, 156; and
 political speeches, 130, 131;
 and praising leadership, 17,
 18–19
Stiles, Marit (MPP), 74, 110–11,
 126, 254–5

storytelling. *See* public narrative

strategies: and campaign managers, 87; for canvassing, 196–7; defined, 101; for harassment, 160, 165; and identifying target voters, 105–6; local, 101–4; for nominations, 79–80; for social media, 139; and SWOT, 104–5

Strengths, Weaknesses, Opportunities, and Threats (SWOT), 104–7, 145–6, 171–2

stress, 183, 218–19

sub-campaign offices, 228–9

substantial representation, 23–5

support: and barriers, 254–5; as bubble, 249; for encouragement, 249; of other politicians/candidates, 65, 80, 248; and racism, 166–8; and winning, 82, 254–5; from young activists, 208–9. *See also* friends/family; teams

support from parties, 62–3, 73

supporters, list of, 79, 87

systemic biases, 21

Taft, Beverley (Bev), 88–9, 90, 202–3, 220, 232

target voters, 105–6

tattoos, 188–9

taxes, 114–15. *See also* finances

teams: overview, 78; after election night, 239; building for campaigns, 82–91, 97–9; campaign managers, 87–8 (*see also* campaign managers); candidate aides, 88–9; canvass coordinators, 89; canvass handler, 203–4; communications, 79, 89, 125; data entry, 89–90; and debates, 215–16; on election night, 234, 237; financial officers, 88, 115; fundraising, 90; inner circle, 85; locating, 86–7; for long term, 250–1; paid positions, 86; as protection, 145, 160–1, 165, 249; public narrative, 78; and self-care, 220; as Team You, 253; tech people, 89; for transitions when winning, 241; as trusted, 82, 88; volunteer coordinators, 89, 90; winning, 82, 236. *See also* canvassing; volunteers

tech people, 89

TED Talks, 132

Thatcher, Margaret, 20–1

This Changes Everything (Klein), 43

threats, 158. *See also* hate; Strengths, Weaknesses, Opportunities, and Threats

throughlines of speeches, 132

TikTok, 140. *See also* social media

timing, 49–59, 77–8, 196

triggers, 171

Trudeau, Justin, 151–2

Trump, Donald, 21, 43

trust, 18–19, 32, 43, 79, 147, 185, 195

truth, 103–4, 167–8, 201, 249–50

Turner, Caroline, 130–1

Turner, John, 211

twenty questions to ask yourself, 257–8

Twitch, 141. *See also* social media

Twitter, 140, 142. *See also* social media

underdogs, 103–4

UNIFOR/CAW, 32

unions, 9, 30–3, 104, 114, 128

values, 124, 125

venues, 231, 234–5

vetting candidates, 75–6. *See also* nominations; political parties

videos: of Hollett, 109; and makeup, 187; and public narrative, 126; social media, 109, 140–1, 189; video calls, 154

violence. *See* hate

volunteer coordinators, 89, 90

volunteers: overview, 92–100; appreciation evening, 241; building during campaign, 181–2; canvassing with new, 196–7; on election night, 234; after election night, 239, 240, 241; hub-and-spoke processes, 112, 181; pulling the

vote, 228; as strength, 106. *See also* teams

voters, target, 105–6, 191–4, 199, 200–1, 205

voters, thanking, 239–40

voting, 42, 199, 212, 227–30. *See also* elections

voting history, 68

weaknesses. *See* Strengths, Weaknesses, Opportunities, and Threats

websites, 119

where to run, 66–71

Williams, Blair, 17

Wilson, Nina, 38

Wilson-Raybould, Jody, 61–2, 143

winning: and advance polls, 230; and anti-racism, 166; and campaign office, 240; after election night, 240; as independent, 61–2; intending to, 58, 229; Nash's first, 232–4; nominations, 72–81; preparation for, 54–5, 174–5, 241; speeches for, 235–6; and support, 254–5

Woodley, Deva, 43

work and running for office, 53–4

working-class representation, 25

workingnarratives.org, 124

Yalnizyan, Armine, 15–16

young people, 15–16, 19, 50–1, 96, 208–9
Youtube, 140. *See also* videos

zone houses, 228–9

 Peggy Nash is an advocate for labour rights and social justice in Canadian politics and the labour movement, as a long-time senior negotiator for the CAW (now Unifor). A former president of the federal New Democratic Party, she was a candidate for leader after the untimely death of Jack Layton. A candidate in several federal elections, she served as a Member of Parliament and was named Official Opposition Industry and Finance Critic. Nash is an educator, a frequent media commentator, a founding member of Equal Voice and a co-founder of X University's Women in the House program.